Thinking
LIKE A
Woman

PERSONAL LIFE AND
POLITICAL IDEAS

May 7, 2001
To Jim,
It has been a pleasure working with you and the Department.
best wishes,

CHRISTINE OVERALL *Christine*

SUMACH
PRESS

To my mother-in-law, Catherine Worth
and
my father-in-law, Arthur Worth
with appreciation and love

NATIONAL LIBRARY OF CANADA CATALOGUING IN PUBLICATION DATA

Overall, Christine, 1949-
Thinking like a woman: personal life and political ideas
ISBN 1-894549-05-8

1. Feminist theory. 2. Social history, 1970- . I. Title.
HQ1190.O94 2001 305.42'01 C2001-930149-9

Copyright © 2001 Christine Overall

Edited by Mary Anne Coffey
Cover and design by Liz Martin

Printed in Canada

Published by
SUMACH PRESS
1415 Bathurst Street, Suite 202
Toronto ON Canada M5R 3H8
sumachpress@on.aibn.com
www.sumachpress.com

CONTENTS

ACKNOWLEDGEMENTS 9
INTRODUCTION 11

FROM MEMORIES

Introduction 19
Grandmother's Presence in the Cottage 21
Like Father, Like Daughter: Work in the 1990s 25
Saying Goodbye to a Whole Generation 28
A Brother, A Son, and Two Halloweens 32
Wading and Splashing in the Dog Days of Summer 35
Stepping Out of Boots and Into Springtime 37
Remembering Grandfather a Century After His Birth 39
For the First Time in My Life, I Saw My Father Cry 42
Looking Forward to the Next Twenty-Five Years of Marriage 45
And So a New Role Begins: "Mother of the Boyfriend" 48

FROM THE BODY

Introduction 51
Our Social World Helps Determine the Extent of Our Disabilities 53
Acupuncture Defies My Western Scepticism 56
Painful Illness Taught Some Valuable Lessons 59
An Evening Sewing Sequins on a Figure Skating Costume 62
There's No Short Answer to Solving Tallness Bias 65
Mandatory Retirement Tramples on Rights of Seniors 68
White People Have Distinct Advantages in Canada 71
Getting a Handle on Half a Century of Living 74
Visible Bra Straps Show Women's Body Confidence 76
Finding Practical, Comfortable Clothes a Boomer Challenge 79
Insomniacs and Sound Sleepers Make Strange Bedfellows 82
Menopause Has Become a Booming Industry 85

From the Home

Introduction 88

A Most Unscholarly Hair-Raising Episode 90
The Kids of the Kid Chosen Last for Every Team 94
Childhood: You Blink, and It's Gone Forever 97
Her Auto-Dyslexia and His Diaper-Dyslexia 100
Where Do Odd Socks Go, and
Other Questions of Laundry Philosophy 104
Why Do Feminists' Daughters Want a Barbie? 107
Mixed Emotions When the Nest Begins to Empty 110
When the Prodigally Spending Son Returns Home 113
The Wonderful Teenage World of Wedgies and Wisdom 116
When Children Disappear From Our City Streets 119
Let's Hope Women Can "Have It All" in the Twenty-First Century 122
Feminist Ideals Don't Hinder Raising a Good Son 125

From the Not-So-Ivory Tower

Introduction 129

High Tuitions Keep Universities for Middle Class 131
Abolish Tenure? Gee, This Guy Harris Might Be On to Something 135
The Things That Dare Not Bare Their Names 138
Celebrating Older Women as a Precious Resource 141
Superomnian Reflections on High School Latin 144
Schools are No Place for Religious Indoctrination 147
Class Differences Are Very Clear in Canadian Society 150
Saving Face Isn't Just Cause for Changing One's Mind 153
Tories' Competition Funding Theory Deserves Failing Grade 156
Stockwell Day's Homophobic Reasoning Lacks Consistency 159

From the Newsroom

Introduction 163

Cloning Expresses Fear of Personal Difference 165
How Far Are the Anti-Abortionists Willing to Go? 169
Homolka Case Suggests Some Women Can
Choose to Be Monsters 173

Minor Hockey in Need of Major Overhaul *176*
Should Sperm Donors Be Paid More Than Blood Donors? *179*
Sexism Discourages Women from Seeking Office *183*
Now We Need a Ban on Bad Smoking-Ban Arguments *186*
Will Sexualizing Women's Bodies Ever End? *189*
Women's Role is Still a Matter of Contention *192*
Latimer Had No Right to Kill His Disabled Daughter *195*
We Need More Ways to Protect, and Empower, Young Women *198*
Mother of Septuplets Faces Difficult Road Ahead *201*
Storing Onions in Pantyhose the Least of Women's Concerns *205*
The Cultural and Racial Pitfalls of In Vitro Fertilization *208*
Whites and "Straights" Have No Need to Hold Pride Marches *211*

FROM THE PHILOSOPHER'S HEART

Introduction 215
The Little Things *217*
Life Without Television:
The World Offers Us Many Other Enticements *221*
Avoiding the Smurf Theory of "Women's Issues" *224*
No Generation is An Island Entire of Itself: Why Baby Boomers
Don't Have It So Easy, Either *227*
Buying More Products Won't Save the World' *231*
Fast-Paced World Overlooks Value of Introversion *234*
It Doesn't Feel Right to Eat Beings That Have Faces *237*
What's It Mean to be a Feminist? Not What You Might Think *240*
The Great Debate: Can a Man Be a Feminist? *243*
There's No Reason Women Can't Do "Male" Jobs *246*
Refusing Rights to Homosexuals Boils Down to Prejudice *249*
Communing With Nature Reveals Humanity's Inhumanity *252*
Church-Imposed Celibacy a Burden, Barrier to Priesthood *255*
How Do I Love Thee? Let Me Count the Conditions *258*
Nine Good Reasons Why the 1990s Were So Important *261*

AFTERWORD 265

REFERENCES 269

Acknowledgements

Creating this book has been a truly collaborative project.

I am grateful to Harvey Schachter, who first invited me to join the Community Editorial Board of *The Kingston Whig-Standard*, and to Steve Lukits, who offered me the opportunity to take over the newspaper's "In Other Words" column. In the ensuing years Steve has continued to be supportive of my writing, and he encouraged me to create this book. Thanks also to Jack Chiang for his talented photography, and to Paul Schliesmann, Barrie Hill-Tout, Michael Den Tandt, and Ron Wadden, who have edited my column with a light and careful hand and provided its weekly titles. Joanne Page, an accomplished writer and my immediate predecessor as the "In Other Words" columnist, very helpfully educated me about the column's history and traditions.

I would also like to express my appreciation to the *Whig-Standard* readers who follow my weekly columns and often write in to state their views about my work. Tom Russell, Marjorie Roantree, Marg Buckholtz, Kathy Silver, and many others have, through their positive feedback, helped me to believe that I am making a difference. Special thanks to Suzi Wong, Margaret Hagel, Terrie Easter Sheen, Laverne Russell, Tom Russell, Nancy Cutway, Steve Cutway, and Alex Bryans for suggesting their favourite columns for inclusion in this book. Thanks also to Val Ross of *The Globe and Mail* for publishing advice, and to Maxine Wilson of the Queen's University Department of Philosophy for her patient assistance with printing and photocopying the manuscript.

Rex Williams of Cariad Ltd. first put me in touch with Beth McAuley at Sumach Press. Beth believed in this project from the very beginning, and encouraged me to feel that it was worth completing. Mary Anne Coffey has been an insightful, supportive, and knowledgeable editor. Her input was invaluable. I am also

grateful to Janice Andreae, who suggested the concept of "locations" as a way of structuring the book, and to Liz Martin, who created the cover design.

For both the challenges and the fun, I thank all of the members of the Kingston Klassics, the adult synchronized skating team to which I've belonged for several years, and especially Rhonda McKnight, our coach from 1992 to 2000, and Christine Sellery, our current coach. The Klassics always provide me with a lighthearted reminder that there is life after work. In the summertime, between skating seasons, the staff and rowers at the Kingston Rowing Club have given me the opportunity to learn a wonderful new sport on unfrozen water.

Over many decades I have been fortunate to have had the steadfast support of my family, especially my parents-in-law, Arthur Worth and Catherine Worth, my sisters-in-law, Barbara Worth and Patricia Sayer, my mother, Dorothy Overall, my aunts, Gwenyth Bayes and Mary Desson, and my brothers, John Overall and David Overall. Finally, my loving appreciation goes to my husband, Ted Worth, and my children, Devon Worth and Narnia Worth, not only for amply providing me with much of the material that a columnist needs, but also for their gentle critiques of my work and their tolerance of and patience with the moods of their in-house writer.

Introduction

ACCORDING TO Mary Rose O'Reilley, a gifted and award-winning teacher, "Truth is symphonic."[1] I take the statement to mean that figuring out who we are and what this universe is all about requires the diverse contributions of many different kinds of people. We can all contribute a piece or a bit part to the collective project of understanding ourselves.

In my contribution to the cultural symphony I play the countermelody of feminism, a tune that may occasionally create some dissonance in the human orchestra but whose ultimate goal is the promotion of greater social harmony. My feminist beliefs and values animate almost everything that I write. I hope I can show through my writing that contrary to most media stereotypes, feminists are not ogres or fanatics. We are human beings like other human beings, with our own hopes, aspirations, and plans, friends and family, troubles and challenges.

As I wrote in my March 31, 1997, column:

> My definition of feminism is brief: You're a feminist if you believe women have been and are subjected to unjust and oppressive treatment, and if you're committed to helping to end that treatment. ... [B]eing a feminist is, after all, not so very strange. It's simply a matter of believing, sincerely, that women are people, not lesser beings than men.

To a considerable extent, fortunately, women in the arts, education, politics, and civic life are no longer required to presume upon the strength of our feminine wiles (if they have them, and I do not). Nor do we have to present ourselves as pseudo-men, acceptable to the degree that we succeed in aping stereotypical masculine values and beliefs. I have entitled this book *Thinking Like a Woman*, because one of the goals of feminism is to make thinking like a woman socially acceptable. It is still not so long

ago that thinking (along with speaking and acting) "like a woman" was taken as a matter of shame and weakness. The phrase remains an insult to any man who is accused of being "like a woman" in any respect. But the only reason the phrase can function as an insult is that being a woman, or being like one, is still covertly assumed to be undesirable or second-rate. Feminism exposes the noxiousness of that assumption.

I am a woman, and being a woman shapes much of my life, though a woman is not all or only what I am. I seek to reclaim the values of "thinking like a woman." In my work as a mother, as an academic, and as a columnist, I draw upon my unique experiences as a woman in a society where gender is still acutely significant. Yet the title of this book is intended neither to suggest that all women think alike (of course we do not), nor that my thinking is necessarily typical of that of other women. I don't think it is. My hope is just that my writing will indicate one feminist's outlook on issues that many women may share.

Having the freedom to write regularly for an audience of newspaper readers is both a great privilege and an unmatchable opportunity. Starting in 1989 I wrote on an occasional basis for *The Kingston Whig-Standard,* after I was requested, along with some other Kingston area citizens, to join the newspaper's innovative Community Editorial Board. Then in 1993 I was invited to become a regular columnist. I took on responsibility for "In Other Words," a feminist column that had first appeared in the newspaper in 1987. The column's very existence was the result of lobbying by a group of Kingston women, who had presented their proposal for a weekly column to Neil Reynolds, the Editor of the *Whig-Standard* at that time. Written first by poet and short story writer Bronwen Wallace, and then by poet and artist Joanne Page, the column was a precious legacy from the two brilliant women who preceded me.

Steve Lukits, the then-editorial page editor, gave me the freedom to write what I pleased, and he encouraged my efforts to explore a variety of topics. There was no requirement for me to confine my writing to political topics narrowly understood, or

even to so-called "women's issues" as they have been standardly construed by the women's movement. Instead, I have the rare freedom of simply writing about topics on which I've been reflecting — the issues that I think matter, and into which a feminist perspective offers some insight.

Thinking Like a Woman is an edited selection from over a decade of my published columns. In deciding what to include I've tried to choose columns that are not merely ephemeral but focus on issues with some lasting significance for women and men and how we live our lives in the new century.

Writing teacher Dorothea Brande once said, "There is just one contribution which every one of us can make: we can give into the common pool of experience some comprehension of the world as it looks to each of us."[2] In *Thinking Like a Woman* I want to offer you a glimpse of the world as it looks to me, and I invite you to decide whether it fits your own experience and perspective.

I've subtitled this collection "Personal Life and Political Ideas" in order to signal the importance, for a feminist, both of women's private struggles and of our attention to power relations and imbalances. The columns also, I hope, reflect the feminist adage "the personal is political." I often write about my childhood memories as well as about my present-day observations and future life goals. Yet as the feminist slogan suggests, my columns about personal life are imbued with my political and moral perspective as a feminist, while my columns on political issues rest on a basis of personal experience.

My understanding of the world is largely derived from three main sources: my philosophical training, my feminist worldview, and my experiences as a family member, teacher, scholar, and administrator.

My philosophical education was primarily in an area called "analytical philosophy." An education in analytical philosophy attempts to promote in its students a sensitivity to the subtleties of language, an avoidance of muddle-headedness, and an ability to evaluate dogma and propaganda.

I think philosophy is everywhere in human life, and I write from the conviction that philosophical thinking is for everyone. It

is no mere ivory tower pursuit, but develops from the effort to understand and evaluate our life experiences. Human beings naturally and almost inevitably find themselves engaging in philosophical reflection on matters of personal and social morality, religious belief, education, politics, public policy, and scientific knowledge.

As a columnist, I'm interested in questions that arise when we reflect upon our personal lives and the social and political world in which we find ourselves. What is the significance of our relationships with our siblings and our parents at various stages of our lives? What do our memories of childhood tell us about ourselves? What features contribute to good childrearing and good education? How does gender — our socialization as feminine or masculine — affect our beliefs, values, and behaviour? How can we create a society in which everyone, whatever their class, race, sexuality, age, or ability, will flourish?

I try to engage readers in thinking along with me about issues that in some cases may already preoccupy them and in other cases may be new. I don't expect readers to agree with me; I just hope they will give my ideas an open consideration. Where they reject my conclusions, I welcome their counterarguments and alternative views. My main concern is to try to be comprehensible and honest in what I write, and to argue clearly and sometimes passionately for my opinions.

My column has provoked a broad range of responses from readers. Some responses are reassuring: my readers phone me or stop me on the street to tell me they've enjoyed a particular column, often because it has evoked similar experiences or memories within their own lives. My reflections about motherhood and my relationships with my family most often seem to provoke in readers that sense of recognition and commonality. Other respondents are gratified to find that I give voice to their political opinions within the daily newspaper. At a time when the culture appears to be tilting to the right, they welcome a progressive outlook on current social and political issues. Such readers often give me suggestions or leads about future topics that they would like to see covered, and I'm grateful for their ideas about how I can

better explain and demonstrate feminist thinking in action.

While I used to think of my feminist views as quite radical, within the last five years or so I believed that the culture was catching up with me, and the feminism that I advocate was becoming a common phenomenon. But the responses of some of my readers have indicated that my optimism may be premature. Angered by my claims, some readers have called into question my education, my intelligence, and my personal morality. These *ad feminam* attacks are unanswerable, for nothing I say to such critics will convince them that I'm well educated, reasonably smart, and not thoroughly despicable. While still disagreeing with me, other readers have taken the time to phone me, e-mail me, or write to the *Whig-Standard* to explain where they think I've gone wrong. I value these responses, for a well-thought-out argument helps me to see where I need to make my own views clearer, or to figure out how to revise opinions that, in light of reader feedback, may no longer seem viable.

People often wonder where I get the topics for my column. "Don't you ever run out of ideas?" they ask. The truth is, there's no shortage of topics. Occasionally I may have a week when I'm feeling overworked, besieged by deadlines, or downcast by the gray weather that southern Ontario experiences in the winter. At those times, fortunately rare, I can find it a challenge to write a new column. But the world is a truly fascinating place, and the small parts of it that I observe from my vantage point as family member, teacher, and writer seldom fail to stimulate my thinking.

British columnist Paul Johnson defines the newspaper column as consisting of "periodic discourses on important and usually topical choices of their [the columnists'] choice." In a collection of his own columns, *To Hell With Picasso and Other Essays*, Johnson lists what he thinks are the prerequisites for all good columnists. They include extensive general knowledge, wide-ranging international travel, and "worldliness." Indeed, Johnson writes, "the columnist ought to know personally the principal rulers of the day, and if possible anyone else who is in and out of the news."[3]

Adopting those criteria, I would have few prospects for success as a columnist. As an academic I am frequently reminded of how little I know, compared with many of my learned colleagues, and I cannot claim to be at all worldly. I don't travel a lot. I live, work, and write not in a cosmopolitan big city but in the smallish city of Kingston, Ontario, population 113,000. I do not have connections with the rich, famous, or powerful — I count myself fortunate to be on a first-name basis with a former Kingston mayor and an aspiring member of the provincial legislature! I am not particularly ambitious or outgoing, and (by choice) I don't even own a television.

I have a friend who speaks of wanting to live "a big life." I like to hope that my life becomes big by virtue of the wonderful people with whom I live and work, and the stimulating and creative ideas I encounter as a person privileged with a good education and an academic career. In my computer I maintain a file, with the unoriginal title, "Ideas," into which I regularly enter possible topics that I think of or are suggested to me for my column. It rarely has fewer than a hundred entries. Sometimes an issue on the front page of today's newspaper becomes the topic of my column. And sometimes an idea may not be used until three years after it was entered in my "Ideas" file.

But whatever the source of the topic, writing my column requires a period of what I call "composting." Mary Rose O'Reilley says, "the junk flowing through our lives is the raw material of new creation." She also quotes Thich N'hat Hanh, a Buddhist writer: "Most work of consciousness happens in an underground storehouse that [the] mind can only fertilize like a good gardener."[4] So I toss ideas, bits of experience, remembered conversations, observations of people and places, books I've read, recent news stories, films I've seen, interactions with family and friends, into the composter of my mind, and let it cook.

I can't write about something simply because it is current or trendy. I have to believe that I have something of my own to say about it. So when I have a particular topic in mind, I mull it over as I walk to and from work, while exercising, or in that dreamy

time just before I fall asleep. In this way, a tiny sprout of an idea may germinate. At this stage I don't make any judgments; I allow myself to take note of whatever occurs to me, setting aside the editorial voice, which will have a role later. Often I have to find a way to contain and express the strong feelings I have about certain issues. Sometimes a column will emerge in one intense and direct writing session, and other times I may have to spend hours cutting and pruning my text. But if the composting process has worked well, a new seedling will issue forth, robust and in good health.

As writers William Strunk, Jr. and E. B. White suggest, all writing is "the Self escaping into the open. No writer long remains incognito."[5] Over the years of writing for the *Whig-Standard* I have been fortunate to build relationships with my readers, who have written to me, phoned me, and stopped me on the street to talk. Many readers say that they feel they have gotten to know me through my column. In *Thinking Like a Woman* I look forward to communicating with a new audience of readers as well as renewing some old connections. I sincerely hope you will enjoy this collection.

1. Mary Rose O'Reilley, *Radical Presence: Teaching as Contemplative Practice* (Portsmouth, NH: Boynton-Cook Publishers, 1998). O'Reilley says she got the idea from her colleague Michael Mikolajczak, who got it from Hans Urs von Balthasar. The very indirect provenance of the idea helps to demonstrate its truth.
2. Dorothea Brande, *Becoming a Writer* (1934; reprint, Los Angeles, CA: J.P. Tarcher, Inc., 1981), 120.
3. Paul Johnson, *To Hell with Picasso and Other Essays* (London: Orion Books, 1997), xii, xiv.
4. O'Reilley, *Radical Presence,* 20, 37.
5. William Strunk, Jr. and E.B. White, *The Elements of Style,* 3rd ed. (New York: Macmillan, 1979), 67.

From Memories

Introduction

SINCE I WAS A YOUNG TEENAGER I've been interested in family histories. Born with a distinctive and fairly rare surname, I had a sense of the complexity of family connections and the tantalizing incompleteness of family stories.

A baby boomer who married her childhood sweetheart, I grew up in a working-class suburb of Toronto. I am the grandchild of both immigrant and native-born Canadians who survived the First World War and the Great Depression. I am the daughter of parents who came of age in the '40s and were deeply shaped by the Second World War, and I am the older sister of two brothers born in the '50s.

The Spanish-American philosopher George Santayana claimed that those who cannot remember the past are condemned to repeat it. But that's not why I think we need to remember our personal history and learn our family histories. Instead, I think we need to recover and retain our past because we are constituted by it. Our history is about who we are, and about our essential connections to other people.

Some cultural commentators have argued that in the late twentieth century we have shifted from a vertical to a horizontal experience of the self. That is, our identity is no longer determined by our relationships to the past, but rather by our links to persons and events in the present. I think that's not accurate. Many of our connections are still vertical. However much we might want to reject the past, to reinvent ourselves, and to shake off the limitations of tradition, our very abilities to reject and to reinvent emerge from the persons and events that shaped us during our early years. An individual with no memories and no history cannot be fully a person.

Whether you love it or you want to leave it behind, your personal and family history is a part of you. And so, as a way to introduce readers to the person that I am, I start this book with my columns "From Memories."

Grandmother's Presence in the Cottage

EVERY SUMMER when I was a child my parents took me to the family cottage in the Kawartha Lakes district. It was owned by my grandparents, who regularly invited their children and grandchildren to share it. We used to drive there on highways that started out as asphalt but eventually became dusty gravel. As we approached the cottage, the road climbed a hill between cow pastures; at its summit we could glimpse the lake, blue and green and sparkling in the sun.

When my grandparents bought it in the late 1940s the cottage was already about forty years old. It was tiny and a bit primitive: a pump in the kitchen produced water for washing; drinking water had to be fetched from a well down the road. There was no bath, no flush toilet. What fascinated me most, as a child, was that there were also no ceilings: I could look straight up and see the wooden rafters and the roof.

The water was rather deep for a small child, but I learned to swim at the lake, with my mother holding the straps of my bathing suit while I did the dog paddle and the breaststroke. In the late afternoon the sun glinted on the choppy waves, and after hours of swimming practice I would finally be coaxed from the water to sit, shivering and wrapped in a towel, and enjoy a snack of milk and cookies.

I shared a bedroom with my brother, and as the older of the two I had the privilege of the upper bunk. At night I could peek over the top of the wall and watch the grown-ups playing cards in the next room. And one morning, very early, when no one else was awake, I leaned out of my bunk and wrote my name — CHRISSIE — in purple crayon on the wooden wall, just under the light. I was four.

My grandmother loved the summer and thrived in the sun and the heat. August was always her favourite month. What I remember most is her cooking. In the early years she used a wood stove. She would get up before everyone else and put some wood on, to take

the chill off the early morning. With the help of her daughters she produced enormous meals, complete with roast chicken or beef, potatoes, vegetables, and fruit pies, even in the severest heat wave.

A sturdy, capable woman, my grandmother kept the cottage going until she was in her late eighties. She cared for my frail grandfather and my disabled uncle, each summer driving them to the lake, which they all loved, and continuing to cook the meals, do the housework, and oversee the cottage maintenance.

But in 1987 she had a stroke, and in that brief moment her life, and that of my family, changed completely. My grandfather went into a seniors' home, my uncle into an institution for the disabled. Grandma was hospitalised, and lay in bed, paralysed down one side of her body, for several months.

Because she is a strong and self-reliant woman, she was determined to recover her independence. She struggled and worked to retrain her muscles, and within less than a year she could walk with a cane.

But Grandma's illness had modified family history. After her stroke the cottage was seldom used. Her children and grandchildren had other responsibilities and interests; her great-grandchildren scarcely knew the cottage. It had become a burden: someone had to air the linens, cut the grass, keep the mice out, and paint the exterior, but no one was having fun there any more.

So this summer, in her ninety-third year, Grandma decided it was time to let the cottage go.

My grandmother is not a sentimentalist. And with good reason. Her mother died of "childbed fever" shortly after Grandma's birth. She was separated from her father and brother and went to live with an aunt, with whom she had a nomadic childhood. She remembers well the First World War, and the flu epidemic of 1918–19. She and my grandfather survived the Depression, raised three daughters, and learned to accept that their only son was severely and incurably disabled. Now she has outlived the man to whom she was married for almost sixty-five years. There is not much room in her history for sentiment.

She offered the cottage for sale "as is," with all its contents. After

all, she now lives in just one room in a seniors' home. Memories live on so possessions are not so necessary, and in any case, there isn't room for them. No sentimental clinging to mementos of the past.

She specified just a few exceptions to the "as is" clause. The family could retain personal effects. And a cedar chest and a bed were to be given to me, the eldest grandchild with the strong sense of family history.

The cedar chest had belonged to my grandfather, who brought it with him to his marriage in 1924. The bed is even older; my grandmother's father, a coffin-maker by trade, built it over a century ago, and carved the high and sombre headboard into a pattern of scrolls and flowers.

The cottage sold easily, within two weeks of being placed on the market. Several days before the new owners were to take possession, four of us drove up to say goodbye to the place.

I had not been at the cottage since before my grandmother's illness. And at first all I saw were the traces of the men in the family: my grandfather's cedar chest, his straw hat on a hook, his pipe tamper in an ash tray; my uncle's pictures and playing cards; my great-grandfather's stately bed.

My grandmother's presence was less obvious. On her dresser was an empty jewellery box. In a drawer was an intricate apron she had crocheted. Some unfinished knitting projects sat on a table. There was nothing of hers that seemed substantial or permanent.

But then I remembered that the whole cottage reflects my grandmother's work. She ran the kitchen, kept the sugar bowl, the tea canister, and the flour bin full, and pushed the ageing appliances to keep functioning. She washed the linens and knitted the heavy sweaters hanging in the cupboard. She arranged the furniture in the living room overlooking the lake, and stored books in the spare bedroom for guests to read. She was always ready with a cup of tea, an extra towel, or a Band-Aid. She made the place comfortable for us all.

Feminist historians have pointed out that women are usually the main source of family security and continuity. They have been the keepers of domestic history in families where the men go off to work

or even to war, as both of my grandfathers and my father did, or just to find new and younger wives, as two of my uncles did. It is the women who write letters and buy gifts, remember birthdays and anniversaries, plan weddings, comfort the bereaved, and tell children and grandchildren the family stories.

My grandmother did all this, and did it well. But she also did something else. She knew when to let go.

Grandma values her memories, but she does not live in the past. She has always loved summer, but she knows that it doesn't last forever, and neither does an era in family history. The cottage belongs to another family now. When the summer has ended, it is time to treasure our memories of sunny days at the lake, and say goodbye to the cottage we once knew so well.

August 23, 1993

Like Father, Like Daughter: Work in the 1990s

RECENTLY I've been thinking about my father.

During my childhood Dad had a series of jobs, and every one of them made him tense and troubled. He worked long hours and often had to be away from home for days at a time. In the morning before leaving for work he was withdrawn and gloomy, hunched silently over his breakfast. When he returned from a day's or a week's work he was usually exhausted and uncommunicative. While my mother hurried to get dinner on the table, he would collapse in a chair with a beer. Later in the evening he just wanted to withdraw behind a newspaper or watch a hockey game.

One of the few subjects on which he expressed any views was money: "Money doesn't grow on trees." "We can't afford it." "You'd better make that last, because there won't be any more of it." Like my mother, Dad was concerned that his children have a good education, better than his own schooling. He was also anxious for each of us to get part-time jobs, and disapproved of my preference for spending the summer hanging out with friends. (One summer when I got a job as a camp counsellor that paid only $200 for nine weeks' work he was furious — not at my employer for exploiting adolescent labour, but at me for failing to find a job that paid better.)

When I grew up I struggled to understand my father's dispirited and pessimistic behaviour. I knew he had had a stern upbringing, with parents who regarded him as a bad boy from whom little could be expected. At the age of nineteen he enlisted in the Air Force, and during the Second World War, as a very young man, he worked as a radar technician at military bases all over the world — in Iceland, India, Egypt, South Africa, and England. He struggled with loneliness, culture shock, and illness. In his twenties he returned to a working-class suburban life where the man's role was to hold down a job, the woman's role was to care for the house, and the children's role was to keep quiet and study hard.

My education and work background is, of course, very different from my dad's. Recently, however, some experiences have brought me closer to my father's world than I ever expected to feel.

For the past fifteen months I have been the sole financial support for my family of four. Accustomed, like so many middle-class families, to the safety cushion of two pay cheques, we find the sudden drop in family income and the resulting decline in our plans and hopes both unexpected and frightening.

But what surprised me most about this change was my personal reaction to the unfamiliar responsibility of providing for two adults and two growing adolescents.

I began to lie awake at night worrying about ways to earn extra money or to make the money I earn go farther. I started to put pressure on my children to earn their own money. I became concerned about their carefree attitudes toward spending. I worried about whether their education would provide them with adequate and secure jobs.

Coming home from work grouchy and exhausted, I began to assume dinner would be ready on the table for me. After the meal I just wanted to collapse behind a newspaper or book. I resented doing housework, and began to expect my spouse to do it all.

Gradually, without ever wanting to, I was turning into my father. But how could that happen?

Given my dad's tough childhood, his indelible war experiences, and the gender-stereotyped culture he grew up in, his behaviour seems easy to account for. But these factors are not the complete explanation for the kind of man he was during my childhood.

The pressures of holding down demanding yet uncertain jobs and of knowing that for years he was the only source of income for our family of five surely also contributed to making my father anxious, taciturn, and preoccupied with money.

Compared with my father's, my job is more secure, more interesting, and better paid; my family's standard of living is higher than that of my family of origin. Yet being the sole support of my family and witnessing the effects of cutbacks and salary freezes at my

workplace have elicited from me some of the same behaviours I noticed years ago in my father.

What this rather humbling observation suggests to me is, first, the malleability of gender roles: economic pressures have fairly easily made a working mother of the '90s behave something like a '50s working father. My father's actions were stereotypically but not inevitably male. As more and more women try to cope with the traditional role stresses formerly imposed mostly on men, the unremitting pressure of selling our labour to survive could cause us to become, as the feminist adage puts it, "the men our mothers warned us about."

But, just as important, my experiences in the '90s recession have made me a little less resentful about my father's behaviour as I was growing up. For Dad, a hard childhood and a stressful war history were followed by years of financial responsibility and constraint. Despite the many differences in our life circumstances, I think I understand him a little better now.

October 4, 1993

Saying Goodbye to a Whole Generation

EARLY ONE MORNING in January I awoke with a dream still vivid in my mind.

In the dream, I was in Toronto with my mother and her youngest sister, my aunt. We were saying goodbye to my grandmother, who was dying. I was crying. And I was saying the Twenty-Third Psalm: "The Lord is my shepherd, I shall not want …".

At breakfast that day I mentioned to my children that I was worried about their great-grandmother, and I wondered if she could be ill.

The next day my mother phoned to say that, after suffering serious heart problems, my grandmother had just been hospitalised. Since I was going to be travelling to Toronto that week for a brief business trip, I welcomed the opportunity to visit her.

Next day, when my mother and I entered Grandma's hospital room, she was sleeping composedly. On hearing her name, she woke easily and immediately welcomed us.

In some ways she seemed to be doing very well. After being out in the bitter cold my hand was icy, but her hand when I held it was warm, soft, and firm. It was not a frail hand, not wrinkled, not weak.

Grandma didn't seem very interested in discussing her failing health. Instead, she wanted to talk about me and my recent activities. Though usually an undemonstrative woman, she told me she was proud of me.

Yet despite her seeming vigour it was clear that something was seriously wrong. She, a woman who always enjoyed food, was unable to eat any of her lunch.

She was a bit sad, too, and predicted that her little great-grandson, my brother's son, whom she had not seen for years, would only come to her funeral. My mother and I demurred, and said of course she would see him again.

But even then I wondered what use it is, to people who are dying, to have to endure the pretences of those who will survive them.

My grandmother's reflectiveness that day was like that of my grandfather, shortly before his death. When I last visited him, just before his death in 1989, he lay in his hospital bed, talked about his long and eventful life, and said, wonderingly, "I don't know what it all means. Do you?"

I, the philosopher by training, had no good answer for him.

On this visit, my grandmother said to me, "Sometimes I ask myself why I struggle to stay alive, and don't just give up."

I tried to respond cheerfully. "And what answer do you get?"

Her face had an enigmatic look. "I don't know. You tell me, you're the philosopher."

Conscious that I hadn't had an answer to my grandfather's question, I tried to reply. I thought of her zest for life and how happy she had been in the seniors' home where she lived after recovering from her stroke. I said, "I think you go on living because you enjoy life so much, and you're glad to be at a stage when you don't have to work, and people can take care of you." But Grandma did not answer.

The next day, when I had to go back to Kingston, I wondered whether I really should stay. There could not be too many more opportunities to visit my grandmother.

And the day after my return, I was not surprised when I got a call from my mother telling me Grandma was dead. So almost immediately I returned to Toronto, to attend her funeral.

As she predicted, the little great-grandson whom she hadn't seen in years was present at the service.

The minister prayed, "Let thy light shine upon her, O Lord," but I added in my mind, "and make sure she's well fed."

Then, unasked, the minister read the Twenty-Third Psalm: "Yea, though I walk through the valley of the shadow of death I shall fear no evil, for thou art with me ...".

Because of my dream, and because of Grandma's comments during our last visit, I wasn't shocked by her death. She was very old, the last of my four grandparents to go. With her departure I say

goodbye to a whole generation — a generation with few resources and little education, a generation that endured two wars, struggled through the Great Depression, and still managed to do a fine job of raising their children and cherishing their grandchildren.

As people remind me, I am lucky to have had my grandmother for so long — at a time when many of my contemporaries are losing their parents. Indeed, many folks are inclined to think that the death of a person so old as my grandmother, a person in declining health, is no tragedy.

But I cannot easily accept her death. The fact that she lived to an advanced age just meant that there was that much longer for me to develop an attachment to her.

I still grapple with what seems to me to be the injustice of death, at any age. Even as a small child, when I first grasped the reality of death, I grieved at the realization that my grandparents would predecease me. Reflecting on her own mother's death, Simone de Beauvoir wrote, "All men must die: but for every man his death is an accident and, even if he knows it and consents to it, an unjustifiable violation." I am still imbued with the childlike idea that people should be immortal. It is difficult to accept the evidence that my own life and life choices are finite.

As I struggle to reconcile myself to my grandmother's death, I sometimes reach for a very small consolation. Grandma hated the cold, and the temperatures in Toronto during January were falling to 28° C below zero. Maybe she just didn't want to endure another cold spell, so she chose — being the decisive person she is — to check out of it.

And what happened then?

Well, although I take comfort from the words of the Twenty-Third Psalm, I don't believe that Grandma is now benignly watching over me, and I don't think that she is simply reunited with my grandfather.

Both of those possibilities sound far too passive for an active woman like her.

Though I don't really have any reason to believe it, I like to think that my grandmother has gone on, with her characteristic

determination, strength, and good humour, to the next set of challenges in her existence.

Grandma was an optimist and a realist, a strong and powerful combination in a family that seems to consist mostly of folks who are realistic but not optimistic, and a few who are optimistic but not realistic.

My grandmother would have been ninety-three today.

Today, and always, I shall remember Hazel Irene Willis Bayes, February 21, 1901–January 14, 1994.

February 21, 1994

A Brother, a Son, and Two Halloweens

THIS IS A TALE of two different but similar Halloweens.

The first Halloween in this story took place in the early '60s. I was twelve years old and in Grade Eight at school. According to the custom in our Scarborough neighbourhood at that time, no child would go shelling out after graduating from primary school.

(In those days we called Halloween activities "shelling out," not "going trick or treat." The latter is an Americanism, I think, which was only adopted in southern Ontario some years later.)

So at twelve years old I had just one more Halloween allowed to me, and even then I knew I'd get a lot of teasing from the neighbours for being out, at my age, begging candy.

So I decided to take my kid brother along, thereby giving myself an excuse for going door to door, giving him a great time, and making Halloween easier for my parents.

My little brother was only three years old — a small thin waif with blond hair and large green eyes.

In my family there wasn't any money for elaborate costumes, and anyway the local stores didn't sell a lot of Halloween paraphernalia the way they do now. We mostly made do with what we had at home.

My brother did have one store-bought item. With our mother's help he had picked out a plastic mask, which looked little bit like a monkey's face. He also chose to wear an old green jacket of mine — it came down to his knees — and a slouchy blue hat pulled low above his mask.

His appearance was pretty ambiguous, but he was convinced he looked like a monkey, and that's what he told all the puzzled neighbours who asked him what he was.

It was a typical Halloween night in Scarborough — dark, damp, and bone chilling. But I had a good time walking from door to door with this would-be monkey. He was my kid brother, a boy full of

fun and ideas, and throughout my childhood he remained my closest ally. Despite the nine years between us I was delighted to be with him.

That Halloween when I took my little brother shelling out was not, after all, my last. The second Halloween in this story took place in Montreal about two decades later.

This time I was guiding from door to door another small boy — my son. He was five years old, a sturdy, muscled child with blond hair and large blue eyes.

He was dressed as a knight in shining armour, and his costume was elaborate, supplemented with accessories given to him by doting relatives. He wore his blue long underwear and a large light blue T-shirt, belted at the waist. Strapped to his chest was a plastic breastplate, and on his head he wore a plastic helmet. He carried a plastic sword and shield.

It was a magical night in Montreal, most unusual for the time of year. So warm was the weather that people were sitting outside. Enjoying the brief reprise of summer, they dispensed candy from their front steps.

That evening I had a wonderful time with my little knight. He personified my ideal of true knighthood: thoughtful, a little solemn, handsome, gentle, and brave. He was my first-born child, and I was delighted to be with him.

There is no grand moral to this tale of two Halloweens. Except, perhaps, that despite the differences between them, I felt proud of both little boys, my brother and my son.

On that first Halloween night in the early '60s, the little monkey was a fragile child who had been ill for most of his first three years. He was off to a tough start in life. Today I still miss that little brother, who now lives a very separate life of his own, in another city.

On that second Halloween night in the early '80s, the little knight was already dreaming of the hockey, baseball and soccer games he would soon be avidly playing. Already today I miss that little son, who has been replaced by an independent and forthright young man — when did it happen?

While brothers and sons grow up fast, I'm glad not much about Halloween has changed. Children still circulate through the streets, running from door to door. Jack-o'-lanterns still grin from windows. Candy treats are perhaps a little more copious than when I was a child, but just as eagerly sought.

Maybe on some far off day I can look forward to enjoying Halloween with a small grandchild. But in the meantime I shall admire the little monkeys, knights, and all the other hopeful hobgoblins who will come to my door tonight.

October 31, 1994

Wading and Splashing in the Dog Days of Summer

This is wading pool weather.

When I was little, around the end of June when the weather got hot my mother would get out my wading pool. It had two fat blue bumpers around the outside, and a yellow plastic bottom stencilled with orange animals.

My mother would put the wading pool in our back yard. I'm not sure how she chose where to put it. Maybe in whatever patch of grass needed watering, since whenever kids got into the pool, they were sure to splash water out of it.

There was a ritual on wading pool days. My mother would move the pool, place the end of the hose inside it, and turn on the water. For the first few seconds the water would run hot from the hose. This was the water that had been lying in the hose for twenty-four hours, heating up in the sun. Then the water ran very cold, straight from under the earth, it seemed, where the sun's heat could not penetrate.

My mother filled the pool early in the day, so that the cold water, raised from deep under the earth, could be warmed by the friendly sun's rays. As the pool filled, its plastic bottom, conforming to the contours of our backyard, became wrinkled and pleated.

Finally, usually after lunch, my mother would pronounce the wading pool ready for use. I put on my bathing suit. It was always faded from water and sun. It had lots of sewn-in ruffles down the front, and a little skirt around my hips. It tied around my neck with strings. (It was never very clear why I, a girl, had to wear an uncomfortable bathing suit that covered my front, while all the boys in the neighbourhood — and our neighbourhood, at that time, seemed to have only boys in it — could wear comfortable and droopy shorts, chests unencumbered with material, no strings around their necks.)

The pool always sat on uneven ground. Perhaps there was no level ground in our backyard. So one thing I loved about that pool,

with its blue bumpers no higher than a foot above the earth, was that it had a deep end and a shallow end. At the deep end, defined by my mother's decision to turn off the hose before the pool overflowed, the water slopped dangerously near the top of the bumpers. The shallow end was tame, unchallenging. The deep end was dangerous and mysterious: little children could drown in that much water, my mother told me. How it was possible to drown in water that barely came to your knees I could not at that time understand.

The surface of the pool was still and inviting. By early afternoon, a few bugs would have met their watery death in the pool. Some ants would continue to struggle, waving their legs in a feeble effort to swim to safety. I was master of their fate: I could overwhelm them with a wave, cavalierly wash them out of the pool, or carefully rescue them on the edge of a leaf and place them back in the grass.

I always had many toys in the wading pool: rubber balls, plastic ducks, toy boats, and lots of dollies — dollies that needed a bath, and dollies that just wanted to go for a swim. Most of the toys bobbed around on the surface of the water; they couldn't drown.

Sometimes two or three friends joined me in the wading pool. We all liked to run through the grass, dive into the pool, and make a huge splash. Soon the pool would be full of cut grass, tracked into the water on our feet. Sometimes we would corral some of the grass into a miniature log boom and pull it by handfuls out of the water.

We also liked to create huge wading pool tidal waves. In the bathtub, tidal waves were firmly forbidden; the water would mark the bathroom floor. But in the wading pool, you could make the water overflow its boundaries as much as you liked.

Nowadays, on the hottest days of summer, I often think that what this nation needs is more wading pools — for adults as well as kids. We'd all feel much better if, like our children, we could shed our inhibitions and joyously jump into wading pools with our friends.

July 10, 1995

Stepping Out of Boots and into Springtime

As I write this column, several days before it appears in print, it's impossible to know what the weather will be like when you read this. In keeping with the spirit of April Fool's Day, it may be snowing. It may rain. Or there may even be beautiful sunshine.

But one thing I do know is that it's around this time in the spring that I want to put away my winter boots.

When I was a kid, the step from boots to shoes was always a mark of the end of winter.

I grew up in one of those post-war suburbs where houses had been slapped down in farmers' fields. Our area was muddy much of the year. Even the schoolyard was mostly unpaved, and turned into a vast dirt playground every spring. The roads were gravel, there were no sidewalks, and every street had a ditch running alongside it.

The ditches ran deep and wide, and filled with fast-running brown water in late March. To kids it was tempting to go wading, or build dams of sand to redirect the water.

Another popular kid activity was to explore the muddy fields that still survived near the subdivision. At this time of year the fields were soft and oozing with water; every footstep sank pleasingly several inches into the gunk.

The prospect of a getting a "soaker" — a wet sock and foot from water that flowed over the top of your boots and down inside — gave all our explorations a small frisson of risk.

So, while kids had a strong motivation to explore the mud and puddles that lay between home and school, mothers had a strong motivation to keep their kids in winter boots for as long as possible.

And what boots they were!

I had the same kind of boots every year. The only thing that ever changed, as I grew, was their size.

Those boots were like everyone else's, too. Smart mothers wrote their offspring's name on the inside, in India ink. Those boots were

so ugly and uncomfortable, most kids would have been happy to lose them.

They were made of brown rubber. They fastened with a rubber strap in a metal buckle, which was usually broken after several months' wear. The boots had a fringe of fake fur along the top inside edge, and by springtime the fur was dirty and bedraggled and coming unglued from the rubber. And since they didn't breathe, those boots were hot and sweaty inside. When they were brand new they smelled like rubber, but by the middle of winter they smelled like mould.

The boots had to be pulled on over my shoes. They had a sort of flap that was supposed to make them easier to slide on and off, but it didn't work. When first purchased in September the boots more or less fit, but by March my feet would have grown. I might get a larger pair of shoes, but I had to live with the same old boots. Squashing new shoes into old boots was like putting on rubber sausages.

Worse still, those winter boots were heavy. They made my feet feel like cement blocks.

So the first day in spring when my mother finally pronounced the road to school dry enough for no boots was a great occasion. Promising to keep my shoes clean, I would carefully pick my route between the puddles. My feet were comfortable and my body seemed ten pounds lighter. I felt like skipping. (It's probably no coincidence that skipping rope and other jumping games were the first post-winter activities adopted by all the little girls at my school.)

Nowadays, of course, as a card-carrying grownup, I have the freedom not to wear boots during winter, if I choose.

But my mother was right: if you don't wear your boots during the winter, your feet will get cold and wet, and your shoes will be ruined.

So, true to my mother's training, I don't give myself permission to put away my winter boots until late March or early April. It's only then that I can really believe that spring is here.

I almost feel ready for a good game of hopscotch.

April 1, 1996

Remembering Grandfather a Century after His Birth

Remembrance Day 1996 is a time for me to remember my grandfather, Charles William Bayes, who died seven and a half years ago at the age of ninety-two.

When I was a child, Poppa, as I called him, was full of fun. Each week when the family went to visit he would provide drawings, jokes, games, and magazines for my brothers and me. He poured us drinks of Coca-Cola, a special treat. And at the end of the visit he would say "come into my office" — a corner of the living room — and give us each a quarter to supplement our allowances.

Poppa loved to sing, and among his songs were some he had learned during the First World War. *Inky Dinky Parley-Vous. It's a Long Way to Tipperary. Pack up Your Troubles in Your Old Kit Bag and Smile, Smile, Smile.*

As a child I had no knowledge of my grandfather's war experiences. But as an adult, in 1983, I was fortunate to record a one-hour conversation with him in which he described his early life. At eighty-six he recalled the days of his childhood and young manhood with detail and vividness.

Bill Bayes, the third of six children, was born on November 9, 1896, in Bermondsey, a working-class district of London, England. He claimed that Queen Victoria was notified of his birth and said, "I am not amused."

His family was "poor but honest." Poppa recalled the smell of the local tannery and the biscuit factory, the streetlights lit by gas, and the vendors selling baked potatoes, lavender, and horsemeat (two slices for a penny).

At thirteen my grandfather passed a labour examination and left school. The family couldn't afford to send him to grammar school. In any case, he said, "mother needed the money" he could earn.

He immediately got a job as an office boy with a tea importer, where he worked six days a week for eight shillings a week.

But by 1910 his family, "tired of being poor," immigrated to Canada. Bill Bayes crossed the ocean on a 10,000-ton boat, "a rusty old thing called the *Tunisian*," which charged $35 per head for the one-way trip.

My grandfather found work in Toronto, but when the war began he enlisted in the army.

"I thought it was a just war, and I should go and help," Poppa told me. Also, he admitted, enlisting appealed to his sense of adventure.

And what did his mother think?

She believed "it was the duty of all English boys to defend their country."

Not yet eighteen, my grandfather was sent to Kapuskasing, Ontario, to be a guard at an internment camp. He carried a gun, but in the winter, he said, it was so cold he couldn't have pulled the trigger even if he wanted to.

At the age of nineteen he joined an overseas regiment, the 124th Battalion, and underwent three months of intensive training in Hampshire, England. "An old sergeant used to teach us bayonet training. He told us to always twist it when you got it in."

Then Bill Bayes was shipped to France, to the front line, where he was immediately immersed in trench warfare.

It was the coldest winter in forty years. Everywhere there was mud, mud, mud, mud. The soldiers were shot at constantly: "We were never out of the sound of guns, never."

The men had little to eat: some hardtack or Irish stew, and a loaf of bread shared with eight others. They slept in a dugout with chicken wire bunks. They were covered in lice.

As a private, working as a runner and dispatcher, Bill Bayes was paid a dollar a day.

It was, as Poppa told me, a hell of a life.

But in 1917, after twelve straight months, his life in the trenches came to an abrupt end. One day he and two others were sent to supply some men, stranded in an outpost, with water and food.

The three had just set off when they were hit by a shell. My grandfather experienced a blinding light and was blown high in the air.

"It was the end of the war for me," said Poppa.

When he regained consciousness he found that one of his companions was dead and the other's leg was almost severed.

My grandfather was seriously wounded: shrapnel was deeply embedded in his arm and neck. But he had to walk two miles to a dressing station. There he was taken by ambulance — "driven by a girl" — to a hospital where he had surgery to remove the shrapnel. A piece had missed his jugular vein by only an eighth of an inch.

He needed six months to recover. Near the end his neck became infected; he developed lockjaw and had to be operated on once more to remove a scrap of shrapnel doctors had missed the first time.

And so, not quite twenty-one years old, my grandfather had firsthand experience of the horrors and dangers of war — and lived to tell the story to his granddaughter.

Sixty-six years later Poppa said, "At least I came back." He added, "I've been lucky all my life."

And that's why, on Remembrance Day 1996, just over a century after his birth, I remember my grandfather, Charles William Bayes.

November 11, 1996

For the First Time in My Life, I Saw My Father Cry

ONE DAY LAST WEEK I was watering my front yard. As I aimed the garden hose at our struggling flowers and yellowing grass I thought of my father.

Years ago he used to stand in the backyard of our Scarborough bungalow, patiently watering his vegetables and flowers. Our tabby cat, Tiger, would follow him as Dad moved about the yard, keeping a respectful but friendly distance.

They were two stoical males, alone in the garden together.

When I was growing up my father was a pessimistic and often impatient man. Abused by his parents and schoolteachers, immersed in a terrible war when he was scarcely past boyhood, then working to support a growing family and struggling with his inner demons, he became a hard disciplinarian with his three children — though not as hard on us as his own parents had been on him.

It was probably easier for him to nurture the growing things in his garden than to nurture the individuals in his family.

In my father's generation of working-class men, the training for manhood was harsh and unforgiving. It permitted few avenues other than anger for emotional expression.

My favourite memories of my father are from my earliest childhood. He once said, attempting to tease me, "Of all my children, it had to be my daughter who is the clumsy one." Yet he was the one who taught me, with surprising tolerance and affection, how to catch a ball and how to skip rope.

Earlier still, when I was three years old, he used to read me poems from *The Golden Book of Poetry*. I always loved a poem called "Baby Goes to Boston." I can still hear my father's voice saying,

> What does the train say?
> Jiggle joggle, jiggle joggle!
> What does the train say?
> Jiggle joggle jee!

> Will the little baby go
> Riding with the locomo?
> Loky moky poky stoky
> Smoky choky chee!

Years later I read that poem to my own children, trying to reproduce the bouncy rhythm of my father's voice.

Another favourite was "The Little Elf." I wonder now what my father — a small man himself, who often felt insecure because of his height — might have felt as he read that poem:

> I met a little Elfman once,
> Down where the lilies blow.
> I asked him why he was so small
> And why he didn't grow.

As I entered my teens I sometimes used to hear my father talk, obscurely, about his battles with what he called his "ego." I don't know what disappointments, what shattered ambitions, he contemplated as he got older and found that the corporate world had less and less use for him. Driven by what is today called an "addictive personality," my father more and more turned for solace to cigarettes and alcohol.

Now, today, my father lies in a bed in a Toronto hospital, immobilized by the frailties of his own body. Early in July he underwent surgery for cancer. The man who once stolidly cared for his garden now needs 24-hour care himself.

When I visited him one Sunday, I thought that a man who always tried to be competent and strong must find it hard to be in a state of helplessness. Cancer and lack of nourishment have wasted his body until he looks tiny and feeble. It's difficult to believe there is any connection to the man whose anger scared me when I was a child.

The assault on his fragile system by anesthetics for surgery followed by morphine, sedatives, and other powerful drugs has made it almost impossible for him to communicate or even to stay in touch with ordinary reality. Though members of the family have struggled

to bring him out of the semiconscious state into which he has slipped, he will not eat and seldom talks or even opens his eyes.

Still I hoped to be able to reach him. So I asked if he remembered the poems he used to read me long ago. When he nodded, I read to him from my copy of *The Golden Book of Poetry*, now ragged and fingerprinted and missing its binding.

First I read him "Baby Goes to Boston," and then I read "The Little Elf." The poem concludes:

He slightly frowned, and with his eye
He looked me through and through —
"I'm just as big for me," said he
"As you are big for you!"

When I finished the verse I looked up from the book. And for the first time in my life I saw my father cry.

July 28, 1997

Looking Forward to the Next Twenty-Five Years of Marriage

Twenty-five years ago today, a young couple got married at the old City Hall in Toronto. He wore a striped shirt, a tie, and grey pants. She wore a sweater and a purple suede miniskirt.

The civil ceremonies were spaced about twenty minutes apart, and the pairs of prospective newlyweds lined up outside the judge's door.

For the young couple's wedding, one invited witness didn't arrive in time for the wedding because she missed her train from London, and another witness turned up at the last moment, clutching a bag of groceries as a wedding present.

The judge who presided over the ceremony was friendly and benign. This bride was the only woman in the lineup who was not pregnant — though some friends and relatives believed this abrupt March wedding must have been occasioned by pregnancy.

The young couple had already been living together for about a year, a step that was still frowned upon by many, a quarter of a century ago.

But the real reason for the rather sudden wedding was the fact that the couple wanted to take a trip to England. As a student, the bride was entitled to a low student airfare. The groom, then employed at a gas station, was not eligible for the airfare — unless he was related to someone who was. Hence the quick wedding, to qualify for a reduced airfare for both.

The reasons behind the wedding sound unromantic. In any case, the bride was a feminist who had doubts about the value of marriage as a legal and social institution. She knew that marriage has a history of oppressing women. Historically, it is an arrangement that has benefited men, economically and socially, by providing them with domestic service and offspring. At the same time it has

often compromised women's freedom and autonomy, giving them a life of domestic drudgery and financial dependence.

However, twenty-five years ago, whatever her doubts about marriage itself, the miniskirted bride had no doubts about the value of a committed relationship.

In some ways the bride and groom were very different. He was relaxed, laid-back, quiet, and optimistic, while she was an intense, talkative, and pessimistic type-A personality. But they shared the same progressive left-wing political values, and had similar moral values and complementary goals for their lives. They both loved books, the theatre, good food, walking and bicycling, and both cared little about elaborate material possessions or keeping up with the Joneses.

What neither member of this young couple could have foreseen — and perhaps no young person can foresee — were the challenges, problems, and rewards of forging a life together over the long term.

After the first wonderful trip to England, both were, for a time, impoverished students, barely surviving on beans and pasta, and dreaming of the day when they would be able to buy books and records and travel the world.

After they graduated they experienced a series of moves and a succession of different homes, as they pursued their careers from one city to another. It is never easy for couples to reconcile the demands of two full-time jobs, and the couple endured lengthy separations at several points when their jobs were not located in the same city.

Eventually their lives were enriched and complicated by the births of two active children, a boy and a girl. The couple raised their kids during a time when daycare was seldom available and in-home childcare was almost beyond their means.

Along with the joys of child rearing there were lots of stresses: sleepless nights, childhood illnesses, dealing with days when the babysitter didn't show up, getting all the household work done in the tiny spaces between working and playing with the kids.

The years were punctuated by unforgetable holidays travelling to Canada's east and west coasts and occasional trips to Europe

during times of prosperity. The couple owned a series of memorable cars, including a 1964 Buick convertible whose engine collapsed during a trip across Canada, and a 1979 Arrow that died at the Quebec/Ontario border during an interprovincial move. Through the years the couple gave each other advice and support on the demands of their careers, and experienced the pleasure of watching their kids grow up.

Moving into middle age together, the couple are still handling very different but equally challenging jobs, and are discovering, with surprise, that they are no longer the mum and dad of young children, but the delighted parents of two independent young adults. After twenty-five years the couple are finding there are many rewards of having a shared history and shared values with someone who knows you and loves you better than anyone else in the world.

Twenty-five years ago, on March 23, 1973, I was that mini-skirted bride. Happy anniversary to my life partner, Ted.

I'm looking forward to the next twenty-five years.

March 23, 1998

And So a New Role Begins: "Mother of the Boyfriend"

I'VE JUST PASSED another landmark in my life.

During a recent visit to my son at his university, he introduced me to his girlfriend. Until we met, this girlfriend had been a mysterious person whose existence, like that of an unperceived star in a distant solar system, I had guessed at but could not confirm.

In meeting the girlfriend, I was perplexed about my own role. I was the mother of her boyfriend. I felt I could only be a symbol, or a stereotype.

How could I possibly be the mother of her boyfriend? It doesn't feel all that long since I was playing the role of girlfriend myself, and being introduced to my own boyfriend's parents. At that time his parents seemed very old to me, and I fear that's how my son and his girlfriend may now see me.

Perceived through the lens of "the boyfriend's mother," I found it hard to be myself. I thought I'd inevitably be seen as an old fogy, someone whose values, culture, and experience are all vastly different from (and maybe inferior to) those of the generation of my son and his girlfriend.

Each stage in human life is hard for those at other stages to grasp. When I was twenty it was difficult to believe I'd ever be thirty, and totally impossible to imagine being forty. At twenty, it was hard for me to recognize any community of feeling or experience with people of my parents' generation.

I belonged to the generation whose media-ascribed motto was "Never trust anyone over thirty." While I didn't give much serious thought to that slogan, I certainly felt my real community was those who were under thirty.

First as a music instructor, then as a philosophy professor, I have been teaching young people all my working life. And when I

started my teaching career my students were only a few years younger than me.

But every year while I get older I confront a new crop of students, all of whom are in late adolescence or their early twenties. It is like being caught in a time warp, where no one ages except me.

Inevitably I find myself receding from my students. My cultural referents, the significant historical events of my youth — the death of U.S. President John F. Kennedy; the cult of the Beatles; Expo 67; the first moonwalk; the War Measures Act — happened long before these people were even born.

A true watershed was reached the first time one of my students said to me, "You remind me of my mother." As a feminist, I sincerely hoped this was a compliment: that the student had a good relationship with her mother, and something about my behaviour recreated that connection.

Nonetheless, whether intended positively or negatively, the remark firmly fixed me: I could no longer even pretend to be within or near the generation of my students, but must resign myself to being of their parents' generation.

I have clear memories of my own parents when they were the age I am now. I think I understand them better, as parents, than I did when I was my son's age. I also feel more appreciation, now, for how they treated me. How patient they were with my moods, my secrets, and my unpredictable behaviour! They deeply respected my privacy. If they worried about me, they kept it to themselves. They were willing to let me grow up.

I hope I can follow their example. But I don't know whether it will ever be easy for me to let my own children go to make a life and create a family of their own. Will I ever accept what is manifestly already true, and has been for years: that I am no longer the most important person in my children's lives?

Of course, on a rational basis, I do accept it and am happy for them. I'm glad about the independence and self-sufficiency my son has achieved. But on a more primitive level I am aghast that my "baby" is no longer with me, to amuse and protect. I find myself wanting to look around to see what happened to the two-year-old

toddler, the five-year-old kindergartner, the nine-year-old hockey player.

For kids, growing up is, I know, a challenge, but for their parents it may be even harder.

After my first dinner with my son and his girlfriend, he told me he thought it had gone well, and that they both had fun. And that was good because, he said, the girlfriend had been nervous about meeting me.

I'm sorry she felt nervous, I tell him. I was nervous too.

April 13, 1998

From the Body

INTRODUCTION

EVERY WOMAN is aware of her body, sometimes painfully aware of it. How we look, walk, talk, sit, and dress ourselves are all subject to the constraints of gendered expectations. While women's supposed obsession with our appearance is ridiculed as being superficial, in fact at all stages of our lives this culture ensures that adornment is crucial to who we are. Clothes, cosmetics, and accessories mark and confirm our gender and announce it to onlookers. Heaven help the girl or woman who deviates from gender norms.

In 1995 my own female body consciousness was deepened when I suddenly became very ill. I experienced severe pain in most joints of my body, and I lost the ability to engage in many of the activities — exercising, working long hours, walking, climbing stairs, even opening doors — that I had previously taken for granted. For six months I was on sick leave from my academic job. Almost the only activity that I was able to sustain was writing my beloved newspaper column.

Initially I was diagnosed with rheumatoid arthritis, a painful, debilitating disease for which there is no cure. But surprisingly, given

my diagnosis, over the course of several years (during which I explored many forms of non-traditional health care), I recovered completely.

My physicians then changed the diagnosis to viral arthritis. That's an interesting way of saying I had swollen, inflamed, painful joints, that no one knows what caused them, but that the cause might have been a virus.

Among other things, the experience reminded me of the fallibility of medicine and the limitations of scientific knowledge. It also reminded me, as if I needed reminding, that I live in a fallible body. I experienced disability first hand, and witnessed the ways in which our culture creates further handicaps for disabled persons. It was a crash course in ableism.

Today, fully recovered, I live in a body that is ageing and entering menopause. It is also a body that enjoys at least one major privilege: that of race. As a white woman, I am considered to have the "normal" or default racial identity, the one that can be ignored. The cultural virus called racism ensures that people of colour are compelled to be only too conscious of the colour of their skin.

In "From the Body" I explore some aspects of being a "material girl," or woman, within a material world where whiteness, maleness, youth, health, and heterosexuality are still privileged bodily characteristics.

Our Social World Helps Determine the Extent of Our Disabilities

Three months ago "disability" was just a word to me.

Oh, I had some theoretical understanding of what it means to be disabled. I supported the movement by people with disabilities to obtain greater recognition of their needs and rights. And I opposed "ableism," which is discrimination on grounds of disability.

But I had no genuine experiential understanding of what it means to be disabled.

Then one Sunday in April I experienced severe pain in my hands and arms — pain that was not soothed by a hot water bottle or an ice pack.

During the ensuing weeks I struggled to finish my end-of-term work, while the pain gradually spread throughout my body. Almost every joint hurt: my neck, my shoulders, my elbows, my wrists, my hips, my knees, and my ankles. When I awoke in the morning the pain was so severe I could scarcely move. It took two or three hours for the stiffness to diminish sufficiently to enable me to walk around. By early afternoon I was so exhausted I had to lie down.

I sought medical treatment, of course. I was prescribed several varieties of non-steroidal anti-inflammatory drugs. My blood was tested many times. I began treatments with an acupuncturist. I consulted a specialist in Chinese herbal medicine. I was referred to a rheumatologist.

All my adult life I've been busy and physically active. I've skated, danced, swum, exercised, and walked everywhere. But by mid-May the world began to close in on me. I couldn't do all the exercises at my aerobics class. Then the class itself became just too hard. The joints in my legs were so sore and wobbly I was afraid to walk to work. I gradually came to rely on my family to drive me everywhere. I rested and slept a lot.

I began to withdraw from my academic commitments. Papers to write, committees to attend, business meetings to travel to — I gave up on almost all of them. I couldn't carry a pile of books any more. I couldn't walk any distance. My ankles were so stiff that I dreaded stairs.

My life required minute planning. In order to reach my office, just a short walk from home, I had to take a cab or wait for a ride from a family member. In order to move around on campus I had to calculate carefully: Was the sidewalk level? Were there stairs I could avoid? Did my destination have an elevator? In order to handle books and papers I had to ask for others' help, or see whether my left shoulder, the strongest remaining joint in my upper body, could carry a backpack.

Well, so what? Lots of people get sick. Lots of people get sicker than I have been. The point of this column is not to engage your sympathy, but rather to present an idea.

My illness changed me, in a few short weeks, from being a strong, able-bodied person to being a much weaker person, with some disabilities.

But the nature of those disabilities is not just a function of my physical condition. It is also a result of the social conditions in which I live.

I am fortunate to remain connected both to my job and to my friends via telephone and e-mail. I have a portable word processor on which I can continue to do some of my work. My family owns a car, which enables me to travel to doctors and hospitals without difficulty.

So, some aspects of my middle-class environment diminish the impairment that I would otherwise endure if I did not have access to phones, computers, and cars.

On the other hand, the physical scope and dimensions of my home and neighbourhood ensure that I continue to be limited in what I can do. My house must be entered by stairs, and my bedroom is at the top of three floors. Many buildings at Queen's University are accessible only by stairs. Most doors, both at home and at work, are heavy and awkward, and I can't use my hands to

push them open. I have trouble turning doorknobs. Many chairs are hard to get into and out of. Bottles and cans are almost impossible to open; pots and pans are too heavy to lift; electrical plugs are hard to insert and remove.

The social world is built almost exclusively for able-bodied persons. Our cultural milieu assumes that its human inhabitants will have full sight, hearing, and mobility. Although some human inventions mitigate the effects of some human disabilities, most of our built environment is for the strong and healthy, not the weak and infirm.

So the meaning and extent of ability and disability are not produced only by our physical characteristics, but also by the social world in which we live.

I used to know this, in theory. But now personal experience has made it completely real to me.

June 26, 1995

Acupuncture Defies My Western Scepticism

I AM NOT a credulous person. My education in philosophy trained me to approach unusual ideas and theories with scepticism. But recently I've experienced some interesting challenges to my ordinary views about illness and medical care, challenges that defy my usual scepticism.

About three months ago, when I became ill with viral arthritis, I was advised by my family doctor to consider alternative modes of treatment in addition to standard western medicine. She directed me to a general practitioner who is also trained in the art and science of acupuncture.

Acupuncture is the insertion of fine, sterilized needles into the body at precise points that have been found to be effective in the treatment of specific disorders. Acupuncture is one aspect of Chinese medicine, which treats illness as a condition of bodily imbalance, a disharmony. Chinese medicine believes that acupuncture works by regulating the flow of Qi (pronounced "chee") or energy through meridians in the body, thus restoring the harmonious energetic balance of the body and returning the person to a state of health.

At the time of my first treatment I had no real expectations that acupuncture would be effective, but I was experiencing so much pain that I was willing to suspend disbelief.

The doctor asked me about my joint pain, checked my pulse at several points on my wrist, and looked at my tongue. Then I lay down on an examining table, with the parts of my body exposed where the needles would be placed. Starting on the right side of my body, the doctor inserted needles at points in my neck, shoulders, elbows, wrists, stomach, knees, and ankles.

During the process I felt vulnerable and disoriented. After all the needles had been inserted in my body, the doctor said she would place one in my forehead to help me to relax. Frankly, the

suggestion that a needle in my forehead would help me to relax seemed like something out of the twilight zone. Nonetheless, as soon as the needle entered my forehead, I felt anxiety and worry drain out of me; I experienced a kind of calm acceptance that was utterly foreign to anything I would have expected. (I'm not usually vulnerable to the power of suggestion from others—especially a suggestion that I will feel *better*.)

Then, since my illness has caused me to feel very cold, the doctor turned on a heat lamp, covered those parts of my body that did not sprout needles, turned down the lights, and left me alone, listening to soft music. Every ten minutes she checked me to be sure I was all right. After half an hour, she reappeared to remove the needles.

Since my first visit I have returned more than ten times for acupuncture treatments. Each time, the doctor questions me about my joint pain, my energy level, and my emotional lability. My answers help her to decide where to place the needles.

Almost everyone wants to know what acupuncture feels like. From the point of view of a North American patient, the experience is unique. At my first visit the sensation was surprising: Some needles caused a sense of warmth or electric current that seemed to travel along my limbs from one joint to another.

The feeling from the needles varies from time to time. Some have been momentarily quite painful. The pain subsides within a few seconds. Most of them produce a feeling of vibration moving through my body from point to point. What is also interesting for me is the psychological effects of acupuncture: the treatment is very calming, and permits me to daydream, reminisce, make optimistic plans, or just doze.

In a brief column it's difficult to convey the experience and the effects of a medical therapy so foreign to western approaches to medical care. After my first treatment, I found my joint pain was slightly diminished. The cumulative result of the treatments is that the pain in my joints is greatly reduced and my mobility increased. I notice an improvement most often the day after a treatment.

As a result of my experiences I've gone from being a sceptic about non-western forms of medical treatment, to being a convert to the benefits of acupuncture.

Acupuncture is not recognized in Ontario as a standard insurable medical treatment. Based on my experience, however, I hope it is only a matter of time before acupuncture's benefits are widely recognized, and it becomes a regular component of medical care in Canada.

July 31, 1995

Painful Illness Taught Some Valuable Lessons

For just over a year I was sick with viral arthritis, a painful, debilitating, and disabling illness. This summer I am fortunate to have recovered almost completely.

But being sick with what seemed, for many months, to be a chronic illness provided me with experiences I would not otherwise have had.

For example, I learned firsthand how healthy people react towards sick people. I had a chance to notice not only how healthy people behaved towards me but also how they behaved towards other sick people whom I encountered in the course of my various treatments for arthritis. (One effect of being ill for months on end was that I started to notice how many other ill people there are.)

Some healthy people, both inside and outside the health care profession, are marvellously sensitive and encouraging. They offer quiet company and a connection to the outside world. They listen attentively and non-judgementally when the sick person describes the illness or expresses worries about the future. Without being pushy, they hold out hope that the sick person can find a way to have a fulfilling life, even while living with the illness.

Other people, however, are made uneasy by illness. They find it threatening. Their reaction is to deny that the illness is real, or to try to talk the sick person into acting well.

Now that I've regained my health I want to remember what I learned about being supportive to those who are ill. I try to recall what it felt like to be ill and disabled.

I don't always succeed. But here's what I remind myself, as a newly healthy person, about those who are ill.

Don't assume you can tell how sick or disabled people are just by looking at them. Listen to what people actually say about their experiences with illness. Some people have hidden or less visible disabilities. Some people struggle valiantly, despite great pain or

weakness, to continue their everyday activities and to look cheerful and well.

Don't push people to try a variety of remedies you may happen to know or have heard about. (This continues to be a hard lesson for me to learn, because I'm enthusiastic about the alternative therapies that worked for me.) People with chronic illness or disabilities don't necessarily want or need advice and recommendations. They may be interested to hear what helped others to feel better, but what helped one person won't help everyone.

Don't recount alarming stories about your own past illnesses or those of other people, unless you are invited and encouraged to do so. (This is also a hard lesson for me. I am still excited and relieved by my own recovery.) Sometimes it can be useful and even, in a way, comforting to hear from healthy people about their own or others' illnesses. But sometimes such stories can merely be discouraging or a source of new worries.

Don't ever say or imply that the person brought the illness on herself. To someone who is ill it's hurtful to hear others assume that the illness is the sick person's own fault. Don't suggest that the sick person failed to take care of her health, didn't eat the right foods, didn't exercise enough, or worked too hard. After all, no one asks to be ill, and as far as I can tell, most diseases and disabilities are caused by factors that the affected person can't do much, if anything, about.

Don't suggest that the ill person should try harder, or pull herself together, or take her mind off her illness. It may be difficult for someone who is healthy to understand just how overwhelming chronic disease and disability can be. If the ill person seems focused on her illness, it is likely because the illness is causing ongoing pain and discomfort, or because she is worried about the effects of the illness, or because she is no longer able to live the life she lived when she was healthy.

Don't push ill people to act as if they are not ill, or to pretend they are not disabled. Healthy people may feel alarmed by others' illness; they may feel threatened by the thought that they too could become disabled. As a consequence, they sometimes pressure those who are chronically ill or disabled to minimize or hide their pain

and impairments. But such pressure simply puts a further burden on individuals who already have more than enough to cope with.

Finally, a truism: don't take your health for granted. Don't assume you will never be disabled. If you are healthy, then love and appreciate your strong, pain-free, functioning body.

People sometimes say that you don't know how precious your health is until you lose it. It's true. Becoming seriously ill or disabled is a hard way to learn that lesson.

August 19, 1996

An Evening Sewing Sequins on a Figure Skating Costume

It's that time of year again, part way through February, when the snow is still on the ground, my academic work is piled high, and I'm longing for a holiday. And into my life each February there comes a new challenge: it's the time to sew sequins.

A concomitant of having a daughter who lives for skating, who regards skating as being as natural as breathing, is that she has to have costumes for competitions. And costumes for team skating, in particular, are usually loaded with sequins.

But alas, costumes don't grow sequins of their own accord.

Now, there is nothing about my reproductive equipment that makes me innately more suited to sewing than my spouse is. In fact, I'm sure he's just as good at sewing seams and buttons as I am — maybe better.

However, the standard assumption is that the skater's mother, not her father, is the sequin sewer in the family.

I never anticipated, when my children were born, that one of the requirements of good motherhood would be the capacity to sew on sequins.

So there we were, a group of mothers, gathered in an upstairs room of a local arena, sewing sequins on a recent Sunday night, after a long day that for most of us had already included paid work, housework, attending skating practices and competitions, or even all of the above.

For sheer mind-numbing boredom, very few activities beat sewing sequins. There are hundreds of them, and the things are diminutive.

Each sequin must be sewn individually. The needle goes up through the fabric and through the middle of the sequin, over to one side of the sequin and down through the fabric, up through the

middle of the sequin again, and down through the fabric on the other side. After every few sequins, it's necessary to knot the thread to anchor the sequins in place. (Not only would it be humiliating, for both daughter and mother, if her sequins started to come off in the middle of the ice; it would also be dangerous for the skaters.)

For those like me who are becoming more nearsighted with age, sewing sequins requires holding the skating dress about four inches from the nose. In an inattentive moment, the thread easily becomes irretrievably knotted, or the needle slips sneakily off the thread and disappears on the floor. Aiming the needle from the underside of the fabric and getting it through the hole in the sequin is no easy matter for the uncoordinated. One's thumb and forefinger end up covered in needle stabs.

While sewing, one must keep hold of one's plastic baggy full of hundreds of sequins. Many of them end up scattered on the floor. One mother, less cautious than the rest, manages to empty her entire bagful onto the floor, from where she retrieves them, one at a time, as she sews. (The grit and dust from the floor no doubt add to the costume's ornamentation.)

Now, each sequin is slightly cup-shaped, and a perennial debate among skating mothers is whether to sew the sequins facing up or facing down. Which method is easier to sew? Which method makes the sequins show up better on the ice? My compromise is to sew on the sequins both ways.

Unfortunately, after a considerable period of eye-crossing concentration, I find that my sequins, instead of marching in an orderly and smooth line around the collar of the skating dress, are somehow careening drunkenly in zigzags. I try in vain to pull them back into line.

And speaking of drunkenly: I can't avoid the suspicion that work like this might go a little more smoothly with a glass of wine near to hand. For some strange reason, however, no one has thought to provide a few bottles.

Having started sewing at 6:00 p.m., I find myself wearily but triumphantly knotting the last sequin at 9:40 p.m. Yes indeed, this

is what makes mothers prematurely age: almost four hours of sewing sequins.

The result of all this labour is an outfit that under almost any other circumstances, the typical parent would never want her daughter to wear in public. The competition dress is extremely short, extremely tight, with a minuscule skirt, and very glittery.

Have sequins ever helped a team to skate better, or earned them extra points? In my realistic moments, I strongly doubt it.

But each time I see my daughter on the ice, performing complicated manoeuvres with the rest of her team in front of seven judges and an audience of hundreds, I like to believe that in some small way my struggle with those sequins helped to make it all possible.

February 17, 1997

There's No Short Answer to Solving Tallness Bias

In this decade feminist analysis has helped to create an awareness of the bias in modern western society in favour of thinness. Persons who are considered to be overweight are seen as lazy, greedy, and uncontrolled. Thinness is regarded as a virtue in itself, to the extent that many people, especially girls, are willing to starve themselves to achieve what they believe is the correct profile.

You could call the bias against fatness a sizeist belief, because it leads to discrimination on the grounds of an individual's size.

But there are other kinds of sizeist beliefs. One that I'm especially aware of is this culture's bias against short people.

The western world is made for tall people, and people value height in human beings of all ages. It's assumed that tallness is an accomplishment for which both children and parents deserve credit.

Almost no one in the west takes it as an achievement to grow fat children, at least beyond the permissible stage of baby fat, and certainly no one brags about their small or short child.

But who hasn't heard parents boast about the height of their children — as if growing taller were an indication of parental merit and children's accomplishment. On the other hand, smallness is considered a problem. In some cases kids are given human growth hormone to try to make them taller.

Maybe the pressure on children to grow up fast is related to this society's irrational prejudice against smallness.

Certainly the human world is not made for short people. In homes and businesses, cupboards and shelves are often placed high up on the wall, hard for short people to reach. Mirrors are sometimes too high to be usable. Desks, tables, counters, and bars are at uncomfortable heights for short people.

Short people get to sit on chairs and couches that make it impossible to keep their back against the chair back and still have

their feet on the floor. This position is uncomfortable and physically stressful. I know some short women who have to carry around a special footstool to accommodate the world of tall people's furniture.

As a short person I find I end up swinging from the metal bars in the bus when I can't get a seat. As a public lecturer I have to speak from microphones and podiums that I can hardly see over.

Short people have to deal with clothes that never fit right off the rack but must always be rehemmed. Virtually all women's apparel appears to have been created for some hypothetical female who is about five feet eight inches tall.

Most team sports are made for tall people. Think of volleyball, basketball, soccer, hockey, and football. Not only is it hard for short people to play these games; sometimes it's a waste of time to attempt them. As a child I was, for example, hopeless at volleyball because the net was so far above my head I didn't have a chance of getting the ball over it. Instead of spiking the ball I had to punch it straight up in the air and hope it would fall on the other side.

Tallness is even regarded as an asset in areas where height has nothing to do with competence, like business, politics, and the professions. People tend to think that tallness, a physical characteristic, is significantly linked to psychological characteristics like leadership ability or mental properties like intelligence. A short woman may be seen as little and "cute", and a small man as insignificant or lacking in authority.

Unfortunately, sometimes views like these can become self-fulfilling. If a short man or woman constantly gets the message that short people are not respected, it wouldn't be surprising if he or she has problems with lack of self-confidence. And it doesn't help to be told that "good things come in small packages."

It's true that some cultural expectations with respect to height are modified by gender norms. Tallness is not always an unmitigated virtue; for girls and women, there is such a thing as being too tall.

But that is largely because of sexist views about gender and size. Since taller is better, and sexism gives priority to men, the expecta-

tion is that men should always be bigger than women. A very tall woman is deemed to have fewer men who will be interested in her.

I sometimes say that once feminism is completely successful, I'm going to work for short people's liberation. It sounds like a joke, but think about it: Why should the size of an individual be made into a personal liability?

If you assume taller is better, then you're failing to see the human being inside the short body.

October 27, 1997

Mandatory Retirement Tramples on Rights of Seniors

LAST WEEK Prime Minister Jean Chrétien celebrated his sixty-fifth birthday. As he officially joined the ranks of Canada's so-called senior citizens and became eligible for his share of the Canada Pension, there were two points worth noting.

First, the Prime Minister is described as being vigorous, healthy, and agile, both mentally and physically. Second, despite his age, no one is making him retire. He has some choice about when to give up his job.

Most Canadians do not enjoy this privilege. In 1990 the Supreme Court of Canada ruled that although our Charter of Rights and Freedoms prohibits discrimination on grounds of age, mandatory retirement at sixty-five is a reasonable limit on individual rights, and therefore not unconstitutional.

I think the case for mandatory retirement is not very convincing.

One argument in favour of mandatory retirement is that as people get older they deteriorate, mentally and physically. Compulsory retirement at sixty-five provides a protection to society from the declining productivity of ageing workers whose labour would no longer be up to the standards achieved by young people.

But there is no reason to believe that sixty-five is the magic line between competence and incompetence. Some people's capacities decline well before that date, while others, of whom our Prime Minister may be one, remain energetic and able for years after. It's not legitimate to stereotype all sixty-five-year-olds as being inevitably "over the hill."

It's also claimed that the only people who oppose compulsory retirement are those with rewarding professional jobs and fat salaries. Those in less privileged circumstances are eager to retire.

It's true that since many of today's jobs are onerous and exhausting, especially in today's era of cutbacks, a lot of people are only too happy to retire. Given the opportunity and the right financial

incentives, many persons will even accept early retirement, before age sixty-five. So I doubt that there is a danger that hoards of older people will cling to their jobs if they are not forced to retire.

The goal of abolishing mandatory retirement would not be to exploit people who would prefer to end their employment and enjoy some years of leisure. People should not be forced to keep working after age sixty-five. Let people take retirement, or even early retirement, if it works for them, but let's not require competent sixty-five-year-olds, who want to continue working, to give up their employment.

People who are disadvantaged by compulsory retirement include not only those with jobs they enjoy, but also those who are in financial need and not ready to retire. They may, for example, still be supporting children, disabled relatives, or elderly parents. Also, since women live longer than men, often have lower pensions, and may have entered the work force late, female workers may have an even greater need to keep working than many males have.

The situation of a woman I know illustrates both the disadvantages of compulsory retirement and the advantages of optional retirement. When she was sixty she was compulsorily retired from her position at a large corporation. As a single woman, whose family history suggests she may live until her nineties, she was worried about the adequacy of her pension. Fortunately, within six months she found another job at a smaller firm — albeit with a lower salary. Last year she reached the normal retirement age of sixty-five. Her firm, unusually, would have been willing to let her continue working, but, though she liked the job, she'd had enough. Unlike many women of her generation, by the time she reached sixty-five she had been working without a break for forty-seven years, more than enough, she felt, to entitle her to the chance to do something else with her life.

Perhaps most of all, the debate about compulsory retirement centres on the supposed conflict between the rights of older people and the needs and well-being of younger generations, who want to move into the jobs vacated by the compulsorily retired.

Philosopher Thomas Hurka (in his book *Principles: Short Essays on Ethics*) argues that although mandatory retirement does discriminate on the basis of age, the discrimination is not unfair. He suggests that if the policy of mandatory retirement is in place long enough, people who are targeted by it in the future will be the same people who benefit from it in the present, by acquiring jobs freed up through the compulsory retirement of earlier generations.

The problem is that although this form of age discrimination can indeed potentially benefit some people — even the same people who eventually are hurt by it — it has in common with other forms of social discrimination the fact that it overgeneralizes about the individuals involved. Some people are not able to continue working after sixty-five; others are. Rather than forcing older people to retire to provide jobs for young people, we should be creating a society in which there is work for all who are competent.

We do not tolerate discrimination on grounds of race or sex, so I fail to see why discrimination on grounds of age should be permissible. Like Prime Minister Jean Chrétien, all Canadians should have the opportunity to continue working past age sixty-five.

January 18, 1999

White People Have Distinct Advantages in Canada

For a long time I've wanted to write about the subject of racism. Yet I felt there was not much that I could say. As a white person, I am in a socially created position of privilege with respect to racism. But maybe there is something significant to be learned from thinking seriously about what it means to be white in Canadian society.

If you watch very young children playing together, you see that race is not relevant to them, any more than eye colour or hair colour or fingernail length. Babies respond to the humanness of other people; they do not seem to respond to skin colour. Children have to be taught that skin colour has social significance.

Being white is a role that white people are socialized into. That is, white people learn to be white. White people learn what the social significance of white skin is and what the social significance of dark skin is. We who are white learn to expect the privileges that go with being white. We who are white very seldom find ourselves in a situation of being a minority, of being in a situation where there is no one else who has had the same experiences. And we who are white almost never have the experience of being considered inferior because of our skin colour.

Part of the privilege of whiteness is the luxury of ignorance and denial about the racial identity white people acquire. Whites are able to ignore their own race, and pretend it does not exist.

Under most circumstances in Canadian society, whiteness is like a default condition. It is a condition that is taken for granted. It is that by comparison with which everything else is considered "different." Whereas a black person is readily recognized by whites as being black, being white is not recognized by whites as being an identity at all. Although whites would not likely assume that all white people are alike, they often come to believe the lie that people who happen to have approximately the same skin colour are all alike.

If a white person meets someone whom he has previously known only through correspondence, he will probably be surprised if that person turns out to be black, but not surprised if the person turns out to be white. If a white person is describing someone who happens to be white, the person's colour will never be mentioned. But if a white person is describing a person of colour, that person's colour will usually be mentioned, almost as if it were the most salient characteristic of him or her.

It is no accident that dark-skinned people are labelled, in North America, "members of visible minorities." Of course white people are not literally invisible, in fact, they are used to being the cultural centre of attention, but their whiteness is. It is the social norm, from which being African-Canadian or Asian or Aboriginal is considered to be a deviation.

Maybe just by virtue of dividing people up by racial categories, we white people learn racism as we grow up. The ideology of racism tells whites to cut themselves off from all the people who are not categorized as white. The ideology of racism says that to be different from white is to be inferior.

Some white people think that the best way to end racism is just to pretend that race is irrelevant. They want to leap forward to a hoped-for future time when skin colour will no longer be a criterion determining a social hierarchy. Or, they want to jump back to early childhood, to the time when as small children, skin colour was just not noticed and not significant.

But I think it's an error to pretend, now, that race is irrelevant. To pretend that race is irrelevant is to overlook all the harms that racism has done, and all the ways in which people of colour have been disadvantaged. In a culture where race has been made relevant, where to be white is to be privileged, and where to be a person of colour is to be disadvantaged, it is irrational to pretend that race does not matter.

So maybe one of the first things we white people must do is to recognize that we have a race. That is, we have a socially constructed set of privileges based on our skin colour.

Whiteness is a real identity, as much a social creation as a so-called "racially visible" identity. White is not the original, the basic human being, from which all others are deviant. Being white is not a divine gift or a natural category, but a matter of social hierarchy.

March 15, 1999

Getting a Handle on Half a Century of Living

As a child I always found it difficult to figure out the ages of the adults around me, though I always wanted to know. I knew the ages of all the kids at school, but who could tell how old the teachers were?

As people get older, their faces seem to get more complicated. When you look at a baby, you look at a face that has no life written on it. An adult wears his years on his countenance, but I didn't know how to read the faces I was seeing, because no adults I knew would tell their real age.

As a kid I couldn't get a grip on what thirty-five or fifty or seventy looked like. When I asked my parents or their friends how old they were they always said something jokey, like "sixteen" or "eighty-five."

Recently I received, by e-mail, the following anonymous rumination on ageing:

> Do you realize that the only time in our lives when we like to get old is when we're kids? If you're less than ten years old, you're so excited about aging that you think in fractions. How old are you? "I'm four and a half." You're never thirty-six and a half. You're four and a half going on five!

Not only is childhood the only time when it's okay to be excited about ageing; I think it's also the only time when it's okay to tell the world your age at all. When you're eight or twelve or sixteen it's quite acceptable to announce how old you are, but soon after there is a taboo on revealing how long you've lived.

When we're young we all love to have a birthday. But beyond the age of twenty-five or so, we're supposed to see birthdays as little more than grim reminders that we're ageing. For children and teenagers, having a birthday is considered an accomplishment. Then after a while, birthdays are more like a series of mistakes. Just think of all the adult birthday cards that seek to console the birthday person, rather than celebrate. It's hard to find a card that doesn't treat the birthday person as if she or he were suffering from an illness.

If ageing isn't really shameful, maybe those of us who are middle-aged or older should "come out" with our real age.

One of the greatest benefits of getting older is feeling less self-conscious and being less easily embarrassed. Young people believe the whole world is watching; older people know it is not.

Especially when you're female. In fact, as many feminists have pointed out, older women tend to be invisible. Youth is at a premium, and since they're not considered to be sexually attractive or available, older women are even less valuable than older men.

For the first part of her life a woman is considered to be "too young". Then suddenly she becomes "too old." I figure there is perhaps one golden year, maybe some time in the mid-twenties, when a woman is just the right age. (Unfortunately in my case I didn't notice it at the time.)

This week I'll be fifty years old. Turning fifty seems momentous, but maybe it's just because everyone pretends it's significant. I can't seem to make much sense of it. Half a century, certainly. Half a lifetime? No, probably more than half. Until now I used to be able to tell myself that I'd lived less than half my life, but now, even with three grandparents who survived and thrived into their nineties, it's clear I've passed the halfway mark.

Baby boomers, notoriously a self-conscious generation, have been analyzing the big five-o for some years. Maybe collectively we thought we would never get old. We can remember when our parents were fifty, but we never thought we'd be that age.

I recall a time when I thought forty was unimaginable, thirty was old, and twenty was the peak of adulthood. Now forty is a friendly memory, thirty seems young, and twenty is scarcely past childhood.

But if I live as long as my grandparents, there will come a day when I'll see fifty as youthful. I have a good friend who frequently gives me a jolt of realism. From her vantage point as a person of sixty-five, retired and still very active, she dismisses all my analyses of getting older. "You're young," she says firmly.

May 25, 1999

Visible Bra Straps Show Women's Body Confidence

YOU MIGHT HAVE noticed that lots of young women are wearing tank tops during the hot weather this summer.

These tops have very thin straps. I have been reliably informed that custom requires that these things be worn with a bra — even though the bra straps are usually visible underneath them.

Since the wearer's bra straps show under the tank top straps, why doesn't today's young woman wear the top without a bra? Going braless was the norm for young women of the hippie generation. At that time feminists were urging women to have greater acceptance of their bodies.

Is it possible that the current generation of young women feel more confident about their underwear than they feel about their bodies?

That idea may sound far-fetched. But I think we should never underestimate women's ambivalence about their own bodies. In North America, women are taught never to be satisfied with their size and shape. And we are exporting this dissatisfaction all over the world.

In Fiji, plump body shapes among men and women used to be a status symbol, reflecting the importance of generous sharing of food. A Fijian's social position was based on how well he or she could feed other people.

But a recent study by researchers from Harvard Medical School shows that the arrival of television, and along with it western cultural values, has produced a sharp increase in eating disorders among teenage girls in Fiji. The study was conducted in 1998, thirty-eight months after the introduction of television on Fiji. It found that 15 percent of the girls surveyed, whose average age was seventeen, reported that they had induced vomiting to control weight, compared with only 3 percent who did so in 1995, just after television was introduced.

Twenty-nine percent of the girls in the 1998 study scored high on a questionnaire that assessed eating disorders, compared with 13 percent in 1995. The 1998 survey found that 74 percent of the girls sometimes felt "too big or too fat," and 62 percent reported dieting in the past month. Those who watched television at least three times a week were 50 percent more likely than other girls to see themselves as fat, even though the frequent television watchers were no more overweight than the girls in any other group.

The Fijian teens' desire to be thin reflects their attempt to conform to western standards of body image. I think what these young girls are learning is body hatred.

Growing up female in the West requires learning to despise the body you have. You learn to wish your body were thinner, that it had bigger (or sometimes smaller) breasts, a smaller waist, slimmer hips and thighs, and smoother, blemish-free skin. The selling of products requires that women be kept in a constant state of discontent, so that we will buy more clothes, more cosmetics, more exercise equipment, and more diet products, in the futile attempt to meet the unrealizable body standards that we have internalized.

The contemporary woman learns to be divided against herself, seeing her body as something separate from herself, an object to be shaped, exercised, controlled, disciplined, and even punished. For many women the body is like an enemy, a betrayer that persists in doing things the woman thinks she should not want, like eating heartily and gaining weight.

This split between the self and the body is at the root of many western religions and philosophies. Yet human beings are not really distinct from their bodies. In learning to hate their bodies, women are learning to hate themselves.

When adolescent girls learn that they are "too big" or "too fat," they are also learning that the world wants less of them. They learn that they are better if they are smaller or thinner. Too big, too fat, and maybe also too loud, too emotional, too talkative, too needy — the lesson in growing up female is that we should diminish ourselves, hold ourselves back, and be less noticeable.

It's hardly surprising, then, that girls who have bought in to the "thinner is better" message have low self-esteem. Some of them succumb to anorexia nervosa, starving themselves until they weigh as little as sixty or seventy pounds. Ten to 15 percent of anorexia nervosa patients die, often after losing at least half their normal body weight.

Anorexia nervosa is usually described as a disease of white middle- to upper-middle class adolescent girls. But Harvard's findings about the new body image among Fijian girls suggest that the female body hatred endemic to the West can easily be exported.

I'd like to believe that those young women wearing tank tops here in Kingston have so much self-confidence that they don't care if their bras show. But I still wonder why that confidence does not extend to their bodies.

June 28, 1999

Finding Practical, Comfortable Clothes

a Boomer Challenge

As I get older I'm not getting any thinner.

My family doctor tells me the reason is that human metabolism becomes more efficient as we age. In addition, older people tend to get less exercise than when they were younger.

I still exercise a lot, maybe even more than twenty years ago, so I figure my metabolism must be becoming very efficient indeed.

My doctor also informs me that I could survive a famine better now than I could have at the age of twenty. No kidding! I come from a long line of peasants and farmers who survived because they could endure hard times. Short stocky bodies, thick bones. I seem to have exactly the kind of body that easily equips itself to survive a famine. I've noticed that my hips and stomach are stocking up for a possible future food shortage.

Unfortunately, this body is not so well suited to fin-de-siècle North America, with its abundantly available nourishment and the proliferation of junk foods of all kinds. Apparently my body has not received the message that there is no need to stock up. When I feel hungry and tired at the end of a long afternoon, I admonish my body, "Use up some of that fat; that's what it's there for." But still my famine stocks do not seem to diminish.

Does this matter? Well, as a feminist I should be indifferent to cultural messages saying that thin is in and the only good woman is a skinny woman. Right? But it isn't that easy.

It should be no news to anyone that cultural images of girls and women seldom include any female weighing more than 115 pounds. But in addition to the subtle fat-hating values inculcated by the media, this culture's love affair with thinness creates a very practical problem for those of us for whom size ten or less is little more than a distant memory.

Finding clothes that are the right size.

Facing the end of summer's hot sunny days is a bad enough prospect, but the autumn is made much worse by the challenge of finding cold-weather clothes that fit.

I don't ask for much. I don't expect to find clothes that are becoming, or even that minimize my so-called "figure flaws."

I'd just like to be able to buy clothes that are practical and comfortable. Clothes that won't shrink after one washing. Clothes that aren't wrinkled after half an hour of wear. Clothes that cost less than a luxury vacation.

The members of the baby-boom generation are ageing, and most of us are not losing weight. As resentful members of other demographic groups are always pointing out, boomers (supposedly) have more buying power than any other generation, by virtue of our sheer numbers and our established economic position. These days, boomers are said to be responsible (or to blame) for most social phenomena, so why don't we get a little recognition in the clothing department?

The market isn't catering to us. Where are the clothes for boomer women? Judging by most women's clothing stores, you would think the big fashion dollars are all controlled by fourteen-year-old girls.

And maybe they are. Maybe fourteen-year-olds, the offspring of the boomers, are more willing to part with cash (or more likely, Mom's credit card or debit card) for new jeans with a 25-inch waist, clingy sweaters available in sizes four to eight, and navel-topping T-shirts, size extra small.

Sure, there are some clothes for the "mature figure." But personally, I'm not interested in wearing polyester cabbage roses, or tunics down to my knees, or "relaxed" jeans that emphasize my pear-shaped body.

My fall clothes-buying challenge is made even worse by the fact that I am also short. How short? Five feet, one and a half inches (and sorry, I don't know how to translate that into metric). Now is that so unusual?

Apparently it is. Any pants I buy, even those made for the so-called "petite," pool around my ankles in layers of useless fabric. I think I should be allowed $5 off the price of any pair of pants, to compensate for the three or four inches of fabric I'm always obliged to cut off each leg.

My adolescent daughter informs me that it's quite acceptable to wear pants that are a little long. Sure, I say, I remember doing that in the '60s, when everyone's bell-bottoms trailed on the ground. The ends of our jeans got dirty, bedraggled, and frayed.

No thanks.

I'm a grownup now. As a midlife woman, I refuse to start wearing dresses shaped like bags, sweaters like the ones my grandmother wore in the '50s, or blouses that look like '70s rejects.

September 13, 1999

INSOMNIACS AND SOUND SLEEPERS MAKE STRANGE BEDFELLOWS

AFTER MANY years of close observation I can definitively say that humankind is divided into two main varieties.

Good sleepers. And insomniacs.

The two groups have trouble understanding each other. Each lives within its own reality.

It's hard for an insomniac to make herself understood to a good sleeper. The reason is that the insomniac usually finds she has the most to say around 3:00 in the morning, when she's feeling frustrated and miserable because she can't sleep. At that point, of course, the sleeper has already enjoyed four or five hours of quality sleep, and is well on his way to four or five more. He's oblivious to the world. From the insomniac's point of view, this protracted and unbroken spate of unconsciousness is virtually incomprehensible.

Now, if you find yourself lying awake for half the night, there's no reason, in principle, why it couldn't be a positive experience. In theory, at least, you could review your accomplishments, relive your great relationships, and contemplate cherished memories.

But instead, for some reason, the brain of the insomniac decides that it is a good idea, late at night, to re-examine all the mistakes the person has ever made — not just on that day, not even in the current year, but in the person's whole life.

For the insomniac, sleeplessness can be a baffling problem. On a night when it doesn't matter whether the insomniac sleeps — let's say on a Saturday, when she knows she can sleep late the next day — the insomniac may be able to get a good sleep. But on a night when a good sleep is essential — for example, right before a big meeting or a major business trip — the insomniac's brain makes the fatal decision to stay conscious forever.

After a night of not sleeping, insomniacs often say they feel as

if they have been run over by a truck. Every muscle, bone, and joint aches. An insomniac friend of mine who grew up in an eastern culture once remarked that after a sleepless night her body felt as if it had been trampled by water buffalo. I guess the bad effects of insomnia are cross-cultural.

Insomnia has been called a "modern epidemic" in the West. And all insomnia-related symptoms are more common in women than in men.

Sleeplessness can be generated by such things as stress, anxiety, depression, alcohol consumption, certain drugs, some diseases, or even poor "sleep hygiene." Shift work, long work hours, and travel across several time zones may all contribute to insomnia.

But another kind of insomnia is what I would call financial insomnia. This is the kind you have when you lie awake wondering how you will cover next month's rent. Or next year's tuition payment. Or how you will make the car payments. Or whether you will ever be able to afford a car.

Sleeplessness may also be aggravated by having little children. Most parents know that sensation of trying to sleep while also keeping part of one's brain functional — in case the baby falls out of his crib or the toddler throws up again.

But there's also an insomnia created by being the parent of teenagers. On the one hand, you want to trust your teen to come in on time. On the other hand, you can't relax until you know he's actually home. And you can't help remembering that time he lost his key, and you fear it might happen again.

Good sleepers are a completely different breed of human being. These are the people who say to themselves, "I'll worry about my problems in the morning." They are the people who climb into bed, mumble "good night, sweetie" and the next minute are off in dreamland almost before the helpless insomniac has found time to decide what to worry about. Good sleepers are the ones who awake promptly when the alarm goes off, and claim to feel "refreshed" and "revitalized" after their night's sleep. Good sleepers find it hard to believe that anyone could have a problem with an activity as simple and natural as sleeping.

I know a lot of insomniacs who somehow got matched up with good sleepers. But given their differences, I wonder about the wisdom of pairing two such dissimilar human beings.

To the good sleeper it's uncomfortable to share a bed with an insomniac who thrashes around, turns the light on and off, and gets up repeatedly to try yet another sleep remedy. But meanwhile, to the insomniac there is nothing more galling than the good sleeper's peaceful snores.

January 17, 2000

Menopause Has Become a Booming Industry

MENOPAUSE has become an industry.

Over the past decade, in books, magazine and newspaper articles, newsletters, support groups, and talk-show discussions, there has been an enormous and unprecedented attention to women's midlife transition.

One positive aspect of this new focus on menopause is that it may reflect a decline in squeamishness about women's bodies. In our grandmothers' and even our mothers' times it was considered to be a gross violation of propriety to talk about menstruation, pregnancy, childbirth, or menopause.

Women were not pregnant; they were "expecting" or "in the family way." Women did not go through menopause; at most they went through the "change of life." The manifestations of that change were not something to be talked about, certainly not in public and certainly not in the presence of men or younger women.

So the more open and enlightened attitude toward women's bodies may help to explain why it is now more acceptable to talk about menopause.

Another often-cited reason for the greater discussion of menopause is that women are living longer. A century ago, the average life expectancy in North America was around fifty.

The low average life expectancy was partly because of high mortality rates in infancy and childhood. In addition, childbirth was a very dangerous time for women.

But if a woman survived infancy and childhood, if she avoided or recovered from serious infectious diseases, and if she then got through the births of her children, she might very well live until old age. So the explanation for today's great attention to menopause cannot be that this is the first time women are going through it.

In a remarkable book called *Declining to Decline: Cultural Combat and the Politics of the Midlife,* Margaret Morganroth

Gullette argues that there may be worrisome reasons for the new media focus on menopause. She suggests its occurrence is no coincidence, at a time when at least some women, including women at midlife, have been acquiring advanced education, political power, cultural success, and professional careers.

Gullette calls the menopause industry the "menoboom." She argues that the menoboom makes menopause appear enormously important, a significant "magic marker" in every woman's life. But menopause is no more significant than other human life events, like the birth and growth of children, the completion of a major project, the death of a friend or relative, a move to a new home, or the loss or change of a job.

The menoboom's emphasis on women's biological life change creates the false impression that only women age. "Men," Gullette says, "are led to think 'Poor dears' and thank their chromosome that their plumbing is different." The implication is that male biology is superior to the "symptom"-producing female body.

Gullette argues that the message of the menoboom is that the cessation of menstruation — and that is all that "menopause" means — inevitably creates a variety of nasty debilitating "symptoms." The menoboom makes menopause into a disease, and the implication is that all midlife women suffer from it.

From this ideology, the next "logical" step, Gullette points out, is that science comes to the rescue with a potpourri of drugs, like hormone "replacement," to ease the "symptoms" — drugs that produce huge profits for the pharmaceutical companies. Simultaneously, the producers of "beauty" products prey upon women's fears of losing their value as they lose their youth.

Letty Cottin Pogrebin, author of *Getting Over Getting Older*, says that the main danger of the menopause industry is that people are encouraged to interpret menopause as the end of "life as a woman." The menoboom generates propaganda that biology is destiny. It insinuates that midlife women are weaker, moodier, and less stable than midlife men, even though both men and women have to deal with the effects of ageing. Pogrebin thinks that the

menopause industry may just be a way to exert control over uppity midlife women.

Are these explanations for the growing cultural focus on menopause correct?

On the one hand, from talking to a lot of different women I find that some genuinely suffer during the menopausal transition. So there may be benefits to the new willingness to discuss different ways of journeying through the menopausal years.

On the other hand, many women breeze through menopause, scarcely noticing the stage in their lives when they cease to menstruate. They make it clear that menopause is not a disease or a disability.

So maybe we should be alert to the possibility that the menopause industry could contribute to what Queen's University professor Mary Wilson Carpenter calls "sexagism," that is, the combination of sexism and ageism that is specifically targeted at older women.

May 23, 2000

From the Home

Introduction

BEFORE I FIRST became pregnant, over two decades ago, I read somewhere that the decision to have children is a decision to change your life forever.

A pretty intimidating thought. But true.

My two children, a son and a daughter, certainly changed my life forever. A mother is not all that I am, but it is a crucial part of my life.

In many ways a child helps to define his parent's identity. He does so first just by making the parent a parent. But the child may also elicit, as mine did, feelings and behaviors such as nurturing, supporting, and disciplining, that the parent would not otherwise have been able to develop.

In addition, children often generate the opportunity for the parent to enjoy activities such as games and sports, arts and sciences, that, without children, the parent would not have experienced. Children also provide the opportunity and even the necessity to meet people — other mothers and fathers, teachers, and coaches —

whom the parent would not have gotten to know if she had not had kids.

Finally, raising a child challenges a thoughtful parent to keep up with the child's intellectual, psychological and moral growth. The parent has the chance to rethink a lot of shibboleths about human beings and human development, and she learns to be open to the insights that living with children may offer.

When I first started writing regularly for the newspaper, my children were emerging from early childhood. Within my column I've had the luxury of reflecting about my kids as they were growing up, especially during the fascinating years of puberty and adolescence. I share with you some of my life-changing experiences as a mother in these columns "From the Home."

A Most Unscholarly Hair-Raising Episode

I NOW understand the true meaning of the word "nit-picking."

As an academic I'd always associated nit-picking with what scholars, at their worst, do to each other and to their work: We supposedly analyze concepts to detect and decipher the finest details, and sort through texts to discover the tiniest, least important ideas to attack and criticize.

But, as I recently learned from tedious experience, "nit-picking" does have a literal meaning. It refers to the apparently endless but important task of removing the nits, or eggs, of lice from a person's hair.

This fall my daughter had the misfortune to "catch" lice. She did not know she had them: Our first intimation of the coming problem came from the mother of a young friend who had caught them. The mother stoically bade us check our own children's heads.

A quick check of child number one produced no foreign bodies. But a comb-through of child number two's long tresses yielded a couple of squirming little bugs caught between the comb's teeth. In late evening Dad was dispatched to purchase a remedy. He returned with a special shampoo — one so powerful that its label advised hair-washers to wear rubber gloves when applying it, and to use it no more than twice because of its toxicity.

Yet the manufacturer would not guarantee that a "re-infestation" would not occur.

After shampooing, two more hours passed on leaden feet as we repeatedly combed through the long hair, searching for more bugs (now presumably dead) and for their nits. These nits, the eggs that the lice laid on the hair shaft, are no bigger than a grain of sand, and white in colour. I felt great relief that the bugs were not living in the hair of child number one, who is blond. Child number two has brown hair, which made spotting the nits easier.

Unfortunately, her hair is very thick, and its length, past her shoulders, made the task worse than the proverbial needle hunt in a

haystack. The purchase of a fine-tooth comb (another old metaphor now rendered literal) did not make the process very much easier, and by 10:30 p.m. our so-to-speak lousy daughter was exhausted and more than ready for bed.

And by this time I was near tears. The whole event seemed like a nightmare. What had I done wrong? Was I guilty of devoting too much time to my work, too little attention to my children? My beautiful little girl a harbour for bugs! I'd always done my best to keep her clean, and she was very fastidious about her own personal care. Surely lice infestations were not something that happened to families like ours!

The next day brought further troubles. Despite my embarrassment the school had to be notified: They were not pleased to learn that an infestation already present in the Grade 6 class had now turned up in the Grade 2 class as well. Our daughter stayed home from class and I from work so that further nit-picking could occur. This meant that our seven-year-old had to sit reasonably still in one place for hours on end, tilting her head this way and that so that the nit-picker could examine each little section of hair and scalp.

The task seemed endless; indeed, I as nit-picker began to suspect that even in the absence of the lice themselves, the nits were capable of reproducing themselves from hair to hair. Each tiny egg had to be grasped individually, pulled painstakingly from the hair shaft, and then carefully discarded.

After several hours of this exercise, I made a despairing call to the County Health Unit for advice to speed up the nit-picking process. Unfortunately the call yielded further bad news. All of our daughter's bedding and clothing must be washed or dry-cleaned. All carpeting and mattresses must be thoroughly vacuumed. All playthings must be baked in the dryer for at least twenty minutes, and those that could not undergo that process must be bundled up in plastic bags and left for two weeks. Every single nit must be individually pulled from my daughter's hair; we could not rely on the shampoo to kill them. All other members of the household must be checked daily to see if they had developed their own thriving bug population.

Only these manoeuvres could assure us that any other stray lice or nits hovering in our daughter's environment would also be killed. "Perhaps," said the kindly woman at the Health Unit, "you can get a friend to help you with nit-picking. You could take turns. And be sure to do it under different lights — natural and artificial. That will help you to spot the nits. Just remember," she concluded cheerily, "there's a great likelihood that she will be re-infested."

At this point I was almost overwhelmed. The tenacious population of nits in my daughter's hair gave new meaning to the term "nit-wit." The more I pulled, the more turned up. Helplessly I turned to my hairdresser, who generously provided an appointment for later that afternoon.

When we arrived, Terry was reassuring. She'd seen this before. "Lice only like a clean head," she said, which, in a peculiar way, was comforting. My daughter sat in the chair and sobbed as her long hair was gradually shorn. I managed to refrain from pointing out that she was fortunate not to be shaved bald — the fate of some young male friends who had caught lice. Tears streamed steadily down her face as Terry reminded her how fast her hair would grow again. All I could think of was how much easier it would be to pull nits from hair that was three rather than thirteen inches long.

Even after that difficult day ended our war against nits continued. Letters came home from the school, commending us on our efforts and encouraging us to keep up our vigilance. A couple of her classmates — those unfortunate enough to have sat near to her — also acquired lice. Eventually our daughter herself was re-infested, just as predicted, and the whole process began again. It was the ultimate exercise in tedium.

Yet I did learn a few things from this experience — aside from elementary facts about the lives of lice. For one thing, it made me confront some of my classist assumptions. Although I was raised working class myself, it hasn't taken me long to acquire some middle-class biases: Only poor people, and not very clean ones at that, get lice. Only bad parents have children with bugs.

As it turns out, of course, lice are no respecters of class, income, or education, or even, it seems, of hygienic practices and good

parenting. I was curiously reassured by all the lice stories told to me by others when they heard of our experience; lots of our friends had also had to declare war on nits. In a very down-to-earth manner, our daughter's lice infestation was a reminder that illnesses and infections of all sorts are not deserved, not invited, not a punishment for carelessness or immorality, but simply the result of being a human being living among human beings.

Another assumption to bite the dust as a result of our episode of lice was my idea that children in the so-called "middle years" — roughly six to twelve — are inevitably problem-free and easy to handle at this stage. As a result of those nits I saw my usually easygoing daughter anxious and upset, forced to miss school and tried to the limits of her patience. I myself lost almost a week of work while trying to cure the problem. Childhood problems will strike at any age, and child rearing doesn't necessarily get easier as children get older; it just generates new challenges.

Finally, I was reminded that the problems I had with my daughter's lice would have been far worse had I been alone. All along I had a partner to join in the work of nit-picking, vacuuming, laundering, and bagging toys. Another adult was present to comfort the lice-inflicted daughter. I also had the support of other women, including one mother who volunteered to check the heads of all the children at the school. What if I had had to cope with my daughter's lice alone? How much more desperate would I have become about the prospects of ever making my daughter lice free? How would I have reacted to the discovery that she was re-infested? How much more time would I have missed from work? And how do single mothers ever manage all the labour and emotional demands that raising children alone entail?

At this point (I cross my fingers as I write this) the lice and the nits have been banished from my daughter and from my household. We all hope that a new epidemic will not strike our local school. As for me, I shall always have sympathy for those who say that something is bugging them. And I now have a newfound respect for anyone who ever claims that they had, literally, a lousy day.

January 31, 1989

The Kids of the Kid Chosen Last for Every Team

As a child I was not an athlete. At school my teachers struggled unsuccessfully to teach me sports skills: I couldn't spike a volleyball over the net, run fast or jump high, throw a baseball straight, or shoot a basketball accurately. Small and unco-ordinated, I was always the kid chosen last for any team.

Not surprisingly, I learned to regard athletic activity exclusively as a source of frustration and embarrassment. I stopped participating in sports and didn't bother to watch them. By the time I was a young adult I looked down on athletics as a mindless occupation chosen only by those incapable of participation in intellectual or artistic activities.

With the kind of lived irony that only parenthood brings, both of my children, now almost sixteen and almost twelve, have turned out to be devoted athletes. It is as if at a very young age they surveyed their mother and deliberately chose to concentrate in that area of human endeavour most different from anything she could do. As a result, raising my kids is, much of the time, an experience something like immersion in a different culture. There are new rules of behaviour for me to understand, new languages to learn, and new values and modes of interaction to assimilate. I have had to unlearn most of my old attitudes toward and beliefs about sports.

The activities pursued by my offspring began, when they were quite little, with soccer, ice hockey, and figure skating, and gradually expanded to include volleyball, basketball, baseball, track and field, precision skating, ice dancing, golf, floor hockey, and rugby. Now the seasons of the year are measured not merely by changes in the weather or the variable demands of my job, but by the sports that are in season and the locales in which they are played. Winter is a time for spending hours at cold airless ice rinks and in hot sweaty gymnasiums. In the summer I move outdoors to watch, squinty-eyed, as my children run, sweating and red-faced, up and

down fields made dry and dusty by the sun. The passing of years is marked by athletic landmarks: The first hat trick scored, the first axel landed, the away games in distant small towns, the rainbow of team uniforms, the memorable competitions, the medals, ribbons, and trophies accumulating in the kids' bedrooms.

At times I have been dismayed by what I've seen and heard in children's athletics. Many of these sports are intensely sex-typed, highly competitive, and psychologically and even physically violent. I have witnessed parents whose overinvolvement in their children's sports leads them to push their kids forward and criticize or harangue the other young competitors. I have heard coaches who berate their team members for the slightest mistake or faltering of attention. I have seen boys who became angry when they lost and who lashed out, verbally and physically, at referees and other players. I have seen girls who seemed to care more about how they look to the spectators than how well they perform.

I have also been chagrined by some of my own reactions to my children's sports. As I live second-hand through every practice, game and competition, my athletic difficulties as a child have come back to haunt me. It has been hard to watch when one of my children seemed not to be given a fair share of the playing time, or was gratuitously hit by a disgruntled member of the other team. If my child messes up a simple catch or throw, fumbles a goal or misses a jump, I feel again the agony of my childhood ineptitudes. I cringe at the repeated falls, scrapes and bruises, the twisted ankles, the sore muscles, and the exhaustion that follow immersion in athletics. When their teams are losing it is hard not to be depressed; when they are winning, it is hard not to gloat.

Gradually, however, I have learned two things. First, I have come to understand that sports are my children's chosen milieu, and that, however the setbacks and losses may appear to me, my kids are happy and fulfilled in that world. What looks to me like a repetitive exercise or a humiliating loss can be taken in stride as just part of the game; a future day will bring new challenges and the hope of victory. For them, the satisfaction of learning a tricky routine, earning points for the team, or developing a skill far outweighs any

difficulties created by pushy parents, harassed coaches, overworked referees or disappointed opponents.

Second, I have learned that children's sports have a glory and excitement all their own. I'll never forget my son's winning goal scored in overtime of the final game of hockey playoffs when he was all of nine years old. Or my daughter's thrilled comment as she came off the ice at a difficult competition: "I want to do that again!" I am delighted to see a precision skating team gradually perfect its routine, or to try to figure out the intricacies of a rugby match, or to learn to recognize the unique style of each member of a volleyball team. I love watching my daughter and a handful of other girls unselfconsciously playing as equals with the boys on their soccer team. I enjoy overhearing my children confer about track-and-field techniques or basketball strategy. I admire them when they keep going, undeterred and undaunted, despite injuries that would slow me down and losses that would discourage me.

My kids' involvement in the world of children's sports gives them the joy of physical mastery and the glow of personal accomplishment. I now realize that my own alienation from that world, early in my life, was a great loss for me. And so my late and vicarious reimmersion in kids' sports has turned out to be a valuable experience in culture shock.

June 16, 1993

Childhood: You Blink, and It's Gone Forever

I WISH I had known, when I first became a parent, how fast children grow up. If I had, then maybe, as a mother, I wouldn't have been in such a hurry.

Maybe I wouldn't have been so eager for my two kids to start to crawl, or say their first word, or make their first friend. Maybe I wouldn't have been so impatient while they learned to feed themselves, to clean up their toys, and to tie their shoes.

It was really only a few years ago that I was reading *Madeleine* and *The Cat in the Hat* over and over again to a delighted one-year-old, or digging for hours in the sandbox with a four-year-old, or getting up in the night to soothe a six-year-old's nightmares.

My children's early years passed in a blur of work and study and diaper-changing and sleepless nights. I lived a double life as a college teacher and a new mother. My days were spent both in the classroom and in the playground, talking philosophy and reading nursery rhymes. I believed — mistakenly, as it turned out — that my life would be less complicated as my children matured. And so I was anxious for them to grow up.

I didn't know then that my children's infancy and early childhood would be fleeting stages, demanding only a brief interval out of my adult life. I didn't know how precious those years would be. I wish I had known how fast children grow up.

When my son was two years old he was a difficult child. I resolved that I would not accept any of the cultural shibboleths about children, and I resolutely disbelieved in a stage called "the terrible twos." My blue-eyed toddler a terrible two? Certainly not.

Yet virtually on schedule, after his second birthday, he developed an uncanny ability to turn himself into what I called, semi-hysterically, "the screaming board." When thwarted (and in his view this was frequent) he would make his entire body rigid, packing a lot of power into such a tiny form, and shriek until I could do

nothing but tuck him under one arm in a sort of football hold and remove him from the scene of his despair.

Yet in my memories of my two-year-old son it is not the rebellion and the tantrums that stand out. What I remember best is a day in December when I took him Christmas shopping.

With admirable forethought and considerable solemn planning, he put together his provisions for our bus and metro trip downtown. In his pocket he assembled a small box of raisins to stave off hunger, a dime to shop with, and a scribbled "list" legible only to himself.

But when we stood at the bus stop in the freezing cold, he decided his provisions were incomplete. First he asked me for some candy. I said no. Then he asked for a choc'lit bar or a lollipop. Again I refused, reminding him that these things were not very healthy — though I was a little nervous about what my refusals might provoke.

But this time, instead of throwing himself into the screaming board routine, he chose a different strategy. Seeking to combine his own desire for sweets with my insistence on nutrition, he concluded that the world must contain a product that would satisfy both. Looking up at me he said, "Then how 'bout some bitamin gum?"

In that one small question I caught a brief glimpse of the person he was going to become: imaginative, optimistic, yet down-to-earth practical.

Now, fourteen years later, my son is no longer searching for vitamin gum. He is learning photography, studying flood mechanisms, playing volleyball, talking politics, and — most recently and unexpectedly — shaving his head bald to show "team spirit" during basketball season.

My younger child's babyhood also passed by quickly.

As a toddler my daughter evinced a flattering appreciation for my little jokes and games. She regarded me as the wittiest person around, and I was thrilled to earn her laughter.

One day, when she was two, I took her for the first time to attend a small preschool. She was captivated by the prospect of painting pictures with a real brush, and didn't notice when I left the building.

After two hours I returned, a little anxious about how well she

had coped with my absence. When she suddenly caught sight of me, she gave me a huge grin. Grabbing my hand, she led me over to the preschool teacher and performed the best introduction I've ever received: "Dis my mummy. Funny guy!"

She had forgiven me for leaving, and she still found me amusing.

Ten years later, I'm no longer the number one "funny guy" in my daughter's eyes. Lots of others — sports coaches, aunts and uncles, schoolteachers, and a myriad of friends — have taken my place. The little girl who once lived to draw now lives to skate. This second child, whose love of books was acquired while I read to her and her older brother, now reads to me. And she has let her hair grow down to her waist.

Children in the middle years and in adolescence are regarded as being much less "cute" than babies and toddlers. In childcare books there's not a lot written about older kids, and adults don't ooh and ah over them the way they do over infants. Maybe grownups don't like to be reminded of how difficult adolescence can be.

Pre-teens and teens want to live their own lives; they're private and independent, and they want to be respected. In some ways they're easy to overlook, but ignoring them is a mistake.

Living with a twelve-year-old and a sixteen-year-old isn't much like living with the children they once were; instead, it's a lot like living with a couple of adults. My children are excellent chefs — providing you like chocolate chip cookies. They love sports — and they play them all. They have definite opinions — and they can defend them. They are interesting, stimulating, complete persons, whom I'm lucky to be with and glad to know.

A decade or so ago I wish I'd known how fast children grow up. I'm no longer considered a funny guy, or a source for vitamin gum. I feel as if there's not much time left before my kids strike out on their own.

It's taken me a lot of years to learn this, but now, finally, I savour each day we have together.

November 29, 1993

Her Auto-Dyslexia and His Diaper-Dyslexia

Some years ago a friend jokingly suggested to me that I was suffering from a condition she called "auto-dyslexia." She invented this term to describe my chronic inability to recognize different automobiles.

While I can make some very rough distinctions — I can tell a Volkswagen bug from a station wagon, for example — I must usually rely on basic characteristics like colour and size in order to recognize cars belonging to friends and relatives. In fact, when I leave my own car in a parking lot, I am able to locate it again primarily on the basis of its colour and its license plate.

My "auto-dyslexic" condition is an example of what I think is a learned perceptual incapacity. When I was a child I was totally indifferent to cars. Unlike boys, little girls in my neighbourhood were not expected to play with or collect toy cars, to be interested in different makes and models of cars, or to be knowledgeable about their operation. And so I grew up entirely ignorant about cars, while my brothers and male friends are able to identify the manufacturer, year, and model of most vehicles they see.

This difference is an example of what I believe are certain fairly pervasive perceptual differences between women and men. These perceptual differences are learned, not innate. What we see and what we are able to see are partly a function of what we are trained to observe. To be socialized as a female is to learn to notice and pay attention to different things than are noticed and attended to by someone who is socialized as a male. In other words, our perceptual capacities are gendered.

I first started thinking about the perceptual differences between women and men some years ago, after reading Robin Lakoff's 1975 book, *Language and Woman's Place*. Lakoff suggests that whereas boys are usually taught only the basic colour categories — red, blue, green, purple, etc. — girls are often encouraged to learn and use

fine-grained distinctions among different shades of colour. Writes Lakoff, "I have seen a man helpless with suppressed laughter at a discussion between two other people as to whether a book jacket was to be described as 'lavender' or 'mauve.'" Surprisingly, however, Lakoff concludes that the capacity to make such distinctions is trivial, and that is why it is allotted to women.

However, as a female who was not provided with this sort of middle-class feminine training, I am inclined to be impressed by some other women's abilities to distinguish between saffron and citron yellow, or to recognize that a paint chip is aquamarine, not turquoise. While I think I know the difference between lavender and mauve, colour labels like "ecru," "taupe," "fuchsia," and "chartreuse" leave me utterly blank.

This example suggests that the perceptual abilities of men and women may vary with their age, class background, and race. Since I don't want to overgeneralize, I'm mostly going to talk about what I was trained to perceive, as a girl growing up in a working class neighbourhood during the '50s and '60s.

Although I didn't learn fancy colour distinctions, one area where my perceptual education was thorough was housework. Thanks to my mother's domestic efficiency, I learned, without any formal instruction, to notice when shelves were dusty, floors needed sweeping, counters wanted wiping. But years after, when I lived in a student co-op with other young women and men, I found that the women's eye for housework was not shared by the male members of the household.

The women never failed to recognize when the fridge or stove needed to be cleaned out or the bathrooms were getting grungy. The men, who were supposed to share the responsibility for keeping the apartment tidy, always had to be reminded when to do their quota of the housework; they never seemed to notice, without prompting, that it was time to vacuum or scrub or mop.

Later, when friends of my generation started to have babies, I was struck by the ways in which women constantly monitor their infants, noticing and cleaning up runny noses, wet diapers, and food-drenched shirts. Fathers' reactions were, however, less

perceptive. I remember one young father holding his infant son, from whose droopy diaper an unambiguous odour was wafting. He finally handed the baby to his mother, asking her vaguely, "Does he need changing?"

This incident shows that acquired perceptual skills and disabilities often serve an important function. The man who is unable to tell when his baby's diaper is dirty will probably not have much responsibility for caring for the infant. And a woman like me, who is virtually unable to recognize entire cars, let alone parts of cars, is never going to be trusted with car maintenance and repair.

A standard division of labour in many families, when I was growing up, allocated responsibility for relationships and emotions to grandmothers, mothers, sisters, and daughters. It was the women who noticed and cared about the details of others' lives: whose father had died, whose relationship was faltering, who was feeling depressed or anxious, who was pregnant or infertile, who just got a new job, or lost weight, or dropped out of school, or suffered from allergies.

The rare man who noticed such details of others' lives was usually thought to be "effeminate" — that is, his masculinity was called into question; he was too much like a woman. Most men, "real" men, were not encouraged or expected to notice the feelings and life struggles of others, especially of women. This attention deficit may be a fairly widespread feature of masculine culture in the west. Even Sigmund Freud said, apparently in all sincerity, "The great question, which I have not been able to answer, despite my thirty years of research into the feminine soul, is 'What does a woman want?'" Feminist legal theorist Catharine MacKinnon suggests in *Feminism Unmodified* that "men are systematically conditioned not even to notice what women want."

That is not to say that men don't acquire their own perceptual skills. In addition to their appreciation for cars, men of my age, for example, were schooled in the perceptual skills required to understand hockey and play it well, to comprehend how machines operate and how to fix them, and to tell the differences among various kinds of screwdrivers.

And every spring, around this time, I'm reminded that most men see the change in seasons differently than I do. While for me the last remnants of ice and snow are a phenomenon to be endured and manoeuvred around, for men they seem to constitute a kind of geological or architectural challenge. During the most recent thaw, men all over my neighbourhood were outside with their shovels, shifting snow piles, pounding at impacted ice, and creating pathways for spring run-off.

Most women don't see the lingering ice and snow in that way. We just wait for it to melt.

April 4, 1994

Where Do Odd Socks Go, and Other Questions of Laundry Philosophy

I HAVE NEVER been a big fan of housework. While I recognize the necessity, indeed, the inevitability of domestic labour, I also bemoan its repetitive nature, its often mindless activities, and its all too short-lived results.

For some years now, feminists have been pointing out that there is nothing about human bodies that somehow makes members of one sex more suited to housework than members of the other. (Though I must confess to a kind of brutal recidivist tendency in myself to believe that taking out the garbage — and also, in these environmentally friendly days, putting the vegetable peelings in the compost heap — must be a job for males.)

As a feminist, I'm committed to ensuring that, as much as possible, domestic work is shared within my household. Unfortunately for me, while this ethical commitment reduces my share of the work, it does not eliminate it. And no matter how much I may feign incompetence, I can hardly pretend to be completely incapable of managing household tasks.

Our family divides up most of the work on the basis of talent — or lack thereof. Hence I very seldom do the cooking. My children are grateful, since they are convinced that I have difficulty identifying the stove.

The other way we divide up some of the work is on the basis of what we least hate to do. In my case, the one exception to my dislike of housework is my mild affection for doing the laundry.

My history of doing laundry goes back to my teens, when I volunteered to be responsible for all the ironing for our family of five. (I didn't volunteer out of any sense of family duty: my weekly ironing stints were the only times I was allowed to listen to top-forty radio.) At that time, my mother imposed high standards: Towels, socks, and even underwear had to be ironed.

Older and wiser now, I no longer do much ironing. I fully realize and appreciate the benefits of the casual wrinkled look.

Nonetheless, for me, washing and drying clothes is a type of meditative exercise. The sound of the water sloshing in the washer and the hot roar of the dryer induce an altered state of consciousness. While the machines do most of the work, it's possible to listen to music, read intermittently, or even to work, in a casual way, at balancing a chequebook or writing a column.

Often, in the trancelike state induced by the laundry, I find myself contemplating my household, my family, and my place among them. And some profound questions arise.

There is, for example, the age-old question of where odd socks go. Almost every laundry day at least one sock loses its mate. Do they disappear into some compartment in the washer, where they will likely cause havoc with its innards at some future date? Or — and this is the hypothesis to which I am inclined — do odd socks vanish into an alternate reality, the same place where chewed pencils, lost nickels, pen tops, and unmatched mitts also find a home?

It would seem that socks have a mind of their own. How else to explain the presence of one white sock embedded within a load of dark clothes? Of course, after consorting so closely with denim jeans and black T-shirts, that sock is no longer white. But someday it will find a new match, when another white sock sneaks into a dark load.

Our twelve-year-old dryer prompts questions of its own. Why on earth does it need three hours to dry two loads of clothes? In so doing, how does it manage to bake all of our sweaters into the texture of papier mâché? And why is there always one stray tissue that ends up in shreds all over every shirt and pair of pants?

Doing the laundry also raises questions of aesthetics. How many holes does a sweatshirt have to have before my son will be willing to throw it out? Why is my spouse convinced that a white or pale-blue shirt is the best possible fashion choice for every social event? Why do the two male members of the family have completely different ideas about how they want their jeans folded — and why can I never remember whose jeans are whose?

Doing the laundry also prompts a number of serious psychological questions. For instance, how can my adolescent daughter wear so many clothes and still complain of needing more? Why do my daughter's clothes look so much more attractive than my own? How long has it been since I bought any new clothes for myself? And is there any connection among these questions?

Doing the laundry poses mysteries all its own, and encourages the launderer to develop her powers as a detective. This small orange button, for example: Since no one in the household wears orange, from what article of clothing could it possibly have fallen? Another mystery: Why would mud be splashed all over a T-shirt — in the middle of the winter? And further: Does the evidence of these food stains suggest that some members of my family still need to wear bibs? Finally, with four adult-sized persons in the household, I wonder, whose underwear are these? And how do their owners ever tell?

When I was a student, my university professors introduced me to philosophical questions about the nature of truth, the existence of reality, and the standards of good and bad.

But now, as a part-time domestic engineer, I can only be grateful that doing the laundry gives me the opportunity to contemplate life's *really* big questions.

February 20, 1995

Why Do Feminists' Daughters Want A Barbie?

ON HER 1990 album, *Momnipotent*, Canadian singer and songwriter Nancy White performed a wry and witty song called "Daughters of Feminists." It explores some of the ironies, for feminist mothers, of raising daughters.

Like other people with strong moral and political commitments, feminist mothers try to impart their beliefs and principles to their offspring.

But daughters of feminists, like children everywhere, have minds of their own. They want to make independent judgements concerning the issues their mothers feel so strongly about.

That independence starts early.

When my daughter was only three she decided she wanted to wear a dress or skirt every morning to daycare. In vain her parents pointed out that T-shirts and pants were easier to take care of. In vain we argued that jeans were more comfortable to play in.

The result was a condition her father nostalgically describes as "clothes wars." And the victor, without a doubt, was our daughter. Her choice for conventionally feminine and elaborate attire triumphed over our recommendations for clothes that were practical and carefree.

As a political movement feminism has had an ambivalent relationship with femininity. On the one hand feminists have been highly critical of some qualities traditionally associated with femininity, like dependence, deference, passivity, and helplessness. Feminists have rejected the preoccupation with domestic chores, physical appearance, and pleasing men that has been many women's destiny.

But on the other hand, feminists have also argued that society needs to place a higher value on certain other characteristics often exemplified by women, characteristics like nurturance, compassion, peaceableness, sensitivity, and the capacity to listen.

The difficulty has been to communicate this distinction, that while some aspects of traditional womanhood can be harmful to women, others are significant and valuable *human* traits, worth cultivating in both girls and boys, women and men.

Unfortunately, femininity, being a real girl or a real woman, appears to be a complete package: If you reject part of it, then you must reject all of it. If you accept part of it, you must accept all of it.

And what Nancy White calls becoming "girlie" starts at a very young age.

Why does it start so early? Presumably because this culture has a heavy stake in producing girls who will be devoted consumers of clothes, makeup, and household products.

For years my daughter wanted a Barbie doll. There were two main rules about toys in our house: No guns and no Barbie dolls. We relaxed the "no guns" rule only to permit water guns, on the grounds that when using a water gun you could clearly see the consequences of shooting. And I finally bought my daughter a Barbie when she presented me with her most reassuring argument: "I promise I won't grow up to be like Barbie!"

She understood that she didn't have to buy into the whole femininity package.

What's the alternative to traditional girlishness? Some people think the only other possibility is to raise daughters as if they were sons.

But while I didn't want my little girl to be "sugar and spice and everything nice," I also knew the alternative wasn't "frogs and snails and puppy dogs' tails." For there are also a few problems in the ways boys are traditionally socialized.

The tough, macho, sexist stance gets internalized early. I had no intention of duplicating it with my daughter. But I did encourage her to be active, to run, jump, play, and climb. I also encouraged her to think things through for herself and to speak out instead of maintaining a demure silence.

My hope has always been that if she can acquire a variety of intellectual and physical skills, my daughter can make her own

choices about what kind of woman to be. The challenge for me now is to be comfortable with the possibility that her choices may not be my choices; her preferences are not the same as mine.

Part of what is exciting, as a feminist, about raising my daughter is that I know she will make a life that is different both from mine and from her grandmothers'.

At the end of Nancy White's song, in the background, two high youthful voices sing, "Daughters of feminists just want to play with their toys!"

Perhaps this little chorus is a reminder, to mothers who are feminists, not to sweat the small stuff. And that feminism commits us to supporting all girls, including our own, to freely develop their lives in their own ways.

June 10, 1996

Mixed Emotions When the Nest Begins to Empty

So-called "empty nest syndrome" used to seem like a bit of a joke to me.

The term refers to the pain suffered, primarily by women, when their children leave home to start independent lives. Full-time housewives were thought to be particularly susceptible to empty nest syndrome, since, allegedly, their whole lives are devoted to their children.

I think this idea degrades at-home mothers, who may very well have other interests besides their children. But, I've learned, it also underestimates what mothers who are employed go through when their children leave home.

Yesterday my eldest child went away to start university. It was in many ways a joyful occasion. I'm glad he has the opportunity for further studies, and that he'll be learning to be self-sufficient within the supportive context of a university.

All his life he's been at home in college and university environments. When he was about two years old, and his babysitter was sick, he would come with me to the community college where I worked. He would sit at the front of the room and make faces and noises at the eighteen-year-old students, who were delighted by any chance for chaos in the classroom. At the age of three he came to the college and played hockey in the hallways, using a rubber ball and a ruler for a stick.

So, higher education seems like a natural destination for him.

But it doesn't feel natural to have him leave home.

Imagine what families with children might look like from the point of view of an anthropologist from Mars. A complete stranger, the new baby, moves into the house. You gradually get to know him or her quite well. The newcomer stays for eighteen or twenty years and then leaves.

I wonder if this stage will be easier for parents like my cousin,

who has six children, three of them now in their teens. The emptying of her nest will be gradual, and will take place over a period of fourteen years. Perhaps she'll have sufficient time to adjust to the process. And maybe she'll be glad of the peace and quiet after the departure of her brood.

But for those with smaller families the exodus of one child leaves a major hole in the group. Our nuclear family is like a wagon that just lost one of its wheels. I fear that a three-wheeled wagon just won't run very well.

For the next four years, before she too leaves for university, our daughter will get to be the only child, just as her older brother was the only child before she was born. But she doesn't see being an "only" as a big advantage. She's well aware of the potential burden of having two parents focused on her, no longer diffused by attention to her sibling.

Some people to whom I've confessed my empty nest sadness have made light of it. They say I should be glad one teenager is out of the house and look forward to the departure of the other. But I find my kids good company — not always relaxing company, but stimulating, interesting, and challenging. They don't let me get away with sloppy thinking, and they have an optimistic, life-embracing attitude.

With my son's departure, a certain lightheartedness is gone from the house. He has a special ability to jolly me out of bad moods and angry moments. Of all of our family, he is the most tolerant.

There will be no more hockey, soccer, and volleyball competitions to attend and cheer at. No more offbeat games with the cats. No more wry jokes.

At least until he returns at Thanksgiving for some home cooking.

Other people offer a kind of mocking comfort, predicting that my son, like many in his underemployed, underpaid generation, will be moving back home when his studies are finished and the world fails to offer him a living wage. Of course this idea is no consolation at all, since I don't want my child moving back home

because he's desperate, and also because I suspect that after he's enjoyed an independent life, he would find it uncomfortable to become dependent once again.

When American poet Nancy Mairs's eldest child left home for the first time, Mairs wrote, in her book *Remembering the Bone House:*

> ... she tolerates me pretty well and even likes me sometimes, I think. But she was never along for the whole ride, and before we know it, we reach her station, the point of transfer we've spent eighteen years preparing her — and, less successfully, ourselves — to reach bravely. Circling and circling outward, she spins off toward college.

Now that my son has reached his point of transfer, I shall miss him.

September 3, 1996

When the Prodigally Spending Son Returns Home

THIS STORY could be called "the prodigal son comes home."

Except he's not really a prodigal son at all. Our firstborn went away to university with our complete approval, and he seems to be doing well there. But, university costs being what they are, he's spending his money — and ours — prodigally. And when he returned home recently for a weekend visit, we were ready to do the late-twentieth century equivalent of killing the fatted calf.

What I didn't anticipate was the effect of his visit on those who are still at home.

Our household has had several weeks to get used to his absence. Our lives are busy but quiet. With just one remaining adolescent in the family, our fifteen-year-old daughter (a composed and organized young woman), the house seems calm and spacious.

But, we discovered, when the prodigal son returns, a house that formerly was roomy suddenly shrinks.

While he was away he seems to have gotten bigger and older. His face looks thinner — after all, he says he doesn't like the meals served in residence (an opinion that subtly flatters his father, the family cook). But he also seems taller, his shoulders wider, his muscles bigger. He takes up a lot of space.

At first he doesn't have much to say about himself, offering only brief and laconic information in response to direct questions. "Do you have a lot of school work to do?" "Not too much." "Is the food in residence getting any better?" "Nope."

But though he doesn't say a great deal, he's very active and energetic. For that reason the cats are glad to see him — to them, the house's usual occupants are pretty dull. At last, the cats purr, here's someone who really knows how to play. Our son incites them to feline riots of running, climbing, chasing, and play fighting.

I notice that the fridge is constantly opening and closing. Food disappears at an alarming rate. Within two days the blue box fills up

with empty cartons, milk bags, and cereal boxes. With our son at home the family size grows from three to four, but the amount of food consumed increases by about 50 percent.

Our son's bedroom, which was preternaturally neat and tidy for the five weeks of his absence, becomes a maelstrom of activity. His suitcase lies open on the floor and he appears determined to live out of it for the duration of his visit, rather than revert to the old pattern of using closets and shelves. He spreads out all his assignments on his desk and scatters his newly opened mail across the carpet.

True to every stereotype I've ever heard, he has also brought a whole week's laundry with him. "I didn't have time to do a light load before I left," he says. He adds, "I'll take care of it myself," but it turns out he's awfully busy during his brief visit, and I find myself washing and drying nine T-shirts, four pairs of jeans, five sweatshirts, and countless unmatched socks.

Amazingly, on top of all this, while he was away our son somehow seems to have acquired the idea that he is an independent adult, capable of making his own decisions. On Saturday night he goes out to see all his old buddies from high school. He doesn't get in until 3:00 a.m. My maternal intuition, unused to this degree of autonomy on the part of my first-born, is immediately alarmed by this behaviour. When he comes in, I awake to complete alertness, and am unable to get back to sleep again — though doubtless he dozes off immediately.

Despite the chaos and crowding he brings to the house, there is no doubt at all that it's nice to have him home. He's cheerful and enthusiastic. He dries dishes without being asked, he feeds the cats, he drives his sister and his mother from store to store to find his father a birthday present. He listens with the fond tolerance of the newly liberated to family arguments. He even spends an evening playing cards with us.

The parents of the original prodigal son were lucky. When their son returned, he came home to stay. But on Sunday night our son must leave to go back to university. The same big hole opens up, once again, in the family.

The house is much too peaceful. Truly, it just isn't the same without him.

October 28, 1996

The Wonderful Teenage World of Wedgies and Wisdom

For several years I've been fortunate to be the mother of two teenagers.

I call myself fortunate even though I think most people deny or overlook the ordinary joys and rewards of parenting adolescents. While the market is swamped with books on raising kids from infancy to ten, I've found very little about teenagers that is genuinely helpful without also being condescending.

We usually hear about the experience of parenting teenagers only under two rather extreme conditions — when kids "go wrong" (get pregnant, do drugs, steal, or act violent), and when kids produce prodigious achievements, as athletes, budding scientists, performing artists, or social activists. In those cases, and those cases only, the parents may receive some attention, to discuss either their failures as nurturers or their astonished pride in their offspring's achievements.

In addition, most people, especially if they have no children or if their own children are pre-adolescent, tend to assume that if your kids are older than twelve, then the most crucial, demanding, and intensive work of parenting is over. Unlike the parents of two-year-olds or even ten-year-olds, the parents of teenagers, I've noticed, are expected to have lots of free time, and no particular day-to-day responsibilities or commitments to their kids.

There's little or no recognition given to the day-in, day-out demands of mothering ordinary teenagers, individuals who are making their way through a crucial stage in their lives. Most people overlook the challenges of being a parent to teenagers, which involve trying to keep up with their lives, listening with an open mind, avoiding living vicariously through them, and maintaining a high degree of humility about one's own plans, values, and beliefs.

And when your kids reach adolescence, you start to realize, if you haven't noticed it before, that while your children learn from you, you also learn from your children.

This week, as my eldest child turns twenty, I'm reflecting on what I have learned from my adolescent children. Here are some of the simple things about which my kids have educated me:

1. what a "wedgie" is;
2. how to give someone a "nuggie" (if these terms are not familiar to you, ask a child);
3. how to make weird or funny noises, including a very startling sound with a plastic straw that is guaranteed to draw stares when performed in a restaurant;
4. how to rationalize procrastinating on household tasks and school assignments;
5. that, even in the worst winter, boots are almost never necessary; shoes will do;
6. that it's not really necessary to tie your shoes; in fact, it's more comfortable and convenient if they're not tied; and
7. that whatever happens at school, a parent should never, ever phone their teacher; they can handle it themselves.

But that's just the day-to-day stuff. I've also learned from my teenagers about more profound aspects of human existence.

In their approach to life my kids remind me of the importance of living for the moment, enjoying what I have now instead of worrying about the future or regretting the past. When I get weighed down with work, or am tempted to take my concerns too seriously, they constantly demonstrate the importance of having fun.

My kids know how to do without sleep, and how to sleep in til noon. They have mastered the art of doing several things at once, and possess enormous powers of concentration: They can do math homework while listening to the radio and talking on the phone, and with stuff strewn all over the room.

As athletes, they show me the value of physical activity and the benefit of participating in sports. I'm never going to forget the exuberance and sheer electric energy exuded by teenagers warming up

before a basketball game or preparing for a precision skating competition. From my kids I've learned about the joys of belonging to a team and the necessity of being loyal to it.

In many ways teenagers are grown up. They often have the insight of adults, while still maintaining the hope and optimism of the very young. And whatever illusions about you your kids may have had when they were little, once they hit adolescence you can no longer conceal your vulnerabilities and your weaknesses. Perceptive teens see right through their parents.

Above all, my kids urge me, in words and action, not to sweat the small stuff. They know that tomorrow is another day; we can start over again every morning; and everything looks different after a few hours of sleep.

Now that my son is twenty I can no longer describe myself as the mother of two teenagers.

But even though one of my children is no longer a teenager, I'm glad there is still one adolescent left in my home. I have a lot of learning to do.

August 11, 1997

When Children Disappear From Our City Streets

In *An American Childhood,* her reminiscence of growing up in Pittsburgh in the '50s, Annie Dillard writes, "My mother had given me the freedom of the streets as soon as I could say our telephone number."

That's what life used to be like for kids growing up in urban North America. I remember my own mother rehearsing with me our address and phone number. People assumed that the worst thing that could happen to a kid was that she might get lost. But if she did, provided she knew her own address and phone number, someone would ensure she got home again. You could trust your neighbours to help.

Nowadays, children no longer go outside. Or when they do, they are accompanied by their parents. Often they're on their way to an organized, adult-run activity — school, or a hockey practice, or dance lessons. Sometimes, if they're outside, they can play in the backyard, providing the yard is fenced, and providing a parent keeps a watchful eye on them the whole time.

What do kids lose when they do not have the freedom of the neighbourhood? They miss any sense of independence and freedom from adult supervision, they miss the opportunity to explore and discover, and they miss the chance to interact and handle conflicts among friends.

Two children I know, aged ten and eight, have never played outside on their own. Even if they go across the street to the home of a friend, their parents escort them. A recent step towards independence was allowing the ten-year-old to cross the street by herself — but observed through the window the whole time by both parents. This family does not live in the heart of a violent American city. They live in a Toronto suburb. But such are the fears for children's safety that these children have never known the freedom that my brothers and I enjoyed as children.

My brothers used to wrap towels around their necks and jump off our veranda yelling "Superman!" The three of us ran all over the neighbourhood, each in our own age-specific gang. There was an overgrown area at the end of the street where we gathered when we wanted to be away from the prying eyes of adults. It was half a square mile of brush, boulders, weeds, and scraggly trees, and it was a paradise for kids.

These days, no parent in her right mind would let her kids play in such a place.

This change has occurred, I think, even since my own children were small. For a time we lived in Montreal, on a narrow, block-long street, lined on each side with row houses. The backyards were tiny, and if kids wanted to play they used the street. We were fortunate that a whole tribe of children were growing up there together. From September to May there were endless road hockey games in front of our house, and in the summer, soccer and baseball.

The parents on the street gave their kids a lot of freedom, partly, I guess, because we felt there was safety in numbers. Nothing could happen to four-year-old Benjamin, who lived two doors down and played on the street, because his older brothers and sister were out there with him, along with my two kids, the three girls from across the street, and the brother-sister pair next door to them. They all watched out for each other, and at any given time, somebody's mother or father was probably giving the gang an occasional glance.

So confident were we about the safety of the neighbourhood that on Sunday mornings our son, aged all of nine, would walk with his five-year-old sister to the nearby bakeshop. There they would buy our croissants for Sunday brunch, and be rewarded by the baker with a cookie each for their efforts.

I had great confidence in our mature little boy, and once the children had demonstrated that they were capable of this feat, I never worried about them. Everyone in the neighbourhood knew them, the baker expected them, and the trip took little more than fifteen minutes. But now I wonder if I was insane to run such a risk.

Apparently our residential neighbourhoods are just more dangerous now than they were even fifteen years ago, and certainly than

they were when I was a kid. We also know more, now, about the risks of child entrapment and child abuse.

But I wonder whether parental fears about their children's safety are partly self-fulfilling. What I mean is that when all the kids have been withdrawn from the neighbourhood, of course it becomes more dangerous for any individual child who ventures out alone. Such a child is no longer under the eyes of other parents, friendly adults, or other kids.

After all, it was partly the very presence of people of all ages that helped to make our streets safe.

November 16, 1998

Let's Hope Women Can "Have It All" in the Twenty-First Century

AFTER GROWING UP with two little brothers, one of them nine years younger, I felt I had the best possible training to be the mother of sons.

My first child was an active and athletic boy. I hoped to have a daughter as well, but, while pregnant with my second child, I felt I was quite ready to welcome a second son into our family.

Instead, we were amazed to find our little family had been graced with a girl.

For me, raising a daughter was a new challenge. I wanted her not to be burdened by traditional stereotypes of what a girl should and should not do. I wanted to avoid living through her, or expecting her to live out my expectations. I wanted her to have the freedom to follow her own adventures and dreams. Yet at the same time I felt I should help her to understand and protect herself from the dangers and restrictions she could face within a world that can still be misogynist.

Even as a little girl it was clear that she would be strong and independent. At the age of two she saw a Christmas crèche in the local library. Marching over to it, she grabbed the Mother of God and announced, "Mine!"

As a five-year-old she sometimes stomped her foot in anger. This made me laugh — not making fun of her, but out of sheer delight at this small girl-child who already had a will of her own.

Right from the beginning, she adored her big brother and loved to play with him. But there was never any question in her own mind that she was his equal.

At two and a half she refused to let him look at a book with her, explaining, in a way that could only annoy an older sibling, "He's too little."

A year or so later, after a battle with me over candy, she said that someday she and her brother would have their own house, "and we won't eat a good supper, and we'll eat all the chocolate we want!"

Following her brother's example, she became a dedicated athlete. She has spent most of her life playing sports and competing on teams. Her generation of girls expects to be physically active and competitive, just like their brothers. Yet she also loved dolls and doll clothes. At eight, while playing with the dolls I had saved from own childhood, she remarked, "They look like they're the history of you."

That "history of me" differs significantly from hers.

My own mother grew up during the Depression and the Second World War, and became part of the generation that married and moved to the suburbs when the men came home from overseas. Like other '50s mothers she stayed home to raise her family, and was only able to follow her dreams of a university education and interesting paid work when her three children were older.

As a part of the baby boomer cohort I, on the other hand, have always worked while raising my children. We feminists thought we could have it all: A good education, fulfilling work, a strong relationship, and children.

Having it all turned out to be pretty difficult. Holding down a job and raising children at the same time make an uneasy combination. Childcare was expensive and often hard to obtain. Having it all turned out to mean trying to do everything, but with no more hours in the day than stay-at-home mothers have.

For me, opportunities and freedom were goals I struggled for. My daughter can rely upon having much of what my own generation had to fight for: greater sexual and reproductive freedom, educational opportunities, a job market that is at least nominally as open to women as it is to men.

At the age of two, my little girl would pretend to "go to work," taking along a lunch pail, her blanket, and a toy shopping cart.

At the same time, she also chose to be feminine. By the age of three she was insisting on wearing dresses to her daycare, though jeans would have been much more practical. She decided to grow

her hair long, and was bemused by my own refusal to wear makeup or ultrafeminine clothes.

Now, as a thoughtful, spirited, and independent teenager, she takes her freedom for granted. She expects to be able to do what she wants with her life, without social limitations based on gender.

Today, on the last International Women's Day of this century, I feel blessed to have this beautiful daughter in my life.

I hope that she will be able to "have it all," whatever that might be. I dream that in her lifetime, all of feminism's hopes for women will be fulfilled.

March 8, 1999

Feminist Ideals Don't Hinder Raising A Good Son

Twenty-two years ago I looked into the blue and knowing eyes of my first baby and embarked on the adventure of raising a son.

Unlike some new mothers I didn't feel completely inexperienced. After all, I had grown up with two younger brothers and had vivid memories of living in a household with their hockey skates, motorcycle parts, and musical instruments.

But my commitment to feminism raised complex issues for me as a new mother.

Some people — both a cartoon version of radical feminists on the one hand, and anti-feminists on the other — believe it's impossible for a feminist to raise a son.

In the '60s a few radical feminists seemed to be saying that men are inherently corrupt, and that inevitably the male tendency to dominate will emerge. From this point of view, a feminist raising a son ends up serving someone who will simply become a contributing part of the patriarchy. Men are biologically destined to oppress women, and a mother is just the son's first target.

Anti-feminists appear to believe that all feminists hate men. They think that no feminist would ever want to raise a son. But even if she wanted to, anti-feminists think a feminist cannot and should not raise a son, because she would ruin his spirit and crush his masculinity with her male-bashing attitude.

I hope it's obvious that I think both of these attitudes are completely false and unjustified.

Yet maybe, indirectly, they point to a challenge in the complex real world. Feminists hope to raise children — kids of either sex — so that they will be committed to equality, and so that they will not contribute to sexism, racism, and heterosexism. For me, raising a son presented me with this question: How can women and men live tolerantly together and love each other, whether as parents, siblings, friends, or lovers? By what means can women and men enhance

each other's lives, sharing a commitment to autonomy and independence, and at the same time fostering love and nurturance?

Put another way, the challenge was simply, How can we raise our sons to be good men?

My children taught me that the most important thing is, first, to treat kids with respect for their developing minds and bodies. And the second is to be genuinely interested in what they say and do, and to be willing to listen when they speak.

From babyhood my son had unstoppable energy, curiosity, and a devotion to play, movement, and adventure. He was born with the need to understand the world and figure out how things work. He loved books and conversation and music.

In raising my son I chose not to believe that he would inevitably do or want or think certain things just because he is male. I don't think men are inherently sexist. And I do think that there are many ways of being a man.

After crawling at six months and walking at ten months, by two my son could toss a ball in the air and hit it with his plastic bat. But this was also the child who asked for a toy shopping cart for his third Christmas, because he liked to go with his dad to buy groceries.

He loved baseball and soccer, and was the goal-scoring hero of his hockey team. And he also built a house for his stuffed bunny out of popsicle sticks.

He learned chess from his grandfather and was thrilled about winning a trophy at his very first tournament. And from the time our second child was born, he was a devoted and playful companion to his little sister. Inspired by their father's excellent cooking, he and his sister would prepare a written "menu" for Sunday breakfast, then serve their parents a meal of cereal, fruit, and juice in bed.

This was the child who, at sixteen, single-handedly defused a post-hockey fight between two men considerably bigger than him. He accomplished this by the simple expedient of placing himself between the two contenders and talking quietly to one of them, while slowly moving him away from the other.

So, looking back over those years, I think a feminist can raise a

son to be a good man. In fact, doing so has been one of the greatest joys of my life.

But of course most of the credit for who he is goes to him.

Today my oldest child — builder of bunny houses, dedicated hockey player, and devoted older brother — is twenty-two. Happy birthday, my son.

August 16, 1999

From the Not-So-Ivory Tower

INTRODUCTION

EDUCATION WAS my way out of my working-class background. The first of my family ever to attend and graduate from university, like American academic Jane Tompkins, I have lived "A Life in School."[1] After I taught at a college in Montreal for nine years, I became a professor of philosophy at Queen's University, Kingston, and have been there since 1984.[2]

There is a stereotype that academia is an ivory tower, remote from everyday concerns. Sometimes I hear my students talk about one day leaving the university and joining the "real world."

It's true that the university is a special place, a privileged place. It provides an unparalleled opportunity to study, read, observe, think, and talk. For both faculty and students it offers the chance to be self-motivating, to live a life not completely structured by the clock.

However, as I tell my students, the university *is* the real world, or one part of it.

The academic world offers a microcosm of small- and large-group dynamics. Students, staff, and faculty must learn to get along with each other. The academic world in no way transcends politics. Political issues, both internal (the structure and governance of the institution) and external (the university's relationship to the public, to government, and increasingly, to corporations) dominate much of the academic agenda. The future of the university has become precarious in the funding climate of the last ten years, in which universities are expected to emulate businesses, the sciences are regarded as the important areas for research and teaching, and the humanities and arts take a secondary place.

Despite these problems, more and more students are flocking to the universities. It's not just that a university education provides a superb preparation for working life, although that is indeed the case. But in addition, students of all ages recognize the value of deep learning, the chance to mature intellectually and socially, and the opportunity to contemplate the "real world" and understand it a bit better. Not remote at all, universities are actually an indispensable ingredient of a flourishing society. In this section, then, I introduce you to my observations of life "From the Not-so-Ivory Tower."

1. Jane Tompkins, *A Life in School: What the Teacher Learned* (Reading, MA: Perseus Books, 1996).
2. Christine Overall, *A Feminist I: Reflections from Academia* (Peterborough, ON: Broadview Press, 1998).

HIGH TUITIONS KEEP UNIVERSITIES FOR MIDDLE CLASS

IN TIMES OF tight economic constraints, reduced social benefits, and ever-higher taxes, it is not surprising that university tuition fees are rising. Tuition fees look like a plausible opportunity for government savings. Get the students to pay more! After all, contemporary wisdom says students are mostly middle-class kids; they — or their parents — have the money to pay for their education, and they are the ones who are going to benefit from all those extra years in the classroom.

As a former student of the '60s, when undergraduates advocated a policy of zero tuition, I am bemused to find that many of the students of the '90s seem to accept that higher tuition fees are not only inevitable but also justified. Organizations like the Ontario Undergraduate Student Alliance believe it is necessary for students to pay more in order to get a higher quality of education.

I am resigned to the view that tuition fee hikes are inevitable, but I don't agree that they are justified. There are very strong arguments not just against raising tuition fees, but actually in favour of lowering them.

It is true that middle-class students, some of them happily subsidized by their parents, are overrepresented in Canada's university classrooms. But that fact is not a good argument for exacerbating a situation that already discriminates against poorer students. It's an argument, instead, for making it easier for working-class and poor people to gain access to the universities, by lowering or even eliminating the financial barriers.

As it stands now, the class imbalance in Canada's universities is self-perpetuating. Universities look and feel and sound like the middle-class institutions they are; people without middle-class advantages easily get the message that they are not welcome. In other words, perceptions of the university by those outside it partly help to determine who is likely to seek access to it.

It is often argued that the effects of increased tuition fees can be mitigated by generous grants, or by the greater availability of larger student loans. Or even by a system whereby tuition costs are repaid on an income-contingent basis: a graduate would have to repay the costs of her education only if her income meets or exceeds a certain minimum; if it doesn't, she wouldn't have to pay.

But this is where the perceptual problem I mentioned earlier arises. Large tuition fees — even with loans or income-contingent repayment systems — still look like large tuition fees.

Many of the people in the working-class neighbourhood where I grew up would not be prepared to take a chance on large tuition fees. They know they are not the kind of people who get grants. And they would be correct; outright grants by governments to students have virtually disappeared.

Many working-class people have also learned, often through bitter experience, to adopt fiscally conservative strategies. They know that lower-income earners will be penalized heavily for a large post-university debt, since they will need longer to repay their loans and thus will incur larger amounts of interest. Rather than contemplating an expensive university education, people with few financial assets who want further training beyond high school are likely to choose cheaper and more accessible vocational training at community colleges.

So, even if loans are liberally available, they will not compensate for the deterrent effect that large tuition fees will have, and many people without the financial advantages of the middle class will continue to be excluded from university education. Realistic perceptions of high tuition fees result in a kind of intimidation factor.

But in addition to this intimidation factor, which will keep many people out of the universities, we also need to consider the effects of high tuition fees on those who actually manage to get into the universities. The prospect of students graduating with a huge debt burden — up to $20,000 already for some graduates —is or should be troubling. The alternative prospect — students spending as much as one-half of what ought to be their studying and learning time at a minimum-wage job — is no better. It's difficult to be a

competent student when you are exhausted, as many now are, by earning the money necessary to stay in school.

But what about the argument that students, as the beneficiaries of their education, have an obligation to pay for a greater share of it?

It's true, in general, that the more education one has, the more one benefits and the better one's life prospects become. But it's also true that the more educated a nation's citizens are, the more that nation benefits. The nation benefits in all the obvious ways — through scientific research, legal and medical expertise, historical and political insight, engineering know-how, artistic development, and business acumen. But it also benefits in less obvious ways from having citizens who have learned to think critically, to evaluate carefully, to contribute to culture, and to support and appreciate the sciences.

A nation that provides university educations for its citizens legitimately expects from its university graduates their commitment to putting their skills and expertise to good use. So, although the individual benefits from higher education, the society does too, and the benefits for individuals are not a sufficient reason to burden them with a substantial proportion of the costs of their education. To require individuals to pay large sums for their education is to endanger the society's collective prospects for future flourishing.

Still, some of today's students believe that if they are willing to contribute more to the costs of their education, its quality will rise. But such a view grossly misunderstands the motive behind raising tuition fees. Governments are seeking to raise tuition fees because, as recent and serious funding cuts show, they are reneging on their former commitments to tertiary education. In effect, they want individuals to pick up some of the financial burden of supporting public institutions, institutions to which politicians are now willing to give only lip service.

And when students are forced to pick up that burden, they will not necessarily find that the quality of their education improves. Instead, the faculty/student ratio may continue to worsen; facilities may continue to deteriorate and equipment to age. To support tuition increases will only reinforce provincial governments' continuing neglect of the universities.

Anyone who values our universities and the education they provide — and surveys suggest that most Canadians do — should be deeply disturbed by the continuing increases in the price tag attached to that education. An enlightened society regards higher education not as a privilege reserved primarily for the wealthy but as a significant resource for the development and flourishing of all its citizens.

March 7, 1994

UPDATE

Post-secondary students are borrowing more money than ever to pay for their education, and are finding it increasingly difficult to pay it back. According to the Canadian Federation of Students, since 1990 tuition fees have increased, on average, more than 125 percent and average student debt at graduation has grown from $8,000 to $25,000. The Canada Student Loans program reported that in 1990-91, only 6 percent of graduates who had borrowed money under the program owed more than $15,000. But by 1996-97, the percentage had grown to 41 percent, with 6 percent owing more than $25,000. Among those with a bachelor's degree, women are more likely than men to have difficulty repaying their loans.

In 1998, amendments were made to the Bankruptcy and Insolvency Act to ensure that student loans cannot be discharged through bankruptcy proceedings until ten years after the student has completed her education.

As a university professor I am personally acquainted with recent graduates who owe as much as $60,000 in student loans. No wonder a university education is a daunting expense for those with few or no financial resources.

Abolish Tenure?
Gee, This Guy Harris Might be on to Something

MIKE HARRIS, leader of the provincial Tories, recently stated that the system of tenure in Ontario's universities, which "guarantees a job whether you're still pulling your weight or not," is "passé" and should be ended. Nobody else, he claims, has this security. Says Harris, "I want to reward people for doing a good job today, not for what they did yesterday."

On reading this I put on one of the many tweed jackets from my extensive academic wardrobe to think about Harris's proposal. As a tenured academic myself, I could see that the abolition of tenure is totally justified.

It's obvious, I reasoned, that tenure is an excuse for laziness. As everyone knows, of all public employees university professors are the most irresponsible and slothful. After all, most of us have only spent twenty years or so training for our professions. And after we are first hired, it takes a mere six years of inspection by the university before the institution decides whether to grant us tenure or dismiss us. Our work is evaluated so seldom: in addition to the three-year probationary assessment, and in-depth assessments whenever we are considered for promotion, the university conducts merit reviews only once a year.

The forty-five to sixty-five hour week that I and most of my colleagues work is a positive breeze, and I'm sure that it's only tenure that enables us to enjoy it. The constant pressure to teach more undergraduates, supervise more graduate students, serve on multiple committees, and produce new research clearly prevents most of us from "pulling our weight." Instructing classes with 100, 200, or even 300 students in them takes hardly any effort at all. And most of us can dash off a book or complete a major research project in just a few hours. As for serving on committees, counselling students, and

supervising graduates — of course all of that would go better if professors could not earn tenure.

I thought back to the week and a half of vacation that I enjoyed last year. Certainly only tenure could have afforded me such a privilege.

I also reminisced about the wonderful travel I get to do as a result of my job as a tenured professor. Why, in the past year alone, I've been to both Toronto and Montreal to lecture and attend conferences. The year before, I went as far as Hamilton and Ottawa. And on all these trips I seldom worked more than nine or ten hours each day.

Of course, some of those professors who are not pulling their weight will claim that tenure is needed to preserve academic freedom. Indeed, my own alma mater, the University of Toronto, defends tenure on the grounds that it preserves academics' right to raise disturbing questions and provocative challenges to the cherished beliefs of society at large. U of T claims that one of the purposes of a university is to examine and criticize the basic values and assumptions of our culture and the various groups within it, and that this process protects society's freedom of speech.

But how necessary is academic freedom? All those independent thinkers, those challengers of the status quo, those initiators of new and untried research projects, those critics of the government — who needs them anyway? With the gradual domination of the universities by government and business, we academics will soon be told exactly what to say, what to teach, and what to think. There will be no need for us to have any independence of thought.

And certainly Ontario's universities will hardly miss all those professors — including many at the beginning of their careers — who will abandon this province and seek jobs in more backward, tradition-bound provinces whose universities still offer tenure.

Of course, I concluded, if Harris is going to abolish tenure for university professors, then he should also propose getting rid of job security for all other public sector workers: primary and secondary school teachers, health care workers, civil servants, social workers, firefighters, and police officers.

Above all, Mike Harris should support the abolition of job security for politicians. If Harris should happen to be elected, I trust he will introduce a mechanism so that he and his fellow travellers can be readily dismissed, after only a few months, if they turn out to be unproductive, lazy, unethical, irresponsible, or just plain incompetent. After all, Brian Mulroney's federal Tories gave us a clear example of the bad consequences when politicians enjoy even nine years' worth of job security.

May 15, 1995

The Things That Dare Not Bare Their Names

"Correctional services," "passed away," "bathroom tissue": what do these three different phrases have in common?

They are all euphemisms.

According to the *Shorter Oxford English Dictionary*, a euphemism is an expression "by which a less distasteful word or expression is substituted for one more exactly descriptive of what is intended." We use a euphemism as a way of speaking in an indirect and inexact way about something we find difficult or embarrassing to name in literal terms.

Not all aspects of our lives are subjected to euphemisms. Some things are easier for us to talk about than others. We have no problem with talking about eating. We have a highly developed vocabulary relating to growing, preparing, serving, and consuming food.

On the other hand, outside of a few standard obscenities, we are scarcely able to discuss any aspects of excretion. Hence, we speaking of "going to the bathroom" to mean using the toilet; "bathroom tissue" to mean "toilet paper." We even try to disguise toilets with elaborate mats, seat covers, and tank covers — somewhat in the way that the Victorians supposedly used to put skirts on the legs of tables.

Other biological events are also euphemized in western culture. Death is the obvious example: we speak of people "passing away," "passing on," or being "laid to rest." A corpse in a funeral home is not dead, it is "resting." An old or unwanted animal is not put to death; it is put to sleep. Apparently we prefer to think of death as an extended nap, or alternatively as the ultimate vacation to an otherworldly destination.

Sex and reproduction are other areas where euphemisms abound. When I was growing up, no woman was ever described as "pregnant"; instead she was said to be "expecting." (Expecting what? This phrase was confusing to a small child, who might have

difficulty differentiating between expecting presents at Christmas, and expecting some unexplained outcome of mum's fat tummy.) People didn't have sex; they were said to "sleep with" their partners. In the '90s we are more direct in discussing pregnancy, but some aspects of sex remain euphemized. Consider the brand labels for condoms. They include "Sheik," "Ramses," "Trojan," and "Titan." Not only do condom manufacturers borrow names from other "exotic" cultures; they also try to hint that the organs condoms cover are inevitably large.

But it is not just biological events that are euphemized. There are other areas of human life about which we have difficulty speaking directly.

Money is one of them. Everyone knows that in most cases it's unacceptable to speak of how much or how little money you earn, or to ask what someone paid for items they own. Campaigns to raise money — a more and more necessary result of ungenerous governments — are also euphemized. In universities, the term "advancement" is being used to describe the process of wheedling money out of former graduates. Some organizations use the term "friend raising" as a substitute for the more literal "fundraising." They want to pretend it isn't really anything so crass as money that they're demanding from potential donors, but just a good relationship.

Another euphemism I've recently noticed are the terms "Correctional Services" or "Corrections" to refer to the prison system. "Correctional Services" could more readily mean a firm that offers copy-editing of manuscripts. It's difficult to associate the phrase with penal institutions.

The tourism industry makes liberal use of euphemisms. At a resort I visited this summer the accommodations varied considerably in quality and cost, but they were all described as either "luxury" or "deluxe" — a semantic distinction that completely escapes me. Not long ago even Ontario license plates carried a euphemism. The plates read: "Ontario: Keep It Beautiful." A member of my family always claimed this really meant "Ontario: Pick up the Garbage!"

The existence of euphemisms shows that in western culture we have trouble talking about basic biological events, like elimination,

sex, reproduction, and death, as well as money, punishment, and maybe even trash.

But there's nothing inevitable about euphemisms. One culture's topic for embarrassed euphemisms may be another culture's focus for discussion and market development.

For example, in Japan, excretion is said to be a source of much interest. Inventors have developed high-tech toilets, with built-in clocks, jets of water and blasts of heat for cleaning purposes, and a temperature control for the toilet seat. There is even a Japan Toilet Association, which sponsors "National Toilet Day" and is dedicated to "the creation of a Toilet Culture for the twenty-first century."

It's enough to make you want to go powder your nose.

August 28, 1995

Celebrating Older Women As A Precious Resource

ALMOST THIRTY years ago, in 1970, one of the first books on the new feminism was published. Entitled *Sisterhood is Powerful*, it presented a wide variety of groundbreaking essays about what was then called "the women's liberation movement."

One article carried the title, "It Hurts to Be Alive and Obsolete: The Ageing Woman." Its pseudonymous author, Zoe Moss, described the commodification of women within consumer culture, and the role played by advertising and the media in setting impossible standards for women of youthfulness and sexual attractiveness.

Zoe Moss did not use the word "ageism" in her article, but she was describing the ageist social standards that legitimise discrimination on grounds of age, especially discrimination against older women. In Moss's words, "men may mature, but women just obsolesce."

Moss specifically included herself among the targets of ageism directed against women. She lamented a culture in which she was considered unattractive or even invisible, a culture in which, by virtue of her age, she was considered "not a person but a joke." "All I ask," Moss concluded, "is to get to know people and to have them interested in knowing me."

How old do you think Moss was when she wrote this article? Sixty-five? Seventy-five? Eighty-five?

In fact, she was forty-three.

In 1970, at the age of forty-three, in the earliest stages of the rebirth of feminism, Zoe Moss already felt herself to be "obsolete."

Now let's fast forward to the late '90s. At Queen's University in late February of this year, a woman named Ursula Franklin presented a talk to a large audience of women and men of all ages, students, faculty, and community members. The auditorium where she spoke was jammed; people filled every seat, lined the aisles, and sat on the floor. The roomful of listeners was silent and attentive.

Dr. Franklin is an accomplished scientist, a university professor, and an activist. She has thirteen honorary degrees and is a Fellow of the Royal Society of Canada. She delivered a robust and clearheaded critique of the role played by the state in the lives of late twentieth century North American citizens. In jurisdictions such as Ontario, Dr. Franklin said, the state offers up its citizens as just another set of investment opportunities for global corporations.

As I listened to her speak, and noticed the rapt attention she earned from the audience, I thought of Zoe Moss. Unlike Moss, no one would ever think of Ursula Franklin as "obsolete," as a joke rather than a person. Yet Dr. Franklin is an elderly woman, well past the usual age of retirement.

Ursula Franklin represents, I believe, much that is hopeful about what Zoe Moss would have called the women's liberation movement. Women like Dr. Franklin are both the products and the contributing architects of a new social climate in which more and more women are able to be respected members of society all their lives, not only as the mothers of children, but as artists, writers, scientists, teachers, and doctors.

Another such woman is Carolyn Heilbrun, a writer and literary critic. Under the pen name Amanda Cross she is the author of a series of mysteries about a detective named Kate Fansler, and under her own name she has written many feminist books. The most recent is *The Last Gift of Time: Life Beyond Sixty*. As its title suggests, Heilbrun celebrates her sixties and looks ahead to her seventies.

During her sixties, Heilbrun tells us, she retired, by choice, from her academic position at Columbia University, and embarked on a post-retirement project of writing a biography of feminist Gloria Steinem. During that decade Heilbrun also bought a house, gave up wearing dresses and other feminine attire, adopted a dog, and learned to use E-mail and the Internet.

In *The Last Gift of Time*, Carolyn Heilbrun writes, "The greatest oddity of one's sixties is that, if one dances for joy, one always supposes it is for the last time. Yet this supposition provides the rarest and most exquisite flavor to one's later years. The piercing

sense of 'last time' adds intensity, while the possibility of 'again' is never quite effaced."

This is the voice of a woman who is aware that she is old but who will never be obsolete.

Zoe Moss would be about seventy-one now. Wherever she is, I hope she has opportunities to hear or read the words of women like Ursula Franklin and Carolyn Heilbrun. Both of these powerful feminists demonstrate that what Moss called "the ageing woman" is a precious resource for this culture. I have no illusions that ageism against women has disappeared. But as a feminist I'm profoundly grateful for role models like Franklin and Heilbrun.

March 9, 1998

Superomnian Reflections on High School Latin

WHY learn Latin?

The cliché says that Latin is a dead language, no longer the common tongue of an entire empire. Though it is occasionally read, it is not spoken.

In the current market-driven educational climate, it might seem we could dismiss Latin altogether. Latin language training appears to have no immediate practical value. It will not enable its possessor to found a business, make money, or engage in corporate competition. It is "irrelevant" to computer literacy, science education, and commercial training.

It's questionable, though, whether every school subject has to be justified in terms of its immediate practical value. Studying Latin should ideally be undertaken for its own sake — that is, for the sake of exploring an ancient culture, literature, and history, which may still speak to our own.

Yet it also has a potential pragmatic value. It's estimated that one of every four Latin words lives on in English, and that about 50 percent of our total vocabulary in English is derived, directly or indirectly, from Latin. As well as English, Latin was the basis for the development of five other European languages: French, Italian, Spanish, Portuguese, and Romanian. As much as 90 percent of the vocabulary of Spanish comes from Latin. So, in the new "global economy," a background in Latin makes the acquisition of these other languages seem smoother and more natural.

As aficionados of Latin point out, educational research also shows that Latin language training enables students to think critically and become more proficient in English. Perhaps most importantly, the study of Latin promotes an understanding of grammar and the structures of language, and it can create a remarkable sensitivity to words.

I studied Latin in high school for three years, and at the time it seemed almost completely useless. Latin class was the scene of my

earliest rebellions, polite and small-scale though they were. "Why do we have to take Latin?" I demanded, and my Latin teachers were unable to offer reasons I could accept.

Reluctantly I memorized Latin declensions and worked my way laboriously through Latin translations. After all, my high school's Latin motto was the sturdy admonition "per ardua ad sapientiam" — wisdom through hard work.

But all the while I was convinced that after high school I would retain no more Latin than the sophomoric injunction, "semper ubi sub ubi" (a nonsensical phrase literally meaning "always/ where/ under/ where," but which high school students were happy to misappropriate).

Not everyone shared my philistine attitude. A classmate and close friend in high school jokingly adopted the nickname "deus" (god), and sometimes addressed me by a transliterated version of my last name: Superomnia. In our high school yearbook he stated that his ambition in life was to speak Latin.

As it turned out, this aspiration accurately foreshadowed his lifelong preoccupation with foreign languages. Over the course of the next decades he eventually mastered French and German well enough to teach them, studied Italian, Russian, and Finnish, and most recently is learning Japanese.

My own appreciation for Latin did not fully mature until many years later, perhaps in the spirit of my alma mater's allusive motto "velut arbor aevo" — as a tree grows.

One vivid occasion of connecting with Latin was on a trip to Italy, where I witnessed the prolific architectural monuments of the Roman world and walked through the extensive ruins of the Latin-speaking population at Pompeii.

Gradually I've come to understand all the ways in which Latin pervades my native language. For example, the concept of feminism has its earliest roots in the Latin word "femina," or woman. Education comes from the Latin "educare," literally meaning "to draw out," and "school" derives from "schola." "Mother" comes from "mater," "father" from "pater," and the root of "family" is evident in

the Latin "familia," meaning household. The motto of the Olympics is the Latin "citius, altius, fortius" — faster, higher, stronger.

Despite the value in Latin that I only now belatedly recognize, I'm glad that courses in Latin are no longer compulsory. There are many areas that young people benefit from learning, and the study of an ancient language is something to which students must come willingly, not out of compulsion.

Courses in Latin are livelier in the '90s than they were thirty years ago. High school and university Latin classes endeavour to acquaint students with the culture, politics, and social life of ancient Roman society. Nevertheless, for me Latin remains a subject best appreciated in hindsight. Although studying Latin is not something I ever want to do again, it is something I'm now glad I did.

May 4, 1998

Schools are No Place for Religious Indoctrination

Within the Ontario school system there is an interesting anachronism: the funding of Roman Catholic schools.

Why does the province continue to support a separate school system?

There are, of course, historical reasons. Section 93(1) of the British North America Act of 1867 guaranteed religious schooling for the Protestant minority in Quebec and the Roman Catholic minority in Ontario. The funding of separate schools was part of the historical costs incurred in bringing together four British colonies to constitute the new Dominion of Canada.

In general, however, other than for these two groups, there is no constitutional right to public funding of religious schools.

And events from history don't necessarily justify what we do today. Historically, for example, when this nation was formed, only property-owning men were entitled to political rights such as the vote. But that historical fact was not a sufficient reason for continuing to deny the suffrage to women.

In the province of Quebec, history no longer prevails. The Quebec school system is moving away from its historical past, with school boards divided on the basis of religion between Protestant and Roman Catholic, to a more modern situation in which boards are constituted on the basis of language, English and French.

Meanwhile, in Ontario, access to increased provincial funding and an influx of students (including new immigrants and students who were formerly in the public school system) mean that the Roman Catholic system has been growing rapidly.

What's odd about the ongoing provincial support for the separate school system is that it involves state sponsorship for one specific religion, a religion by no means shared by everyone.

Some might argue that the separate school system is what a substantial segment of the population — Roman Catholics — want.

But if the criterion for support of religious schools is based on what people want, then there are some interesting consequences.

In today's multicultural Canada, it is hardly surprising that adherents of other religions, including Judaism, Islam, and fundamentalist Protestantism, also argue on behalf of state support for a religious education for their children.

Why should these people be compelled to pay taxes for an education system that they believe is not right, morally and spiritually, for their offspring?

But funding schools for many different religions would raise difficult questions about which religions to support. It would also mean the end of public education. Ontario's children would not then have an education in common.

I think it's questionable whether religious instruction in school is good for children. Taking up precious time in the school day to indoctrinate children in a religion's precepts and practices means less time to devote to learning mathematics, science, history, geography, art, music, and literature.

This argument is not directed specifically against the Roman Catholic system. I have no doubt separate school teachers do a fine job. The question is whether religious schooling should be publicly funded. I would have the same doubts about any other religious school system, if it had state support.

Ideally school is where kids learn to think. Religious instruction, however, at least at the primary level, encourages blanket acceptance much more than thought. Instead of teaching developing minds to take things on faith, we should be encouraging them to think independently and critically. If certain topics are off limits as far as investigation and inquiry are concerned, this is likely to have a stultifying effect on the child's mind.

Some people believe that in order for kids to learn morality, they have to learn religion. But religious belief is in no way necessary for ethical behaviour. A school can teach kids the importance of fairness, tolerance, sharing, open-mindedness, truthfulness, and honesty not on the basis of some supposed grounding in religion, but rather because living with values like these creates a better community for everyone.

Schools should teach children about the history, beliefs, and values of a whole range of religions, not just one. And they should do so not with the purpose of inculcating one faith, but with the purpose of creating understanding of all faiths.

I think the general principle of separation of church and state is a good one to follow. There are no longer sufficient reasons to give one religion a favoured status. In today's Ontario many religions co-exist, and even Christianity (certainly not one particular form of Christianity) cannot claim to be more deserving than others.

I understand that some parents sincerely believe that religious indoctrination is essential for their children. But if that is their belief, then it is their responsibility to teach their religion to their children at home and in the religious institution of their choice.

July 20, 1998

Class Differences Are Very Clear in Canadian Society

ONE HUNDRED and fifty years ago, or even one hundred years ago, socio-economic class differences in Canada were obvious. If you were born poor, chances are you'd stay poor. If you were a male who came from a labourer's or tradesman's family, you'd likely be a labourer or a tradesman like your father. Women worked very hard, but their primary identities were as wives and mothers, not as breadwinners. Illiteracy was high; opportunities were low.

Differences in socio-economic class were taken for granted. Such differences were even believed to have a divine source: God created some people to be workers, and others to be owners. Those who were impoverished were believed to be poor by nature, not as a result of social forces.

Has the situation changed? Are we now an equal opportunity society? Are socio-economic class differences irrelevant in Canada?

Part of the contemporary mystique about class is the idea that Canada is not a class society, and that there are no significant (or at least no permanent) socio-economic barriers among segments of Canadian society.

We're certainly encouraged to hide class differences, or ignore them. No matter if their income is low people are subtly taught to believe they belong to the middle class. Very few people seem to have an explicit identification with the working class. I have talked to university students who come from working-class backgrounds, and who are deliberately hiding their origins. To keep up with the more affluent students they work twenty or more hours a week, smuggle food from the cafeteria to their residence rooms, accumulate mounting debt, and choose not to talk about their homes and families.

But are socio-economic class differences irrelevant? I don't think so.

Here's one piece of evidence: A study released by Statistics Canada in November 1998 showed that children's future is closely

tied to their parents' incomes, especially their fathers'. The total market income of young adults aged twenty-eight to thirty-one in 1994 was related to the incomes of their parents in 1982, when the children were sixteen to nineteen. Offspring with fathers who had income from assets, including investment income and dividends, ended up with higher incomes of their own than did offspring of fathers who did not have income from assets. By contrast, those young adults whose fathers had received income from Unemployment Insurance, regardless of the amount, ended up making less.

Another indication of the persistence of class differences is the great divide that exists between those with and those without a university degree. In 1996, people in Canada with a university degree earned, on average, $42,054. Meanwhile, a high school graduate earned $22,846, and those who did not complete high school earned $19,639. And a study released by Statistics Canada in June 1998 showed that citizens with only a high school diploma had much less chance of ever moving out of low-paying jobs than did university graduates.

I suggest that these figures are straightforward indications of class differences in Canada, differences relating to amount of education and size of income.

Provincial Progressive Conservative party leader Mike Harris recently made the bizarre pronouncement that 1999 will be the year of the middle class. As a member of the middle class myself, I wonder what year is *not* the year of the middle class. If by "middle class" he means people who are genuinely comfortable, well educated, well employed, and well paid, then every year is the year of the middle class.

Perhaps Harris is trying to take advantage of people's widespread belief that, regardless of income or education, they all belong to the middle class. If everyone is (supposedly) middle class, then Harris can be perceived as celebrating everyone.

Harris claims that this is the year of the middle class in the sense that people will be encouraged to move into the middle class. But ironically, with his government's unwavering attacks on education at

all levels, and the relentless increases in the costs of access to university, it seems that he is strangling one of the most direct routes for Ontarians to improve their class position. The figures from Statistics Canada show plainly that more education enables people to achieve higher salaries, yet Harris seems bent on putting obstacles in the way of those who seek this route to middle-class membership.

Maybe what we really need in this province is not a year of the middle class, but instead a year of the working class, or a year of the poor.

February 1, 1999

Saving Face Isn't Just Cause for Changing One's Mind

According to an old saying, "It's a woman's prerogative to change her mind."

I suppose this stereotype allowed women a little lenience. But it wasn't very flattering. It was supposed to show how indecisive and wavering women are.

Changing one's mind was usually taken as a sign of weakness. Real men, it was assumed, don't change their minds.

But now that this society is calling in question a lot of old shibboleths, we can ask whether changing one's mind is a bad thing, or whether instead it should be both a woman's and a man's prerogative to change their minds.

Probably either extreme is a problem. On the one hand, repeatedly vacillating indicates a failure of resolve or lack of confidence in one's own thinking. But on the other hand, never being willing to change your mind could mean you're inflexible, don't listen, or just won't rethink your opinions. Or it may just mean you're so conceited that you assume you can never make an error.

Sometimes changing one's mind represents moral commitment and personal integrity. Here's an example.

Fifteen years ago Michael Fox, a member of the Queen's University Department of Philosophy, wrote a book in which he contended that experimentation on animals is justified. He argued that the benefits to human beings of animal experimentation outweighed the suffering of the animals used in research.

But after the book's publication Professor Fox changed his mind. He decided that the book had been written from a "might makes right" perspective that assumes that human beings can do what they want with non-human animals just because we are stronger and more powerful than they are. And "might makes right" is hardly an adequate foundation for ethical claims.

Because he had always been committed to non-violence, Fox began to question his earlier view that human-imposed animal suffering is acceptable. He decided that non-maleficence, or the principle of avoiding harm, is a stronger foundation for human treatment of animals.

Moreover, Fox had the courage of his changed convictions. Instead of concealing his change of mind he chose to publicly repudiate his earlier work on animal experimentation. Most recently he published a new book, *Deep Vegetarianism*, in which he defends vegetarianism as one way of reducing the suffering of non-human animals.

This striking reversal in perspective did not make Michael Fox popular with the scientists whose work he had originally supported. Some people thought that such a dramatic change in opinion must show he was crazy.

But whether or not you agree with Fox's new position, it is clear that he adopted it as a matter of personal integrity.

Now contrast this change of mind with another one: The decision in January by Industry Minister John Manley to withdraw the federal government's bailout package for Canada's NHL teams.

Only three days earlier Manley had said that the federal government was willing to commit millions to NHL hockey because it is an essential part of Canada's culture. He had claimed that Canadians place the NHL teams' financial well-being above social issues like health, unemployment, and homelessness.

John Manley and his colleagues in the federal government changed their minds because Canadians by the thousands protested the use of their tax money to support wealthy hockey players and millionaire club owners.

Now you might say it's good that the Liberals are responsive to their constituency. But if so, given all the polling that the federal government notoriously spends money on, why did they not know, before considering the NHL bailout, that the vast majority of Canadians would oppose making hockey into a charity?

So at the very least, Manley and company are guilty of failing to pay attention to Canadians' real wishes in the first place. They're

also guilty of failing to devise a policy that could be defended on its own strengths.

But just as bad is the fact that their change of policy did not come about through a careful reconsideration of its merits, or from an attempt to maintain political integrity. Instead it boiled down to self-preservation. Manley and his pals were just looking for what sells. They changed their minds because their prime consideration is popularity — whatever would enable them to be re-elected.

So I'd say it's a person's prerogative to change his or her mind when that person has made a careful reconsideration of the original opinion or decision.

But it's not a person's — or a government's — prerogative to change their mind if they simply failed to think carefully in the first place. Or if they are changing their mind for simple expediency, in order to maintain their power and popularity.

February 28, 2000

Tories' Competition Funding Theory Deserves Failing Grade

A CHILDREN'S BOOK called *The Story About Ping*, written by Marjorie Flack, tells of a little duckling who lives with his large duck family on a boat in the Yangtze River. The ducks spend the day on the shore of the river looking for good things to eat, and are called home to the boat in the evening. But when they return, the Master of the boat always gives the last duck aboard a spank on the back.

Even as a small child I found this procedure unfair. There must always be someone who is last, so one duck is going to get spanked every single day, no matter how much she rushes to get home, or whatever her reason for being late.

In addition, I worried that the ducks might fight among each other in order not to be the last one home. Wouldn't the strongest ducks gang up on a weaker member of the brood and prevent him from arriving on time, so that he would be the one to be spanked?

I was reminded of the ducks' Tough Love regime when I heard about the Ontario government's most recent announcement about university funding. Despite the government's predictable self-congratulation, operating grants will increase by only 2 percent — not even enough to keep up with inflation.

That tiny increase will in no way provide the needed funding for the double cohort of high school graduates who will flood the universities in 2003 when the Tories abolish the fifth year of high school. Nor will it help the universities to deal with the increased enrolment resulting from the growing numbers of young people in the eighteen to twenty-three age group.

Worse still, half of that small increase in operating grants will be tied to what the Tories call "performance."

What is "performance"? Forget about things like how much students learn, or how much graduates' lives are enriched, or the

extent to which they become more informed and involved citizens. The Tories will measure performance by reference to the percentage of the first-year class that graduates, the percentage of graduates employed after six months, and the percentage employed after two years.

Universities scoring in the top third on these criteria will receive twice as much as those in the middle third. Universities in the bottom third will receive no money at all.

Like the last duck on the boat, some universities are going to be spanked — even if there is little difference in percentages between the top performers and the bottom performers, and even if a relatively low performance is caused by a lack of government support.

Harris may take the view that tying funding to performance will encourage competition among Ontario's universities. But is competition the best way to run an educational system?

As a university professor and the parent of a university student, I firmly believe that academic institutions are — and should be — different from corporations. Co-operation is essential to the productive functioning of universities, which thrive when they share research tools and findings, teaching methods, and library resources. Universities also have a history of promoting student and faculty exchanges. The government should be encouraging universities to find new ways of sharing their assets, not taking steps to persuade them to outdo each other.

The latest bad news about university funding is likely to contribute to further demoralization among faculty, staff, and administrators at universities that are struggling to provide excellent education and research with diminishing budgets. If Harris wants to close some of the province's universities maybe he should have the guts to do so, instead of just allowing them to die a slow death by attrition.

The government's policy of malign neglect toward the universities is consistent with its general moral policy. It's based on the biblical parable of the talents. The moral of the parable is, "Unto every one that hath shall be given, and he shall have abundance; but

from him that hath not shall be taken away even that which he hath" (Matthew 25:29).

This is an odd approach to distributive justice, but it is the Tory government's philosophy for running the province. Unto the rich shall be given yet more — whether we're talking about powerful corporations, wealthy citizens, or big universities. But from those who have not — including welfare recipients, squeegee kids, libraries, inner city schools, cash-strapped hospitals, small arts organizations, and universities with only modest endowments — will be taken even the little they used to have.

In Ontario, if you're a quick, rich duck you will probably still be allowed on the Tory boat. But if you're a slow, poor little duck, all Harris has for you is a spank on the back.

March 20, 2000

Stockwell Day's Homophobic Reasoning Lacks Consistency

As a candidate for leadership of the reborn Reform Party (now called the Canadian Alliance party), Stockwell Day has shocked many people with his anti-gay sentiments. Even his political fellow traveller Tom Long has expressed concern that gays, lesbians, and bisexuals will not feel welcome in the renamed party.

Like homophobes everywhere, Day thinks that it's bad not to be heterosexual. And he believes that the 10 percent or more of the population that is not heterosexual is choosing to be bad.

According to Day, homosexuality is a choice, not an innate orientation. "Ultimately we all make decisions," says Day.

Really? How did Stockwell Day get to be such an expert on homosexuality?

Sexual orientation is a highly contested subject. Questions about the nature and origins of sexual orientations are hotly debated by scientists, social scientists, and scholars in the humanities. They recognize that if it's legitimate to ask why gay, lesbian, and bisexual people have the sexual orientation they have, then it is equally legitimate to ask why other people are straight.

Some scientists have offered genetic explanations for sexual orientations, or explanations based on brain structure or hormonal exposure. Others explain sexual orientation in terms of family modelling, the influence of parents, the effects of siblings, or a combination of all of these.

According to explanations such as these, sexual orientations, including heterosexuality, are objective, intrinsic, culture-independent facts about people. This is sometimes referred to as the essentialist view of sexuality.

Other scholars, especially in the humanities, have taken a different view of sexual orientations. Instead of regarding

heterosexuality or lesbianism or homosexuality as essential, ahistorical "facts" about people, facts that are unrelated to social context, some scholars have suggested that sexual orientation categories themselves are social creations.

According to this view, one cannot be gay — or straight — independent of a social environment that defines heterosexuality and homosexuality as roles or ways of being. Sexual orientations are socially constructed. There are historical variations in how sexuality is shaped and formed in different eras. Although people have always engaged in same-sex and opposite-sex sexual activity, no one is essentially straight or gay. This is sometimes referred to as the social constructionist view of sexuality.

Now the question is, has Stockwell Day made an informed study of this huge area of scientific and scholarly debate about the nature and origins of sexual orientations?

I know of nothing in Day's background that would give him expertise on the issue of sexual orientations. So how could he possibly have acquired this "knowledge" he claims to have, that gayness is chosen? He doesn't have the research background or the qualifications.

In saying that homosexuality is a choice, Day is claiming to know better than many of the scientists working on this issue. Many scientists offer explanations having to do with factors such as biological factors or family dynamics, causes that would be out of the control of any individual. If it turns out that genetic, hormonal, or social influences are part of the story, then it is hardly the case that an individual can control them, and "choose" to be gay.

Day's pronouncements also have some interesting implications about heterosexuality.

There are a couple of possibilities. He might say that homosexuality is a choice, but heterosexuality is not a choice. This is inconsistent, but maybe Day wouldn't let himself be held back by a little thing like inconsistency in reasoning.

But if heterosexuality is not a choice, then those who are heterosexual certainly do not deserve any moral praise for being heterosexual. Day cannot claim that they are choosing to do the

right thing, if he thinks they are not choosing at all. And he cannot believe that heterosexuals are morally superior to homosexuals. If human beings are destined (by what? God? Biology?) to be heterosexual, then they certainly are not entitled to claim the moral high road about their sexual orientation.

On the other hand, maybe Day would opt for consistency. He might say that if homosexuality is a choice, then so is heterosexuality.

But to say that heterosexuality is a choice has a further implication, one that might make Day a little uncomfortable. Religious fundamentalists such as Day usually depend on the concept of "naturalness" to try to justify their moral stances. They regard heterosexuality as "natural" and homosexuality as "unnatural." According to this view, homosexuals "choose" to be "unnatural."

But if heterosexuality is also chosen, then it is no more "natural" then homosexuality. There is nothing inevitable about heterosexuality. Being heterosexual is not a matter of biological or social destiny.

So which is it, Stockwell? Is heterosexuality chosen or not chosen?

Either way, you've got quite an interesting theory.

June 19, 2000

From the Newsroom

Introduction

TODAY'S NEWS STORY is tomorrow's history. The events that are printed in the newspaper or broadcast on radio, television, or Web sites often have an enduring significance. If the past helps to constitute who we are now, then the stories of today tell us who we are becoming.

As a feminist I believe it's important to examine the larger context of contemporary issues. We need to consider what current events may suggest about what it means to be a woman today, and about what women's future challenges and possibilities are. In this section I look at newsworthy events related to procreation and sexuality, as well as violence, work, political participation, motherhood, and disability. Because many of these stories are ongoing, in several cases I've provided updates to remind readers of recent developments.

I have a special interest in issues concerning reproduction, from pregnancy and abortion to in vitro fertilization and cloning, because I have long believed that the opportunity to choose whether, when, and how to procreate is central to women's full personhood and

participation in our society.¹ By the same token, it could be said that issues of sexuality are also vital to what it means to be a woman: both how we choose to express our sexuality and how we are sexualized by cultural pressures to be stereotypically feminine and desirable.

In applying a feminist analysis I try to address three major groups of questions. First, who or what is wielding control and authority, and where does the real power lie? Second, what fundamental values are animating the debate, and whose values are they? Third, how do social categories like gender, race, class, sexuality, and ability define the scope and limits of individuals' freedom and opportunities?

Using this framework, let's take a closer look at some of the stories issuing "From the Newsroom."

1 Christine Overall, *Ethics and Human Reproduction: A Feminist Analysis* (Boston: Allen and Unwin, 1978); and *Human Reproduction: Principles, Practices, Policies* (Toronto: Oxford University Press, 1993).

Cloning Expresses Fear of Personal Difference

IN THE RECENT debate about the cloning of human embryos, what is interesting is not just what is being said but also what is not being said about the morality of the practice.

Cloning is the technological production of two or more genetically identical living beings. The process has been successfully applied to cattle and is now being attempted with human cells.

Prior to the cloning procedure, a woman is subjected to hormonal stimulation to induce her ovaries to produce several eggs simultaneously. The eggs are then removed and fertilized by sperm to produce embryos, a process known as in vitro fertilization (IVF).

After the embryo has undergone early stages of development, it is divided into several separate clusters of cells. Each of these new cell clusters — all of which are genetically identical and the same sex — can then be implanted in a woman's uterus, and will have the same developmental potential as the original embryo.

To some people, cloning is the stuff of dystopian science fiction. Even many ardent fans of scientific technology — including those who happily defend IVF — are worried about the prospect of being able to produce multiple identical copies of one human being.

I think they're right to be worried, but wrong about the reasons for worrying.

Genetically identical individuals are by no means new. Throughout human history there have been identical twins, and, much more rarely, triplets and quadruplets. The famous Dionne girls, born in Corbeil, Ontario, in 1934, are the first and still the only instance in which five genetically identical babies survived past infancy.

In the West there seems to be a superstitious awe of identical multiples. Consider the public reaction to the Dionnes. For nine years Annette, Yvonne, Cécile, Emilie, and Marie were given an upbringing that was both isolated and public. Virtually quarantined

from their parents, their siblings, and other children, they were on display for days at a time to thousands of paying tourists who filed past their nursery window.

Perhaps sheer human diversity makes it harder for us to countenance biological identity. The curious yet apprehensive reaction to three or four or five identical human beings appears to be the expression of a fear of sameness.

Yet the fear of sameness can't be the whole explanation. Look at how this culture ordinarily handles identical children. The usual approach is to *emphasize* their similarities, to make them look and act as much alike as possible, with the same clothes, the same hairstyles, similar names, and the same activities. It is as if we try to control biological identicals by imposing additional social similarities.

Perhaps what this culture really fears is the development of diversity, the possibility that even genetically identical entities may turn into unpredictable and unique individuals.

For although identicals start out the same as embryos, they gradually become distinct and autonomous entities. The environments of two identical individuals are never precisely the same. These discrepancies produce differences in the originally identical human beings, whose personal and social experiences — including even uterine experiences — can never be exactly uniform.

By making possible the creation of large numbers of cloned people, the new technology appears to defy our cultural trepidation about identicals. Yet paradoxically, it may be the technological extension of the human attempt to minimize diversity.

The development of cloning requires the production of embryos that are not only identical but "quality controlled." It thereby calls into question women's reproductive labour, which ordinarily generates unique, individual embryos whose characteristics are unpredictable.

In contrast to cloning, with its emphasis on scientific management, women's ordinary reproductive processes may seem random, uncontrolled, and unreliable. When multiple copies of one human baby can be technologically produced, women's role in reproduction may be devalued and demeaned.

Of course, it will still be necessary to obtain eggs from women. But if cloning becomes widespread, which women will provide the eggs (and thereby be subjected to extensive hormonal stimulation), and how will they be encouraged to do this? The question is troubling, since the removal of eggs does not, itself, in any way benefit women, and hormonal hyperstimulation may carry short- and long-term health risks.

And of course, women will still be needed for gestating the cloned embryos. But mere pregnancy starts to look scientifically unimpressive by comparison with the technological wizardry of cloning. Moreover, given the high-tech regulation of present-day pregnancies resulting from IVF, it seems unlikely that a "cloned" pregnancy would be allowed to simply take its course. A woman carrying a clone would probably be subjected to the panoply of prenatal testing and technological "management" of childbirth.

Some years ago I heard a mother say of her two good-looking little boys, "I'm glad I have a matched set." Will cloning encourage people to want the ultimate in "matched sets"? If so, will there be pressure on (some) women to gestate embryos, simply in order to complete a "set"?

Cloning may also encourage us to see children as manipulable and commodifiable products. Indeed, some commentators have advocated the commercial marketing of multiples — selling sets of identical embryos to eager consumers who don't want to cope with the differences that ordinary siblings manifest. When one embryo from a cloned set has already been gestated, a photograph of the resulting child could be shown to prospective purchasers of other embryos in the set, to indicate how their new baby will "turn out." Other commentators have waxed enthusiastic about the potential of using cloned siblings as sources of spare body parts for each other.

Even without these macabre proposals, there is good reason to worry that cloned children will be seen as curiosities or freaks, or as ongoing experimental investigations into the comparative effects of heredity and environment.

In light of these potential problems, it is important to ask exactly whom cloning benefits. Is there any prospect that it will enhance

the quality of people's lives? Will it encourage respect for women's labour? Better childrearing? More committed and more sensitive parents?

Or, more likely, will it merely provide a further opportunity for the technologization of human reproduction and the commodification of human bodies?

Within the near future, the development of cloning will tell us a lot about what's valued in this culture. Cloning offers the illusion of perfect control over the sex, race, appearance, and other characteristics of large numbers of offspring. I predict that the technology will not be beneficial for the children it generates, or for the women who provide the eggs and gestate the cloned embryos.

Cloning is the technological expression of the human fear of personal difference.

November 15, 1993

How Far Are the Anti-Abortionists Willing to Go?

FOR THOSE who care about women's freedom and health, a disturbing feature of 1994 was the repeated violence in Canada and the United States against abortion providers. In November Dr. Garson (Gary) Romalis, a Vancouver doctor who performs abortions, was shot at home by an assailant using an assault rifle. On December 30, two women who worked at abortion clinics were shot and killed in Brookline, Massachusetts.

I suspect there is a weird and grisly logic behind these shootings. Anti-abortionists claim to believe that every human embryo and fetus is a complete and whole human person, indistinguishable, morally and socially and legally, from any fourteen-year-old girl or forty-year-old man. According to anti-abortionists, acts of abortion are acts of homicide. As a consequence, some anti-abortionists may see the murder of physicians who perform abortions and the workers who assist at abortion clinics as the elimination of killers and their accomplices.

But anti-abortionists who view the world this way should recognize that their beliefs have further implications. If every fetus and every embryo is indistinguishable, morally, legally, and socially, from children and adults, then anti-abortionists should seek to confiscate all IUDs, morning after pills, and even birth control pills, as potential murder weapons. Anti-abortionists should suspect every pregnant woman who suffers a miscarriage of being a killer, or at least criminally negligent, and should advocate judicial investigations of spontaneous abortions. They should police pregnant women to be sure they do nothing to harm the human person inside their uterus.

Anti-abortionists should advocate that every pregnant woman who drinks alcohol be arrested for violating laws against providing alcohol to minors. They should regard every pregnant woman who has a surgical or medical procedure for the maintenance of her own health as guilty of subjecting her fetus to health risks.

If a pregnant woman's life or health is endangered, anti-abortionists should never favour saving her over the fetus, for after all, according to their views, the pregnant woman and the fetus are morally equal. And anti-abortionists should view all scientists involved in embryo experimentation or in vitro fertilization as potential murderers, since embryos often die during these processes.

Are anti-abortionists willing to pursue these implications of their beliefs?

Unfortunately for those who advocate and seek to protect women's civil rights, some anti-abortionists are, indeed, willing to go almost that far. Some anti-abortionists do favour policing pregnant women's alcohol and cigarette consumption. Some of them advocate the forcible detention of pregnant women who are thought guilty of "fetal abuse." And in the United States there have been legal cases forcing pregnant women, against their will, to have caesarean sections, supposedly for the well-being of the fetus.

So some anti-abortionists do seem willing to follow their views about the status of the embryo and the fetus to their absurd conclusion. In fact, they appear to value fetuses and embryos more than women, since, in seeking to ban abortions, they are willing to sacrifice pregnant women's health and well-being to preserve fetuses. These kinds of behaviours may actually indicate another agenda behind the anti-abortion movement: the control of women, in particular, control of women's reproductive capacities, with the aim of confining women to the traditional activities of mothering and domestic work.

On the other hand, if anti-abortionists do not accept these implications, then they'd better rethink their views on the moral status of embryos and fetuses.

Embryos and fetuses are not the same, morally, legally, and socially, as children and adults. And there are at least two reasons for this.

First, embryos and fetuses are at a very early stage of human development, and their sentience — that is, their capacity to feel and perceive — is at first non-existent and then only gradually develops after the first three months of gestation. So, if sentience

and stage of development matter at all, then early abortions may be preferable to abortions undertaken later in pregnancy.

Significantly, at the Brookline clinics where the December murders of abortion workers occurred, the so-called abortion pill, RU-486, was being tested. This medication precipitates the expulsion of the embryo very early in its development. Ironically, then, the killer at the Brookline clinics was assaulting workers who were helping to provide morally preferable abortions, if the stage of gestational development is at all important.

A second important reason that embryos and fetuses are different from children and adults is that embryos and fetuses are located in and wholly dependent upon the bodies of women.

Legally speaking, no human person in this culture is expected to sacrifice his or her health or well being for the sake of another living entity. We are never legally compelled to donate our eyes or bone marrow or organs, even if other people — including members of our own family — need them. We are never forced, against our will, to provide our bodies to sustain the lives of other living beings.

Pregnancy should be no different. The law should not compel any woman to sustain the life of an embryo or fetus against her will. For this reason it makes sense that abortion is legal in Canada. Abortion is now rightly considered by most members of this society to be a medical procedure that is performed for the benefit of women's health.

There is no justification for vigilante activities at abortion clinics. If anti-abortionists truly believe, as they claim to, that assault and murder are morally wrong, then they should never participate in, advocate, or condone terrorist attacks upon persons who are providing a legal medical procedure.

January 9, 1995

UPDATE

Violence by murderous "pro-life" zealots against health care workers who provide abortions has not diminished. Attacks on abortion workers in both the United States and Canada continued throughout the '90s; some of them were fatal. John Salvi, who was convicted for the murders at the Brookline clinic, was given a life sentence and committed suicide while in prison. But James Kopp, of St. Albans, Vermont, who has been identified as a suspect in the shooting of Dr. Romalis, remains at large. He has also been charged with the October 1998 killing of Dr. Barnett Slepian in Buffalo, New York.

After his shooting Dr. Romalis almost bled to death. But he survived and courageously returned to work. In July 2000, he was stabbed outside his office in the Seymour Medical Centre in Vancouver by an unknown assailant.

Homolka Case Suggests Some Women Can Choose to be Monsters

Behind every great man is a woman, we say, but behind every monster is a woman too, behind each of those countless men who stood astride their narrow worlds and crushed other human beings, causing them hideous suffering and pain. There she is in the shadows, a vague female silhouette, tenderly wiping blood from their hands.

I AM REMINDED of this comment by feminist author Jill Tweedie as I read recent accounts of the Paul Bernardo murder trial.

Bernardo is charged with first-degree murder in the deaths of fifteen-year-old Kristen French and fourteen-year-old Lesley Mahaffy. In her mid-1993 trial with respect to the same deaths, Bernardo's former wife, Karla Homolka, negotiated a plea bargain. She was sentenced to twelve years for manslaughter — currently being served in Kingston's Prison for Women — in return for agreeing to testify against her former husband.

Under our legal system, Bernardo is, of course, considered innocent until proven guilty. What I am wondering about now is Homolka's role in the monstrous crimes committed against two vulnerable adolescents.

The Bernardo case has been described in the media as a sort of "whodunit." The question is, in part, the relative responsibility of Homolka and Bernardo for the crimes.

Bernardo's defence plans to argue that Homolka was not coerced into participation in the sexual torture and murder of the two young girls. The defence will claim that she negotiated the plea bargain as a way to save herself, at the expense of Bernardo, from more severe legal penalties for her actions.

On the other hand, the Crown argues that Homolka was terrorized into participating in acts of sexual degradation, torture, and murder.

Her terrorization is claimed to have occurred because Bernardo is alleged to have beaten his wife. In addition, it is alleged that he videotaped Homolka in acts of sexual assault against her deliberately drugged and unconscious younger sister, Tammy, who later died by choking on her own vomit. Bernardo's purported threat to Homolka was that if she did not participate in his later crimes against Lesley Mahaffy and Kristen French, he would reveal the tapes of Homolka and Tammy to the rest of her family.

How compelling was this threat?

Was Homolka a beaten and blackmailed victim of Bernardo?

In *Femininity and Domination*, philosopher Sandra Bartky has written about the danger to some women who begin to adopt the worldview of the men to whom they are attached. Says Bartky, "To affirm a man's sense of reality is at the same time to affirm his values. 'Stand by your man': What else can this mean?"

Feminist writer Susan Brownmiller has argued in *Against Our Will* that feminists must "cease to excuse every battered woman who engages in criminal behaviour, with the argument that she is, after all, merely a victim of the patriarchy, socialized into her feminine passivity, brainwashed into robotry by an evil man." Brownmiller argues, "The point of feminism is to give women the courage to exercise free will, not to use the 'brainwashed victim' excuse to explain away the behavior of a woman who surrenders her free will."

Like Brownmiller, I too am inclined to draw a moral line at making excuses for a woman like Homolka. In light of the reported evidence, especially with regard to her sexual assault on her sister, I find it hard to see Homolka as merely a helpless victim. She is a "victim" who nonetheless participated in, perhaps even encouraged, the misogynist torture of young girls.

Kristen French is reported to have said, during the course of her torment, that some things are worth dying for. This child seems to have felt that it would be better to die than to do what she was being forced to do. I have to conclude that that girl had far more courage and moral will than was apparently possessed by Karla Homolka.

Homolka's case suggests that, like some men, some women are capable of choosing to be moral monsters. Being female is neither a

guarantee of ethical virtue nor a sign of moral victimhood.

Homolka may be a prime example of the hideous results when a woman adopts and participates in the degrading values and abhorrent practices of a male torturer with whom she is allied. For at least a year, it seems, Karla Homolka stood by her man.

June 12, 1995

UPDATE

After being transferred from Kingston's Prison for Women, which is now closed, Karla Homolka was moved to a prison in Joliette, Quebec. Media reports of her activities in prison suggest that she has a bright, upbeat view of herself. She expresses no shame or remorse for her crimes, which she interprets as resulting from her victim status as a so-called battered woman. Psychologists have commented on her apparent "moral vacuity."

So far Homolka's requests for escorted day releases have been denied. But after serving two-thirds of her sentence, on July 5, 2001, she will be eligible for early release from prison, unless it can be demonstrated that she is a threat to public safety.

Minor Hockey in Need of Major Overhaul

A FIFTEEN-year-old boy died last month while playing a hockey game.

Dallas Saunders dove in front of a slapshot that was headed for the net. The puck hit him in the chest and he suffered a cardiac arrest.

Linda Olson, chairwoman of the Abbotsford Minor Hockey Association in which he played, said, "He played for the team, he played for a win."

Any parent who has spent hours in freezing arenas watching a son (and it is usually a son) play hockey would hear Dallas Saunders's story with a twinge of fear.

My son has been playing minor hockey for thirteen years. This is his final year. So now his games have a special significance, for him and for his parents.

He loved the game right from the beginning. As a six-year-old he would come off the bench with so much energy his skates didn't seem to hit the ice until he was halfway across the rink.

Watching little kids play hockey is one of the delights of parenting. They have a lot of fun — though they spend as much time falling down as they spend skating. Penalties are rare. The puck appears to be in slow motion. The kids repeatedly leave the ice to get their helmet tightened or their laces retied.

But then the boys hit puberty and the game seems to change. Things get a lot rougher; there are more penalties, and more deliberate attempts to get away with breaking the rules.

"It's the testosterone," says a father, winking.

Suddenly hockey becomes a way for some boys to define their masculinity. The game becomes a serious struggle.

And some parents treat each competition as a life and death battle.

Sportswriter Roy MacGregor writes about the joys and problems of minor league hockey in his recent book *The Home Team:*

Fathers, Sons and Hockey. He describes the premature culling of the best boys for elite hockey — as early as the age of nine. He deplores the destructive pressures on kids, and the increasing levels of danger on the ice.

In minor hockey, he writes, parents try to get prestige and reflected status from their child's accomplishments. Says MacGregor, "I have seen fathers offer a child money for scoring. I have seen fathers attacking referees, screaming at each other, screaming at their own children and other children. I have seen a father so desperate to win that he was willing to use illegal players in a house-level tournament for ten-year-olds."

Hockey seems to bring out atavistic impulses, both in players and in spectators. I've experienced it myself: If some huge kid on the opposing team tries to bash my son, I'm ready to climb over the arena glass to give the kid a piece of my mind. If the referee makes calls I think are unfair, I'm among the first to complain.

So I have mixed feelings about kids' hockey. On the one hand, hockey may help boys to use up their energy and aggression. Played at its best, hockey demonstrates cooperation, mutual support, and athletic skill and endurance of a high calibre.

On the other hand, I've also seen unnecessary hostility, violence both on and off the rink, real vindictiveness, and a concern for some outdated concept of manhood over a concern for hockey skills.

And I'm not so sure minor hockey is good for its audience, including me. Parents get really angry. They act irrationally; they berate referees and other parents; they even boo kids. MacGregor says parents actually booed Wayne Gretzky — when he was only ten years old — on the grounds that he supposedly had the puck too long.

"In Canada," writes MacGregor, "it has been said that parents would rather have their sons grow up to play in the NHL than become a doctor."

Thanks to a hockey puck, fifteen-year-old Dallas Saunders won't grow up at all.

It might be said that his death was a freak accident. Dallas "played for the team, he played for a win," and when players go all out, injuries can occur.

But the belligerence and competitiveness of minor hockey at the senior levels may increase the likelihood of injury.

Maybe some Canadian boys, and their parents, need a new concept of achievement in minor hockey. One that emphasizes cooperation, fun, and skill development, in place of violence, aggression, and danger.

February 5, 1996

Should Sperm Donors Be Paid More Than Blood Donors?

LAST WEEK federal Minister of Health David Dingwall announced that Ottawa will ban the sale of sperm.

The policy change follows the recommendation in the final report, issued in 1993, of the Royal Commission on New Reproductive Technologies. The Royal Commission recommended that sperm donors be compensated "only for their inconvenience and for the direct costs of donation. Payment for sperm should not be substantial enough to constitute an incentive to donate."

Officials at Canadian sperm banks say that the money they now pay donors to compensate for time and out-of-pocket expenses ranges from $40 up to more than $100. They claim that such payments do not represent a financial incentive to potential sperm providers.

Let's say, conservatively, that masturbating and ejaculating require five minutes on the part of the sperm provider. If so, then the lowest paid "donors" are receiving the equivalent of $480 per hour, and the highest paid are receiving the equivalent of more than $1,200 per hour.

It might be objected that "donating" sperm takes more than five minutes. One must add in the time involved in travelling to and from the sperm donation centre, having blood tests and physical examinations, and filling out forms and answering health questions during pre-screening appointments.

But those requirements are surely not much different from what blood donors must undergo, and no one is offering to compensate blood donors for their time and out-of-pocket expenses.

Indeed, it could be argued that blood donors are more in need of compensation, since blood donation — unlike sperm donation — has little that is inherently pleasurable about it.

So, are payments to sperm providers justified? The question has significance that goes beyond the men who provide the sperm and the women who, through the process of artificial insemination, receive it.

The wider question is whether human body parts or products should be bought and sold. Is such a practice appropriate within the Canadian health care context?

Our health care system upholds the principle that blood is not a commodity to be bought and sold. Whatever the recent problems in our blood supply and distribution system, no one is advocating that we move toward a system of buying blood from donors.

There are several difficulties with buying blood and other body products. First, the purchase of blood gives potential providers an incentive to be less than honest about their health status. Second, the purchase of blood offers potential providers an incentive to contribute blood more often than is healthy for them or for the quality of their blood. Third, buying blood is incompatible with the general principle that human body parts and products should not be commodified, and are not appropriate means for profit making.

Recruiting blood donors, with no material incentive except coffee and donuts, is a challenge, but it is not impossible. There are many Canadians who are willing to donate blood without financial recompense. They know how important blood and blood products are to the health of sick and injured Canadians.

Should the situation of sperm donors be any different?

Murray Kroach, a Toronto gynaecologist and reproductive biology specialist who also runs a sperm-banking service for his patients, thinks most of his donors would refuse to participate if they were not compensated.

If he's right, this means two things. First, those who claim that the current payments to sperm providers are only for time and out-of-pocket expenses may be mistaken. The payments may be serving as a real financial incentive. And second, the average sperm donor is not as generous and socially responsible as the average blood donor. Indeed, Dr. Kroach remarks, "In this day and age, very few people are going to be willing to do this [donate sperm] just out of the good of their heart."

So it might be argued that if the federal government is going to set up government-run sperm banks, it will have to continue to pay sperm providers. If it doesn't, the women who are potential sperm recipients would face higher costs to pay for human sperm imported from the United States.

The problem is that the continuation of the practice of buying sperm contributes to the ongoing commodification of reproductive body parts. A health climate in which the buying of sperm from men seems normal is a climate in which the buying of ova and embryos from women also seems normal. It's a climate in which the buying of babies from "surrogate" mothers may seem like a logical extension of the process of buying gametes. (Interestingly, the federal government is also drafting legislation to ban the sale of human eggs and embryos, and outlaw commercial contracts for "surrogate" mothers.)

Why should it be necessary to pay sperm providers for their sperm? Is sperm different, in commercial terms, from blood? Are sperm providers different, in commercial terms, from blood providers?

Maybe so-called sperm donors should more accurately be labelled sperm vendors.

June 17, 1996

UPDATE

When a federal election was called in 1997, the proposed legislation banning the sale of human sperm and eggs died on the order paper. But by 1999 the Liberal government was reassessing its commitment to banning the sale of sperm, on the grounds that it has long been an established and accepted practice. There were fears that any ban would seriously limit the supply of sperm.

New legislation is now being prepared that will regulate the buying and selling of sperm but not outlaw it. Potential "donors"

will be allowed to recover the costs of travelling to and from clinics, but supposedly the financial incentive will not be sufficient to motivate men to donate hundreds of times.

Meanwhile, although there is a voluntary moratorium in Canada on the selling of human eggs, some couples have been buying eggs in the United States. And in this country, women have been exchanging eggs through a barter system by which a "donor" can receive in vitro fertilization in return for giving up half her eggs to another couple willing to subsidize her treatment. New federal legislation will likely outlaw the commercial buying and selling of eggs, but may permit compensation for the "donors'" "time, inconvenience, and other expenses."

Sexism Discourages Women from Seeking Office

A REPORT, released in mid-February 1997, on the number of female politicians around the world suggests that women are not just failing to gain ground; they are actually losing ground.

A study of 179 parliaments by the Geneva-based Inter-Parliamentary Union found that women hold only 11.7 percent of all seats. This is a decline from 14.6 percent in 1988. And it's scarcely ahead of levels reached in the 1970s.

In terms of its proportion of women in federal Parliament, Canada stands only twenty-first. Two other strongholds of democracy place far worse: the United States is forty-first; the United Kingdom is fiftieth.

At 18 percent, Canada is well above the average. Even so, consider what the figure means: fewer than one in five members of Canada's Parliament are women.

What is the explanation for the decline in women's active participation in governments around the world? We need to figure out some answers to that question before we can consider how, if at all, approximate gender parity might ever be achieved.

Women's relatively low participation is certainly not a matter of innate incapacity. There's nothing about women's biological makeup that makes us unsuited to political life. If there were, there would no way of explaining the presence of the minority of women who do succeed in politics.

It's become more and more apparent that biologistic explanations for women's intellectual attainments, job accomplishments, and creative achievements are far overshadowed by the effects of social conditions.

In a general way, it is sexism that explains why women have not made headway in political life. But just to say sexism is too simple. It is not only blatant discrimination, but also a complex network of factors that deter women from politics.

First, citizens, both men and women, may not always be supportive of women in politics. This absence of support extends to the structure of party politics. The Inter-Parliamentary Union's study notes that 89.2 percent of political parties are headed by men. It found that women have relatively little influence in party politics.

Moreover, as the social and political climate becomes more conservative in the 1990s, there may be a reaction to women in politics. It's not exactly a backlash; it's an example of what I call the "Smurf" phenomenon (which I discuss more fully in "Avoiding the Smurf Theory of 'Women's Issues'" on page 224). This is the view that in any given activity, you only need one representative of each different kind of human being, including women.

In a sexist climate, even one woman is highly noticeable, and if there's more than one, that leads to a tendency to overestimate the number of women present. The presence of a few women in a governing body may make people think "progress" has gone far enough, that there isn't any need for more women in politics.

There are also economic causes for women's lower participation in politics. On average women earn considerably less than men. Entering politics and waging political campaigns are expensive activities — not projects that the single mother, the housewife, or the woman earning minimum wage can possibly contemplate.

In addition, political life may not be well suited to the some of the interests and goals that women have traditionally sought. The demands of pregnancy, nursing, and rearing children are not readily compatible with political life. The study notes that political life often requires long periods of absence from one's family, and women may be unwilling or unable to go through them. Even now, in the late '90s, men are less involved with childrearing than women, so it's easier for men than women to combine a political career with parenthood.

It's quite possible that political life could be made more compatible with the demands of motherhood. But that change would require a transformation in the political culture — a culture that has developed to suit men's standard career paths.

As well, the moral climate of political life may not be congenial for a lot of women. I don't by any means think women are inherently more moral than men. But women's social concerns and values may not be attuned to the adversarial life of politics: the backroom dealing, corruption, haggling, backstabbing and self-aggrandizement.

Whenever a woman does succeed in breaking into politics, at least at the national level, she is a member of a minority. Organizations are often tough for members of minorities to navigate. For example, it can be harder to get information and learn the ropes.

As a member of a minority, a woman in politics is also very visible. There may well be different standards for her behaviour. Sexual activity that would be tolerated or overlooked in men is likely to be frowned upon in women. Worse still, women are more likely to be in danger of sexual harassment and even assault in almost any social environment.

Why are there so few women in politics? It's probable both that systematic barriers tend to screen women out and also that politics is not attractive to many women. As long as political life is defined by the men who dominate it, it may continue to be hostile to women.

March 3, 1997

Now We Need a Ban on Bad Smoking-Ban Arguments

When Toronto introduced a ban on smoking in all its restaurants and bars, scores of indignant objections were registered by smokers and non-smokers alike.

What was striking was how weak their reasoning was. There may be good arguments against the smoking ban, but so far no one appears to be producing them.

Here are some of the bad arguments against the smoking ban that I've heard.

1. Non-smokers who patronize smoke-filled bars do so by choice. If non-smokers want totally smoke-free restaurants

and bars they can refuse to patronize those that allow smoking. What's wrong with this argument? Well, if the only bars are the smoke-filled ones, then non-smokers have no real alternative: they can either go to smoke-filled bars or stay out of bars altogether. That isn't much of a choice.

That brings us to the next bad argument against the smoking ban:

2. If there's sufficient demand for smoke-free bars and restaurants, then the market will supply them.

It's a funny thing, but the market hasn't supplied them so far. Despite the fact that non-smokers are in the majority, it's definitely not the case that a majority of restaurants and bars are smoke-free. The notion that the market smoothly adjusts to the wants of consumers is a capitalist myth.

3. Employees at bars and restaurants should know that smoke is one of the features of their jobs.

But, in light of the known risks of secondhand smoke, it's hard to understand why employees of restaurants and bars should be required to put up with poorer working conditions than other employees have to tolerate. The issue here is whether smoking is necessary and inevitable in restaurants and bars; the opponent of the smoking ban can't just assume it is.

4. Smoking is legal, so people have a right to smoke, especially in restaurants and bars.

It's true that smoking is legal, but it doesn't follow from this that people have a *right* to smoke in any strong sense. If there is a right to smoke, it is certainly not on a par with, for example, the right to health care, the right to vote, or the right not to be discriminated against on grounds of sex or race.

In addition, even if an activity is not illegal, it does not follow that I have a right to indulge in it anywhere I please. Think of an activity like racing formula one cars: It's legal, but I don't have a right to do it just anywhere and under any circumstances I choose. Or hunting: It's legal, but there are lots of restrictions on it.

Bad argument number four is closely related to argument number five.

5. The owners of bars and restaurants have a right to decide what activities will be allowed on the premises they own.

This is false. There are appropriate legal limits on what owners can do. A restaurant owner cannot decide to flout public health regulations governing the quality and sanitation of the products he or she serves. Even when certain activities are entirely legal, restauranteurs and bar owners may not be able to permit them on their premises. Examples include gambling, sex, fighting, and bringing in animals other than guide dogs.

6. In the hospitality industry the wishes of the clientele come first.

Not always. There are limits on how much alcohol servers can sell to a drunken patron. And customers asking to be served substances like unpasteurized milk, uninspected meat, or hash brownies will not find their wishes being complied with.

7. Restaurants and bars are for socializing; people need to be able to smoke to enjoy themselves.

It's false that all people need to smoke to enjoy themselves. Non-smokers manage to have fun without smoking. And even smokers are not necessarily smoking every single second.

Yet since some people do need to smoke to enjoy themselves, this is an argument for creating distinct, separately ventilated rooms

for smokers, which is precisely what the Toronto bylaw allows.

And that brings us to the last bad argument:

8. The anti-smoking lobby has gone way too far. They're killing a mouse with a sledgehammer. After all, smoking in restaurants and bars isn't particularly important.

This argument is naive as well as bad. Cigarette smoking kills people. Secondhand smoke harms the health of employees and non-smoking patrons. Allowing smoking in bars and restaurants gives the message that smoking's okay; maybe it even conveys the idea that smoking is part of good times. Smoking in public places is significant — and it's worth preventing.

I'm not saying there are no good arguments against the Toronto smoking ban. I'm just saying none of these arguments are any good. If anyone wants to claim the anti-smoking bylaw is a mistake, they'd better come up with something better than this.

March 17, 1997

Will Sexualizing Women's Bodies Ever End?

On a hot day in the summer of 1991, a woman named Gwen Jacobs took off her shirt and walked topless down a street in Guelph, Ontario. She believed there should be no legal difference between her situation and that of a man who takes off his shirt.

Jacobs was charged with and convicted of indecency. But in December 1996 the Ontario Appeal Court quashed her conviction, saying there was nothing degrading or dehumanising in what she had done.

Nonetheless, an official in Cambridge, Ontario, declared that Cambridge would continue to require women to cover their breasts. Cambridge citizen Fatima Pereira Henson then took up the challenge: she went swimming at a public pool without a swim top. A lifeguard asked her to put on a top. When she refused she was charged with trespassing.

Is this issue a straightforward matter of equality? Are women's breasts just like men's, as Henson and Jacobs claim?

The answer is no; it's a mistake to say there are no differences between women's and men's breasts. Aside from the obvious dissimilarities in size and shape, there's the crucial difference that women's breasts are capable of suckling an infant whereas men's are not.

But are these differences sufficient to justify the existence of laws preventing women from shedding their shirts?

Some people claim that women must be legally compelled to stay covered to avoid "offending" onlookers.

Why would anyone be offended by a normal and healthy part of the female body? The answer may be because that part of the body is usually kept covered. But if women's breasts were exposed more often, then people would get used to seeing them. This seems to be the operative principle on some beaches in Europe, where toplessness is not unusual.

More likely what people are getting at when they claim to be offended by bare breasts is that women's breasts are intensely sexualised. In this culture, female breasts are almost exclusively seen as sexual objects.

The question then is whether the law should cater to and reinforce this sexual perception of women's bodies. In this respect civil dissidents like Gwen Jacobs are, I think, justified. They're correct to complain about the sexualising of women's bodies. Whatever the context, the exposure of female breasts is inevitably a sexual event, and women have no control over being perceived this way.

Consider the fact that the Cambridge town council has now adopted a bylaw requiring females to wear a swim top at municipal pools. The new law exempts only girls aged five and under. This exemption suggests either that Cambridge councillors are under the impression that girls grow breasts at age six, or that they regard all girls age six or older as potential sex objects.

Even breastfeeding is perceived as a sexual act. In British Columbia a woman named Michelle Poirier was ordered not to breastfeed her daughter in her office during her lunch hour because some people were offended. One worthy citizen described breastfeeding in public as "repulsive."

Imagine: A mother's loving nourishment of her infant is considered "repulsive." If anything indicates the nature of misogyny in this culture, that opinion does.

Some may argue that women must be compelled to cover their breasts because if they do not they are endangering themselves. Just as women who wear short skirts or tight shirts are sometimes thought to be permitting sexual aggression, women who go topless might be seen as inviting attack.

But that argument assumes, falsely, that men cannot control their sexual and aggressive urges. It also fails to place responsibility where it belongs: on men who regard women as sexual prey. Whatever they wear, women do not forfeit their entitlement to be free from assault. If Gwen Jacobs and Fatima Pereira Henson were ever in danger of being attacked, then there must be more efforts to protect women from predatory men.

It seems likely that despite the precedent set by Jacobs's case, most women will not choose to expose their breasts. And that's probably wise. If some do, they need to be aware of the possible dangers, and also aware that their breasts will automatically be sexualised.

But if a woman chooses to shed her shirt on a hot day when men are doing the same, I don't see why the woman's act should be against the law. I oppose criminalizing this behaviour when it is not criminal for men.

Even more important, if a woman chooses to breastfeed her infant when she is at a shopping mall, a train station, her office, or a public park, she should not encounter any restrictions, whether in the form of anti-toplessness laws or in the guise of public disapproval from those who profess to find female breasts "repulsive."

April 21, 1997

Women's Role is Still a Matter of Contention

A STUDY released this month by Statistics Canada suggests that Canadians are "torn" and "ambivalent" about the role of women. Specifically, Canadians have mixed feelings about women's work in the home and outside the home, and about whether caring for small children should take priority over women's paid work.

In the study, 68 percent of men and 73 percent of women agreed that both men and women ought to contribute to household income. Sixty-four percent of women also said that it is important or very important to their happiness in life to be able to take a paying job.

But women do paid work for a variety of reasons. For many it is a matter of sheer economic need. And some women may fear that leaving the workforce while their children are young will compromise their capacity to obtain paid work later. They worry that they won't be able to compete, that their qualifications will be outdated, that they will fail to accumulate job experience, or that they will be unfairly perceived as unreliable for having a hiatus in their work career.

In some cases, where a double income provides luxuries, families may get used to having the things those incomes can buy. It's hard to imagine cutting back to a point where some of the good things the family has taken for granted have to be eliminated.

Other women do paid work because they don't find the life of the stay-at-home mother sufficiently fulfilling. Some women are in the workforce because their paid work is so interesting they could not do otherwise.

But the StatsCan study reveals that while a majority of Canadians think women have a responsibility to contribute to household income, 59 percent of men and 51 percent of women believe that preschool children suffer if both parents are employed.

There might be some basis to this view, if only because many

parents are working so hard and are so stressed that the family's psychological resources are stretched to the limit and beyond.

But it does not follow that all mothers should stay at home with their children.

I suspect that many women themselves are ambivalent about this. Some women who have done paid work throughout their children's early years may wish they could have been at home for more of the time. Some women who have been full-time mothers for years may wish they could have had at least some paid work.

There's no doubt that mothering is valuable. But it seems highly unlikely that mothers must be present every single hour of their children's lives. In the StatsCan study, 59 percent of men and 67 percent of women agreed that an employed mother can have a warm relationship with her children.

And there is no reason to suppose that all nurturing must be done by women. A loving and attentive father is just as good as a loving and attentive mother. In fact, a loving and attentive father is probably better than a mother who wishes she were not at home with the kids.

Moreover, there's plenty of evidence to suggest that children do fine in good daycare. Both good paid providers and good parents can equally give a healthy start to their children.

Similarly, bad care is bad care, whether it is given in a group situation by paid daycare providers, or it is provided by the child's own parent.

How to care for the children is a hard decision to make, and many parents might be happier with opportunities for balance: more time to spend with their children, while maintaining some paid work.

Unfortunately, in many cases two incomes in the family barely pay for shelter, food, clothing, utilities, and transportation. For these families, to have a parent in the home caring for the kids would be a luxury they cannot afford.

In addition, people often face an all-or-nothing situation: They must either do paid work full-time (or even, in these downsized days, more than full-time, as people are forced to do the work of

fellow workers who have been eliminated or have taken early retirement), or they don't get to do paid work at all. The part-time work that is available is often very poorly paid and insecure, with few benefits and erratic hours.

The question is whether work needs to be structured in this way. Canadians need more secure opportunities for work-sharing, and more part-time jobs that are not dead end and poorly paid, with few or no benefits.

But the last thing this country needs is a return to the '50s culture that said that a woman's place must be in the home.

September 29, 1997

Latimer Had No Right to Kill His Disabled Daughter

On November 5, 1997, Robert Latimer was found guilty of second-degree murder in the killing of his disabled daughter Tracy, a twelve-year-old who was born with severe cerebral palsy.

The Latimer case provoked divided reactions. Disabled persons and their allies insisted that Latimer must be found guilty and punished. On the other hand, many advocates of legalized euthanasia regard Latimer as a hero.

But those who reject the guilty verdict in the Latimer case may be confusing a number of quite distinct moral issues.

The first issue is the deliberate killing of a human being. Here, organizations on behalf of disabled people are surely right to point out that the fact that Tracy Latimer was disabled should make no difference to our assessments of Robert Latimer's actions. The fact that a person is disabled does not morally justify murdering her. In fact, if this killing had been sanctioned by the courts, there would be good reason for people with disabilities, elderly and infirm people, and sick children to live in fear that others might take their lives with impunity.

The second issue is Tracy Latimer's physical condition and its implications. Whether or not she was in severe, unremitting pain, whether or not she was suffering, and certainly whether or not she was a burden to her family is irrelevant to the question of whether her father was justified in killing her. Tracy's condition does not mitigate the wrongness of what Latimer did. Robert Latimer was not entitled to make the decision to take her life.

The third issue is Latimer's intentions. It's possible Latimer was motivated by the wish to get rid of a burdensome responsibility. Certainly his initial lies to police about how Tracy died could indicate self-interested motives.

Yet most accounts suggest his motives were positive. At his trial, claims were made that he is a kind, loving father, devoted to his

family. His legal defence explained the event as an act of mercy killing. He very likely believed that his little girl was suffering severely, and that by killing her, he was helping her.

But his intentions are irrelevant to the moral question of whether or not it was permissible to kill her. However benign his motives, he did not have the right to kill his daughter.

The fourth issue is Robert Latimer's sentence, and here the problem gets even more complex. Punishment may be justified by its role in deterring others, in reforming the criminal, or in protecting society. Latimer's second-degree murder conviction carries with it a mandatory minimum of ten years in prison before eligibility for parole. Yet the jury that convicted him recommended a sentence of only one year in prison before parole, and they had good reasons to do so.

Latimer has violated one of the most important social taboos. He cannot be permitted to avoid punishment. Failure to punish him would send a deplorable message to this nation: that although most killing is wrong, killing disabled persons is not. Insofar as punishment has the function of deterring others from committing comparable crimes, it is essential that Latimer be punished.

Perhaps punishment also has a reformative role to play in Latimer's case — Latimer needs to learn that he was deadly wrong to take the matter into his own hands.

At the same time, all the evidence suggests that this man is in no way a danger to society. He is not likely to be violent towards anyone else. Insofar as punishment has a protective role for society, it is probably not needed in this case. Moreover, Latimer is the father of other children, who will sorely miss their parent if he is in prison for a long time. It would seem that the consequences of a lengthy punishment for Latimer could be very bad in terms of the effects on his family. For all these reasons, a short sentence would be appropriate.

The fifth issue in the Latimer debate is euthanasia. I agree with people with disabilities who say that the Latimer case has nothing to do with euthanasia. That is, the jury's decision that Latimer was guilty of second-degree murder implies nothing about whether

euthanasia, within properly constituted circumstances, might sometimes be warranted. As a society, we may need to recognize that a competent individual has the right to decide to end his or her own life, and may need medical assistance to do so. But Tracy Latimer was not competent to make that decision, and Robert Latimer was not entitled to unilaterally make it for her.

Although Latimer's motive was mercy killing, and although mercy killing, at the request of a suffering person who is competent to make the decision, may sometimes be justified, Latimer was in no way designated or entitled to kill his daughter.

November 17, 1997

We Need More Ways to Protect, and Empower, Young Women

LAST MONTH, fourteen-year-old Reena Virk was cruelly beaten and left to drown at a waterfront park in Victoria, British Columbia. Eight teenagers aged fourteen to sixteen, seven of them girls, face charges connected to Reena's death, ranging from aggravated assault to second-degree murder.

This month Paul Bernardo is appealing his designation as a dangerous offender and is seeking to have his murder convictions overturned. Bernardo was responsible for torturing and killing teenagers Leslie Mahaffy and Kristen French, with the assistance of his young wife, Karla Homolka.

And on December 6 we commemorated the 1989 deaths of the fourteen young women who were murdered at Montreal's École Polytechnique by Marc Lépine.

People disagree as to how to interpret these events. For example, was the Montreal Massacre the result of a random set of acts by a lunatic? Or was it instead a symptom of misogyny and anti-feminism taken to their "logical" conclusion in the murders of young women studying engineering, a traditionally male field?

Was Karla Homolka the victim of an abusive and vicious man who co-opted her into participation in his unspeakable crimes? Or did she collaborate willingly in the sexual torture and murder of Bernardo's young victims, and then clean up the evidence?

Is the participation of seven girls in the death of Reena Virk the senseless behaviour of a small number of kids on the fringes of society? Or does it indicate a growing propensity for violence and anomie among teenage girls?

I have struggled to make sense of these events, both as a feminist and also, perhaps more personally, as the mother of an adolescent girl.

I don't subscribe to the view that all women are necessarily victims. Nor do I believe women are incapable of participating in vicious crimes. Women can both kill and be killed. In that respect they are no different from men, though women are still much less likely than men to engage in violent crime.

I also believe that while many girls are getting the message that they are free to be whatever they wish, others continue to see their destiny only in terms of acceptance by their peer group and linking their lives to a man. Some girls are working to be engineers, athletes, or musicians, while others hope to manipulate their sexuality to buy acceptance and love. While some see personal power as the choice to learn and to become what they wish, others interpret personal power in terms of brute force and mindless violence. Instead of embracing an autonomous sense of equality, some girls are getting the message that equality means being free to be as predatory as males have often been encouraged to be.

But while only a tiny fraction of women are killers, all women are vulnerable to violence, assault, and murder. As the mother of two children, I am more fearful for my daughter than for my son. As children both were equally vulnerable, but that was no longer the case as they moved into adolescence. My son is taller and stronger than his sister, but most of all he has the simple advantage of being male in a society where being female is made into a type of disadvantage.

I tend to be more protective of my daughter than of my son. This may seem sexist, and I deeply regret that it is necessary. I don't think it is sexism on my part, but rather my awareness of the dangers to and constraints on a young girl that result from living in a sexist society. The fact is that my daughter is likely to be regarded as prey in the eyes of sexual predators whereas my son is not. This does not, of course, mean that my son is invulnerable, or that violence cannot touch his life. But it does mean that by virtue of his sex, my son is likely to have more freedom and a greater capacity to control his life than my daughter has.

As a mother I am outraged that girls and women are still so vulnerable to assault. As a feminist I am appalled that some girls and

women are becoming more violent without becoming more powerful. As a feminist and as a mother, I believe we need to find more ways both of protecting and of genuinely empowering young women.

December 15, 1997

Update

For their roles in the attack on Reena Virk, six girls aged between fourteen and sixteen were given sentences ranging from sixty days' conditional custody to one year in jail. The girls were all tried as young offenders. Warren Glowatski, aged eighteen, the only male charged, was tried in adult court and found guilty of second-degree murder in Reena's beating and drowning. He received a life sentence with no chance of parole for seven years. Kelly Ellard, seventeen, was also tried on a second degree murder charge and received a life sentence. She will serve a minimum of five and a maximum of seven years before being eligible for parole.

Paul Bernardo, who is serving two concurrent sentences for the first-degree murder of Leslie Mahaffy and Kristen French, has been entirely unsuccessful in his quest to have his designation as a dangerous offender dropped and his convictions overturned. Most recently, in the spring of 2000, he lost an appeal of his 1995 convictions when an Ontario judge threw out the case without even hearing from the Crown.

Mother of Septuplets Faces Difficult Road Ahead

CHRISTMAS IS A time when practitioners of the Christian faith celebrate what they regard as the most important birth in human history.

As a result, this time of year serves as a reminder of the joys and terrors of embarking on parenthood. Childrearing, viewed in advance, is a mysterious and daunting process, and the decision to have a child is a decision to become vulnerable for the rest of one's life.

Bobbi and Kenny McCaughey might be forgiven for feeling especially vulnerable around now. They're the parents of the unique and precedent-setting septuplets, four boys and three girls ranging in weight from 3 lb. 4 oz. to 2 lb. 5 oz., who were born in Des Moines, Iowa, by caesarean section on November 19, 1997.

Some people interpret the seven infants as the reward for the McCaugheys' Baptist faith. "Any child is a gift from God, no matter whether it's one at a time or seven at a time," says Bobbi McCaughey. But it's hardly surprising that, while all of us are said to be God's children, when it came time for God's Son to be born, there was only one of Him. He did not have six siblings.

Ms. McCaughey says she and her husband experienced "sheer terror" when they learned she was expecting seven babies. How will they cope? Kenny McCaughey says, "We're just trusting in God."

This faithful acceptance of God's will contrasts interestingly with the interventionist approach taken by the medical profession in treating Bobbi McCaughey's infertility problems. Before the conception of the septuplets, the McCaugheys were not childless. They already had a daughter, Mikayla, herself the result of fertility drugs administered to her mother. When Bobbi McCaughey had difficulty becoming pregnant a second time, she was given more drugs to induce ovulation. Instead of passively accepting infertility, the McCaugheys resorted to a medical treatment that was spectacularly successful.

Multiple births are more common now than they were prior to the invention of high-tech fertility procedures. The identical Dionne quintuplets created a worldwide sensation when they were born in 1934, for they were the first quintuplets in the history of humanity to survive past infancy. The McCaughey septuplets are part of a growing number of late twentieth-century multiple births resulting both from the administration of fertility drugs and from the use of in vitro fertilization, which involves implanting several fertilized eggs into the patient's uterus.

Unlike the Dionnes, the McCaugheys are not all identical, that is, produced by the splitting of one egg. Since the septuplets include both boys and girls, they must come from at least two fertilized eggs, and probably more. Another potential difference from the Dionnes is that they are not likely to be exploited as the quintuplets were.

The Ontario government put the Dionnes on year-round display as a tourist attraction, as if the five pretty little girls were exotic zoo animals. Although the McCaugheys are unique, multiples are now common enough that they have some hopes of growing up without enormous public attention. I notice that in the doll section of local stores it's possible to buy not only twin dolls, but also triplet dolls and even quintuplet dolls. The idea is that it is more and more normal to raise multiples.

I'm a little surprised to find that retailers are not pushing septuplet dolls for Christmas 1997. But perhaps the doll industry is waiting to be sure all seven of these babies survive. The infants were born prematurely, at thirty-one weeks, and prematurity often has dangerous consequences for babies.

I have to wonder what life will be like for the members of this family. Kenny McCaughey, age twenty-seven, is a billing clerk at an automobile dealership, and Bobbi McCaughey, twenty-nine, is a seamstress. Even with free Pampers, a new house provided by local businesses, and a steady stream of donated baby quilts, toys, and pacifiers, this family is facing years of potential money problems.

And what about the psychological stresses of caring for seven infants? The experience would be like running a permanent, 24-hour-a-day childcare centre in one's own home. Consider the

sleep deprivation, the marathon feeding and diaper-changing sessions, and the non-stop labour just to ensure that the babies have clean clothes and cooked food.

Caring for even one newborn is hard enough. A friend told me she had always wanted to have twins — until her first child was born and she saw how much work just one baby demands. Now multiply those demands by seven.

After the birth, US President Clinton reportedly said to Bobbi McCaughey, "When those kids all go off to school, you'll be able to get a job running any major corporation in America." That's an old story, that motherhood is just as demanding as running a business and is respected just as much. But in practical fact, Bobbi McCaughey faces fifteen to twenty years of the most intensive caregiving that any mother in human history has ever experienced. And she'll never be paid like a corporate executive.

Throughout her life as the mother of eight, I hope her faith in God will help to sustain her. She's going to need a lot more support than just donated diapers.

December 22, 1997

UPDATE

Infertility treatments greatly increase women's chances of having a multiple pregnancy. Fifteen to 17 percent of all multiple births result from infertility treatments. But it's estimated that 60 percent of triplets, 90 percent of quadruplets, and 99 percent of quintuplets result from these treatments. Patients undergoing in vitro fertilization are ten times more likely to experience a multiple birth than women without IVF.

Bobbi McCaughey's septuplet pregnancy resulted not from IVF but from the use of an infertility drug. All seven of her babies — Kenneth, Alexis, Natalie, Kelsey, Brandon, Nathan, and Joel — survived infancy, although two of them, Nathan and Alexis,

experienced some medical problems. All of the children are said to be developing at a normal pace for preemies. The parents have issued a CD and have agreed to endorse some commercial products in order to earn enough money to support their family.

Storing Onions in Pantyhose the Least of Women's Concerns

ALONG WITH the comics in the newspaper, I often read "Dear Abby" and "Hints from Heloise." Ironically, I seem to get the least practical value out of Heloise. At least the comics afford a few minutes of entertainment, and Abby provides thirty-second solutions to the (apparently) real life problems people get into.

But Heloise's hints seem to belong to another dimension altogether. Who could possibly use her suggestions?

Here's a recent one, on the burning issue of how to use old pantyhose. Heloise suggests, "Use for storing onions. Tie each one separately with twist-ties, and when you need an onion, just snip one off the bottom."

What planet is Heloise living on? First of all, would anyone really feel good about eating onions that have been stored in old pantyhose? Even if the pantyhose has been washed, I doubt that I'd care to eat dinner with someone who stores her vegetables in her castoffs.

Second, who on earth has the time to thread onions into pantyhose and tie each one separately with a twist tie? If I had so much spare time on my hands I'd be better off learning to do something useful like knitting or rug-hooking.

And third, if you followed Heloise's hint, just what would your kitchen look like? Would you attach the onion-filled pantyhose to the ceiling? Drape them from the top of the fridge? Prop them in a corner? If you're going to store onions in old pantyhose, why not knot each leg of a worn-out pair of jeans and use them to hold potatoes? Or maybe the economical householder could stow delicious apples in the cups of old brassieres.

I don't think "Hints from Heloise" should be so impractical. There are lots of challenges in contemporary life for which citizens

might benefit from a well-directed hint or two. For example, I could do with a tip about how to prevent the cats from leaving cat hair all over the house. Or how to get the kitchen scraps out to the composter when the snow is too deep to walk in the backyard. Or how to keep the fridge filled when there are teenagers in the family. Or how to find the two socks (each a different colour) that are missing after each laundry.

Or maybe Heloise could take on the truly serious issues. There are a lot of topics on which women would welcome some hints. For example, women need practical tips on how to ensure that they earn the same amount as men for work of equal value — especially when not even our federal government is willing to honour the principle of pay equity. Some women need tips on how not to bump their heads on the glass ceiling — and how to go on smiling when men are promoted and they are not. Lots of women would benefit from suggestions on how to combine full-time paid employment with childrearing — without burning out.

Women might welcome some tips on how to enjoy their sexuality, while also protecting themselves from unwanted harassment and attacks, and avoiding sexually transmitted diseases. How about some hints on raising children so that they are self-confident and strong, but also aware of the sexual predators who threaten their safety?

Lots of women need tips on withstanding pressures from the media and advertising. I mean hints for recognizing the propaganda suggesting that thin is good, thinner is better, and that women should starve themselves to obtain the "right" look. Some women need tips on coping with eating disorders and learning to eat well, exercise, and enjoy their bodies.

In today's lean-and-mean political climate, some women need ideas about how to survive now that social welfare payments have been drastically cut. Some single mothers could use ideas on how to do the impossible: make their skimpy food budget last the whole month, or pay for new shoes for their kids.

Shorter hospital stays and the growing emphasis on home care almost always mean that women do extra work. So, as the health

care system continues to be cut back, many women will need hints on caring for aging or sick or disabled family members.

And what about women with disabilities? Or elderly women, women with health problems, any women who do not fit the standard model for womanhood. What about lesbian and bisexual women, women of colour, women who have to face discrimination and disdain because they are not heterosexual, not white, not young enough, not thin enough or sexually available enough? Surely these women could use some hints on how to survive and thrive.

Let me know when Heloise, or someone else, is providing "hints" for handling the challenges of an inequitable society. Maybe "Dear Abby" could take on this stuff. She could call it "Putting Up With Patriarchy."

In the meantime, I won't be storing any onions in old pantyhose.

March 22, 1999

The Cultural and Racial Pitfalls of In Vitro Fertilization

NEW REPRODUCTIVE and genetic technologies appear to create many opportunities for infertile women.

For example, using the technology for freezing or cryopreserving embryos, it is now possible to give birth to twins who are born years apart. A woman who has undergone in vitro fertilization can have some embryos implanted immediately and others frozen for implantation later in her life. She can also serve as a so-called "surrogate" mother by gestating an embryo generated from the gametes obtained from another woman and man.

She can even become, simultaneously, both the mother and the grandmother of a baby, by gestating her own daughter's fertilized egg. And if her relationship with her male partner ends, then she may, like at least one American couple, find herself in a "custody" battle concerning the possession of frozen embryos.

Whether all these opportunities are a blessing is debatable.

Donna Fasano and Deborah Perry-Rogers are two women who have each had years of problems with infertility. Separately, and unknown to each other, they sought help at a fertility clinic in Manhattan, where each went through in vitro fertilization. Deborah Perry-Rogers did not become pregnant, but Donna Fasano became pregnant with twins.

Some weeks after their separate visits to the clinic they were informed that a mistake had been made. Their doctor, Lillian Nash, had transferred into Ms. Fasano's uterus not only four of her own eggs, fertilized by her husband, but also several other fertilized eggs derived from Ms. Perry-Rogers and her husband.

Probably lots of mothers have worried that their newborn babies might be switched in the hospital. But now the possibility exists that women's fertilized eggs could be scrambled.

As if this story were not already complex enough, there is one further ingredient. Ms. Fasano and her husband are white; Ms. Perry-Rogers and her husband are black. And when Ms. Fasano gave birth to her twin boys, one turned out to be white and the other turned out to be black. DNA tests have established that Ms. Fasano is the biological mother of the white baby but not of the black baby.

This story demonstrates several aspects of western cultural attitudes toward reproduction. First, a genetic link with one's offspring is regarded as paramount, indeed, virtually essential. North Americans want children who are biologically related to them, and they will go to extraordinary lengths to obtain such children.

Second, in a culture where race and colour are central determinants of status, racial congruence within the family is considered highly desirable. So, for example, when women whose male partners are infertile seek artificial insemination with donor sperm, medical clinics virtually always attempt to "match" the race of the donor with the race of the recipient. Very few couples, it seems, want babies who are of a different colour than themselves.

The Rogers have filed a lawsuit that seeks custody of one boy and claims negligence, malpractice, and breach of contract on the part of the doctor who treated the two women. And in response the lawyer for the Fasano family has announced that the Fasanos will give up the black twin to Ms. Perry-Rogers, provided that DNA tests confirm that the Rogers are the biological parents of the boy.

Ms. Fasano says, "We're giving him up because we love him." Yet this situation makes me uneasy.

Maybe giving up one twin *is* an extraordinarily altruistic act on the part of the Fasanos. Certainly transferring this child is likely to make Ms. Perry-Rogers and her husband happy. And if the relocation takes place early enough, the boy may not experience any psychological repercussions resulting from his transfer from one couple to the other.

But although this child is not the product of Ms. Fasano's egg and her husband's sperm, he is the creation of her body. I can't help wondering whether Ms. Fasano has an important bond with this baby through her pregnancy with him and the first few months of

his care. The boy is not "hers" in the sense of being biologically related to her, yet he is hers by virtue of her close physical ties to him.

In which family does this child belong? Both race consciousness and the emphasis on a genetic link may have influenced the situation.

I also wonder whether the Rogers will want this twin just as much in the future as they do now, if DNA tests were to show that the scrambling of eggs is even more extensive — if, that is, the baby turns out not to be genetically related to them either. Reproductive technology may have made the black twin a potential orphan.

And would the Fasanos find it more difficult to surrender this child if he, like their other son, were white?

April 12, 1999

Whites and "Straights" Have No Need to Hold Pride Marches

WHAT'S WRONG with this picture?

A few weeks ago this newspaper reported that a man in London, Ontario, planned to hold a "straight pride" parade, to coincide with his city's annual Gay Pride parade. Raphael Bergmann claimed he wanted to "let the public know there are people in this community who believe in family values."

I'm reminded of those neo-nazi groups that proclaim their "white pride," in defiance of the movement by people of colour to reclaim pride in their own races and skin colours.

I think these assertions of white pride and straight pride are wrong. But what makes them wrong?

It's fine, I think, to be proud to be an individual who happens to be white or happens to be heterosexual. In saying that demonstrations of "white pride" or "straight pride" are wrong, I am not saying that being white or being straight is something to be ashamed of.

Of course, it *is* something to be ashamed of if a white person thinks his skin colour makes him a better person, or if he uses his skin privilege to get advantages not available to people of colour. And it is something to be ashamed of if a straight person is homophobic, or assumes that heterosexuality is inherently better.

But as a matter of personal characteristics, of course it's fine to have white skin. It's fine to be sexually oriented to members of the other sex. These things just happen to be the characteristics of many people, just as having brown or yellow or black or beige skin, or being gay or lesbian or bisexual, is characteristic of many other people.

In a truly rational and liberated society one's skin colour and sexual orientation might have historical or cultural significance. But

they would have no further significance for political rights and freedoms, for one's safety and well-being, or for access to jobs, housing, a good education, and a happy and fulfilling life.

But if it's fine to be white or to be heterosexual, is there any need, in our society as it is now, for whites as a group or heterosexuals as a group to claim pride in their skin colour or sexuality?

I say no, because to be white or to be heterosexual is to be a part of the dominant, mainstream groups in this culture. Representations of heterosexuality and of whiteness are everywhere. We who are heterosexual take for granted that the standard images in movies, videos, TV programs, popular songs, musicals, and advertising in all media will be of heterosexual attraction, romance, love, and sexual connection.

We who are white are able to live without any race consciousness, to live as if we did not have a race at all, because to be white is to be the standard kind of human being in this culture. To be any other colour is to be typecast as a member of a race, rather than, as the white person is, to be considered merely an individual.

Under these circumstances, where being white and being heterosexual have never been a disadvantage, where we gain everyday privileges from belonging to the dominant group, there is no need for a pride parade for white or straight people.

Whites and straights are already overflowing with pride; in fact, we're downright conceited, because we tend to assume that we are the way human beings should be. That's why the real meaning of a "straight pride" parade is an anti-gay message. And "white pride" is deeply threatening to people of colour because it is an assertion of white dominance and superiority.

By contrast, people who are lesbian, gay, bisexual, or transgendered have been subjected to cultural invisibility or to horrid discrimination, from everyday taunts and insults to outright violence. And people of colour are routinely subjected to blatant or subtle racism almost every day that they live within white culture. People who are not heterosexual or who are not white are categorized by often-vicious stereotyping, merely by virtue of their skin colour or their sexuality.

So, it makes sense for outsiders to the white, heterosexual mainstream to assert their pride in who they are, to stand up and make themselves visible by choice. It is a way of saying that being gay or being black is not a matter of shame. It is also a way of combating stereotypes that are affixed on the basis of group identity.

I think the guy in London who wanted to hold a straight pride parade must be far too worried about his own sexuality. If he were really confident in and proud of himself, he would not need to proclaim his sexual privilege in a parade.

July 26, 1999

UPDATE

Regrettably, "straight pride" is a questionable "cause" that isn't going away. The Internet even offers straight pride T-shirts for sale.

And concurrent with the huge twentieth annual Pride Parade held in Toronto in June 2000, about fifty participants held a "Straight Pride Stride" event. One organizer stated that they came "to celebrate that we have a right to be straight."

They do indeed. And unlike the right to be gay, lesbian, bisexual, or transsexual, no one has ever challenged it.

From the Philosopher's Heart

Introduction

MANY YEARS AGO, when for the first time I enrolled in a philosophy course, I was thrilled to find the professors talking about topics — morality, meaning, truth — that I had been thinking about privately. Until that point I had believed I was a little weird to be so passionately interested in these subjects.

Philosophy has a bad reputation. A lot of people think of it as dry, abstruse, unrelated to everyday life, and so theoretical and difficult as to be incomprehensible to ordinary mortals. The reality is that philosophy can be thought provoking and challenging.

Philosophy is an intellectual discipline, but it is not merely cerebral. Good philosophy comes from caring about what you think and write. Good philosophy engages the heart as well as the mind, our feelings as well as our thoughts.

Philosophers may have very different methods and a variety of interests, but I think all philosophers share three characteristics.

First, philosophers are ready to question fundamental assumptions that are ordinarily taken for granted — assumptions that, for example, underlie religion, ethics, knowledge, politics, and science. Second, philosophers are committed to developing arguments for their beliefs. In this context, "argument" does not mean a disagreement or dispute. An argument is a set of reasons that are carefully put together to provide evidence for a conclusion. Finally, philosophers are willing to consider counter-arguments, that is, arguments that present the other side, and to revise their views if the evidence warrants it.

As I indicated in the Introduction to this book, I believe that philosophical thinking is for everyone. We all have the hearts of philosophers, for as human beings we all have an interest in what is true and what is good. In this final section of *Thinking Like a Woman*, I offer you my own thinking "From the Philosopher's Heart."

The Little Things

YEARS AGO as a young child attending an Anglican Sunday school I was repeatedly told that "God sees the little sparrows fall." Those words were partly intended, I believe, to be comforting to us eight-year-olds, who often had to deal with fear, loneliness and isolation as much as any adult does, and who might well have been reassured by the thought that God was watching out for us.

For me, however, the notion that God had his eye on me was no more helpful than the earlier belief I'd had that Santa Claus "sees you when you're sleeping, he knows when you're awake." I didn't care for the idea of being constantly watched, of having no privacy from beings much more powerful than I, and above all of never being able to get away with small sins and peccadilloes. To me God just seemed like a too observant, never-sleeping schoolteacher.

Partly because of these feelings it was a great relief, one decade later, to abandon belief in an all-seeing God. Now, perhaps, I could have my privacy back; I could be truly anonymous. What I, one small person, did or said didn't much matter after all.

Lately, however, I've been thinking again about those sparrows. I looked in my old copy of the King James Bible, given to me on my ninth birthday, for the origin of that Sunday School teaching about sparrows: "Are not two sparrows sold for a farthing? And one of them shall not fall on the ground without your Father. But the very hairs of your head are all numbered. Fear ye not therefore, ye are of more value than many sparrows" (Matthew 10: 29-31).

I don't accept the speciesism of the last line: I'm no longer very convinced that some kinds of living beings are inherently more valuable than others. But I am drawn, more strongly than I once was, by the idea that human beings, what happens to us and what we do, genuinely matter.

Most of the time we're told that we don't matter much. Our relatives may love us, a few friends may care, but beyond our small

circles we're of little significance. What we do doesn't make much difference. We don't have much effect on the world. We can't change things.

Although most children originally have a tremendous faith in their own capacities and talents, they are systematically taught that their ideas are not worth listening to and that their efforts amount to little. These opinions are reinforced in adults — especially in women, in working-class people, and in people of colour, all of whom are encouraged to undervalue their own abilities and influence.

After years of being subjected to the belittling and undermining of their plans and hopes, many people are left with little sense of their own value. Through the operation of internalized oppression, people often perpetuate these ideas, both within themselves and in other adults and in children: "You can't fight city hall." "You can't change human nature." "What difference can I possibly make?" "Nothing can be done about it." "We just have to put up with it." "It's no use complaining."

People who care about what is happening around them and protest against it are often told that they are "overly sensitive," that they should grow a "thicker skin." The implication seems to be that we should go through life feeling numb and being passive: not caring, not reacting, not resisting, above all, not rebelling against "the system." Commitment is embarrassing; concern is inappropriate. We should just live our own lives, get by as best we can, look out for number one, and mind our own business.

I now think that this belief in our own insignificance, our lack of influence, our impotence, is a central component in the maintenance of powerlessness. We live in a culture in which oppression on the basis of race, sex, class, age, ability, and sexual orientation flourishes; in which the objectification and degradation of and violence toward human beings are growing; and in which non-human beings and the rest of the living environment are being destroyed. These conditions appear to exist with the acquiescence of most people — but not because they approve of oppression, degradation, violence, and destruction. In fact, most people want to resist them, want to

make changes, want to work toward a better environment and a better society. Most people's non-activism stems from their assumption that they are unable to do anything to make a difference.

How many times do people say, with respect to some terrible circumstance or event, "I feel so helpless," or "If only there were something I could do." Violent, oppressive, destructive conditions flourish in part because people are too afraid, too timid, too convinced of their own powerlessness to try to change them.

This is not to suggest a conspiracy theory, that learned helplessness is deliberately inculcated by certain persons or institutions. But it is to say that feelings of powerlessness are a core element (though of course not the only element) in the maintenance of existing hurtful conditions.

If the belief that we are helpless to bring about change serves the causes of inequality and social disintegration, then that is a very good reason for rejecting the belief. If the conviction that we don't matter is integral to the perpetuation of the status quo, then the conviction that we do matter may be one key to changing it.

The internalized oppression that says, "What possible difference can I make?" will, of course, resist the adoption of the contradictory idea that each of us can make a difference. So I suggest that we begin by treating this idea as an assumption — not for the sake of argument, but for the sake of our lives. I propose that we all try proceeding on the assumption that what we do does matter, that we can and do make a difference, that we are significant. Assuming that we are powerless has never done us much good, so it's unlikely that assuming we are powerful can hurt us.

The hard part about adopting this assumption will be acknowledging that some of those "small sins and peccadilloes" I referred to above are substantial after all. The litter you toss from the car, the racist remark you make to a friend, the slap you administer to your child — all of them really do make the world a worse place for all of us.

But the good part about assuming that we can and do make a difference is that we can come to see how much and how well we can contribute to a peaceful and just world. Every time you lug

that blue box full of cans, bottles and newspapers to the curb for collection, every time you donate blood or give to the United Way, every time you speak up against a racist or sexist joke, every time you hug your children, every time you ride your bike and leave your car at home, every time you encourage and appreciate fairness and thoughtfulness in others, you manifest your power to change the world.

The "little things" mean a lot. I'm not referring to heroic or spectacular actions but the seemingly ordinary events in human lives: Carrying a mug for your coffee so you don't need plastic cups; signing an anti-war petition; writing a letter to the newspaper in support of pay equity; joining a community environmental action group; giving up smoking; smiling at the neighbour's children; avoiding misogynist language; learning about cultures other than your own; reducing your consumption of meat; reading books instead of watching television; coaching the girls' soccer team; composting your kitchen garbage; deciding not to buy war toys for your children; marching in support of human rights; refusing to cross a picket line; teaching your son how to cook.

Some people will disagree with some of the measures I've included here, and others will have their own lists of "little things" that can mean a lot. The point here is to try adopting the view that each of us, and each of our actions, genuinely counts towards creating the world we live in.

Unlike my eight-year-old self, I no longer believe that God records all our actions in some cosmic accounting book. But I do believe that even if God is not watching the sparrows' fall, human beings can watch them. And not only can we see them fall, we can also nourish them back to good health, and cherish their joyful return to flight.

December 29, 1990

Life Without Television:
The World Offers Us Many Other Enticements

For the past two decades I have lived without television. Actually, that isn't completely true. For a couple of months, about eighteen years ago, I owned a cast-off TV donated by my grandparents, who felt sure that every young student needed one. It received only two rather fuzzy channels. Then Nudnik, my delinquent cat, chewed through the electric wire, almost electrocuting herself and setting my tiny two-room apartment ablaze in the process. I got rid of the TV.

Since that time my television viewing has been confined to overnight visits to relatives or brief stays in hotels, when I mainly see professional hockey or baseball, whichever is in season. And even before I began my TV-free existence, I tended to watch very little. So I belong to a tiny minority of North Americans (probably most of them under six months of age) who have never followed a soap opera, do not have a favourite game show, don't watch talk shows, know nothing about situation comedies, can't see old movies, are not plagued by reruns and don't structure evenings around the tube. In other words, I live a form of life so unusual that some consider it deviant and even subversive.

There is a fairly standard set of reactions to my revelation that I have no TV (a revelation usually extracted to account for my blankness about some TV-related reference). While my choice not to own a TV is not intended as a reflection on others' choice to own one, most people feel compelled to explain the role of TV in their lives.

Response Number One to my confession of TV-less existence is the acceptance stage. "Oh, I understand that," says the acquaintance. "TV is really so bad these days. It's a waste of time to watch it."

When I then admit I have found other activities more worthwhile than TV-watching, Response Number Two is usually forthcoming. This is the denial stage: "Actually, I hardly ever watch

it myself," says the acquaintance. "I seldom even turn it on. I don't know why I don't just get rid of it."

The vehemence of this stage is surprising. Sometimes it makes me incautious enough to advocate tossing out the television. Yet that recommendation always prompts Response Number Three, the attempt to restore cognitive balance: "But there is a lot of good stuff on TV these days," says my acquaintance. "Of course, I don't watch any junk. The science programs are excellent; too bad you didn't see that one last week on whales. And don't you think you miss out on the flavour and immediacy of the news reporting? Radio and newspapers just can't match it."

I'm ready to acknowledge that other media are very different from TV. Indeed, a television-free existence does have one drawback: I suffer from a form of cultural illiteracy. I can't appreciate and often don't even understand others' references to television programs, commercials, actors, announcers, timetables or seasons. My answer to the question "Did you see that show the other night?" is always a conversation stopping "No." My students' attempts to illuminate their opinions by reference to TV-derived evidence don't convince me. And I can't share others' delight (or disgust) in a recent program.

After this admission, my acquaintance will ordinarily administer the coup de grâce: Response Number Four. (Some people go directly to Number Four, perhaps sensing my vulnerability as a parent.) "What about your children? Doesn't it bother them? They're missing out on all those kids' shows."

Most people interpret the absence of a TV as a serious childhood deprivation. Many believe that TV is a minimum necessary element of normal human development, and some appear to construct their sense of self and of what is important in life in terms of their TV viewing. Nevertheless, it is possible for all members of the family, including the children, to live very well without TV. When someone once asked my son what it's like to live without TV, he simply replied, "What's it like to live *with* TV?"

Why don't we have a television? TV ownership is so much the norm that while I am often called upon to account for my lack of

one, TV owners seldom have to explain why they have one. Some people construct interesting hypotheses to account for this lacuna in our home. When he was quite little, my son returned from preschool one day and asked whether we were poor. Even after contemplating our many unpaid bills, I had to tell him, in all honesty, that we were not. Why did he ask? Because a four-year-old friend had informed him that if we did not have a TV it must be because we were poor.

A student laughed when he learned that my household lacked a TV. "Your children will still find a way to watch it," he said scornfully. "You can't prevent them from being exposed to it." Quite true — my children sometimes watch television at the homes of friends and relatives. It's not forbidden to them.

My aim has not been to entirely protect my children, or myself, from exposure to television. While I suspect that a lot of violence, intolerance, unabashed consumption, and stereotypical behaviour is depicted on television, the main justification for having a TV-free home is not so much what television offers as what it precludes.

We are not deprived through the absence of a TV, though in some homes the presence of a TV may be a deprivation. Recent studies show that, on average, Canadians watch 3.4 hours of TV every day. So if a hypothetical Canadian starts to watch TV at the age of two, and continues until death at, say, seventy-seven, this person will have watched 93,075 hours of TV, which is equivalent to more than ten and a half years of an average lifetime.

But the world offers many other enticements, especially for us privileged North Americans. In our household, family life, friends, work and school, books, sports, art, music, drama, writing, politics, and travel, all take precedence over TV.

When I told my daughter I was writing about our life without television, she struck a dramatic pose and suggested a theme: "TV or not TV." Indeed. We have chosen "not TV," because we believe a television-free existence enhances our brief lives on this planet.

July 19, 1991

Avoiding the Smurf Theory of "Women's Issues"

I SPEAK as a woman. But, as an academic, a mother, and a white, middle-aged, middle-class woman, I cannot speak for all women.

One of the insights of feminism is the recognition of how diverse women are. As much as I'd occasionally like to generalize about women (at least partly in the interests of solidarity and political strategy), it is usually both inaccurate and misleading to do so.

There is no such thing as *the* woman's point of view. Yet women in the workplace, especially in jobs and professions where numbers of women are low, sometimes find themselves called upon to represent women, to serve as tokens of womankind, or to put forward the "woman's point of view."

I think of this as the "Smurf Theory" about women. Smurfs are cartoon characters who look like little blue elves. They come in different varieties — one is old, one is smart, one is a cook, one is a builder, one is a practical joker. Interestingly, they are all male, with one exception: There is one female Smurf. Looking at the Smurfs as comic representations of some human foibles, one would never guess that more than 50 percent of all human beings are female. In the Smurf world, to be female is to be just another minority deviation from the youthful male norm.

The Smurf Theory of women is exemplified whenever a woman is expected or expects herself to represent "the woman's point of view." The Smurf Theory regards women as either a subset of Man, or a deviation from the norm constituted by men.

Significantly, individual men are virtually never expected to represent all men or the men's point of view. Even with the recent creation of newspaper columns on "men" or "men's issues," the expectation and the reality is that the male author is speaking only for himself, not for some implausible univocal men's point of view.

I can't speak for women, or represent the woman's point of view. Instead I speak as a feminist, that is, from an awareness of the socially

constructed disadvantages of being female in this culture. I want to speak about my understanding of subjects that affect women, and that affect me, as one woman.

Issues that affect women are not the same as "women's issues." Not so long ago many newspapers included a women's page, devoted to "women's issues," which were conventionally understood to include fashion, cooking, community activities, and social events. Almost no one any longer believes women's interests are or should be confined in this manner.

More recently, the term "women's issues" has come to mean such topics as abortion, sexual assault, and workplace discrimination. These subjects are centrally important to women, but to call them "women's issues" may have several dubious implications. It may suggest that women's issues are confined to what is topical and controversial. It may suggest that they affect all women in the same way. And it may suggest that they are relevant to women only, and that women bear the responsibility for handling them. Calling them "women's issues" appears to imply that they do not affect men, or that men don't have to worry about them.

To avoid the ghettoization implied by the term "women's issues," many feminists insist that *all* issues are women's issues. This is not to suggest that social problems affect all women in the same way, or that women think and feel the same about various topics. But it is to say that literally every aspect of human life is significant to (some) women.

There is an important reason why all issues are women's issues. Western culture is gendered, that is, it divides virtually all aspects of our social life into "feminine" and "masculine" components. Some of these divisions are obvious — for example, the distinctions between women's and men's clothing, and between girls' and boys' toys. (Women are permitted to wear some clothes associated with men, and girls can get away with playing with "boys'" toys. But interestingly, the culture penalizes men who wear "women's" clothes, or boys who play with "girls'" toys; that is, males are punished when they seem to act like women.)

Other gender divisions are not so obvious. For example, economist Monica Townson has written about the gendered structure of the taxation system in Canada, and the disadvantages it generates for women. Recent news reports have exposed a gender difference in the cost of goods marketed to women and to men: women pay more for the same products and services when they are labelled "for women." Philosophers Sandra Harding and Evelyn Fox Keller have exposed some of the ways in which science is gendered. And some geographers and social planners have recently been investigating how even our architecture and our uses of space reflect conventional notions about femininity and masculinity, and express the perceived superiority of men.

Adopting the Smurf theory of women prevents us from noticing the deeply gendered character of society, and exploring the ways in which sexism disadvantages women. When we reject the Smurf theory, we start to notice the complexity of women's lives, and the courage, creativity, and dignity of individual girls and women.

August 9, 1993

No Generation Is An Island Entire of Itself: Why Baby Boomers Don't Have It So Easy Either

THE SO-CALLED baby boom generation, that large and varied group of people born between the end of the Second World War and the beginning of the '60s, has been the target of a lot of criticisms recently. The boomers are pictured as a privileged bunch, living well, setting cultural standards and priorities, and hogging all the good jobs. Young people in their twenties, members of the so-called Generation X, are sometimes bitter about the comforts the boomers allegedly enjoy.

But does the current media image constitute an accurate picture of the baby boomers?

My views on this question are not disinterested, since I'm a boomer myself. But when I hear the baby boomers being blamed for the situation of those in their twenties, several objections come to mind.

First, I wonder whether it is fair to generalize about a large group of people, born over the period of a decade and a half. How similar are people born in the late 1940s to those born in the early 1960s? My younger brother, born in 1958, though technically a boomer, has always felt that his life does not resemble that of people born just after the war.

I wonder whether it is any more legitimate to stereotype the members of a demographic cohort than it is to stereotype the members of a race or class.

Second, I'm not convinced that life has been as easy for many of the boomers as the clichés claim. The post-war generation experienced the full consequences of growing up in the '50s and '60s, and being part of a large demographic bulge.

My own growing-up experiences reflect those times. During the early years of the Cold War my primary school scheduled air raid

drills. I remember my first-grade teacher coaching the kids in the class to crouch under our desks for the duration of the drill. Half a decade later, not even into my teens, I experienced many sleepless nights worrying about the possibility of a nuclear war. I heard the talk on the radio and TV about hostility between the United States and Russia. We didn't have the money to build a bomb shelter, of course, but my mother began to accumulate extra non-perishable food in the basement.

When I finished primary school, my local high school was crammed to its limits with more than 2,000 students. Ugly portable classrooms, hastily assembled to accommodate my bloated generation, were scattered around the schoolyard. The teachers were hastily assembled too — including my Grade Nine mathematics teacher, a man recruited from industry, with no prior teacher training or practice. (I remember that, thanks to his inexperience, only three students out of thirty-five in the class passed the Christmas examination.)

When the post-war generation entered the job market we found that the pre-boomers, members of the cohort born prior to and during the war, had already claimed many of the best jobs. As a group we boomers would be competing fiercely with them and with each other for the rest of our working lives. When I applied to graduate school in the early 1970s, I received an ominous letter informing me that applicants should pursue post-graduate education only for the sheer love of study, since most of us would never get jobs in our field.

Indeed, many of my peers have been chronically underemployed ever since they left school, and many others who did find decent work are now, in middle age, facing layoffs and either permanent unemployment or a future of part-time, temporary, low-paying jobs. At the same time, many of us bear the responsibility of caring for ageing parents while raising our own children — children who are now or soon will be ready to start their working lives.

In the coming decades the baby boomers can anticipate continuing scarce resources and prolonged competition — for adequate

housing and health care, for pensions, and for security during our senior years.

What this brief survey shows is that most baby boomers can probably produce a litany of complaints about the results of belonging to a demographic glut, and of coping with the problems that previous generations bequeathed us. Just as Generation X blames their predecessors for delivering them a world of environmental depredation and scarcity of all kinds, the boomers blamed their parents for handing them a world seemingly dedicated to war, thoughtless population growth, and material accumulation.

But exactly how new is it for a generation to complain about their situation, and to blame their woes on the previous generation?

Neither the baby boom cohort nor the so-called Generation X are the only groups with problems. Consider what the future looked like for the generations in North America that reached adulthood during the Depression or the Second World War. Imagine coming onto the job market in, say, 1933, with an unemployment rate at that time of about 30 percent, and almost no social security measures. Or entering late adolescence during the early '40s, when young men and women were being recruited for the war effort, and faced the prospect of injury or death in an unimaginable conflict far from home.

The situation of the Depression and the Second World War generations makes the circumstances of both Generation X and of the baby boom look fairly comfortable by comparison. So when members of either of these recent generations complain about our situation, we need to gain a little perspective by remembering that our parents and grandparents faced situations that were often much worse.

And we also need to remember that in most cases it *was* our parents and grandparents who experienced those hard times. Generations are not so separate as the labels seem to imply. Just as the boomers are the offspring of people who survived the Depression and the war, some of today's Generation X are the offspring of the oldest baby boomers.

No baby boomer is likely to say to her own child, "Too bad, I've got a job, you haven't. You were born in the wrong generation."

Baby boomers are profoundly concerned not just about our own children, but also about the children of our friends, neighbours, and co-workers. We care about the future of the young people whom many of us encounter in our work as teachers, business people, or health care workers.

Whatever decade we grow up in, we all have our own unique struggles. But we're also strongly connected to succeeding generations. In her science fiction novel *The Children of Men*, P. D. James depicts a society in which human beings have become sterile and no more children are born. Its ageing members are apathetic and visionless. The novel vividly demonstrates how present-day plans, hopes, and prospects largely depend upon the flourishing of future generations. For that reason, the well-being of the members of one generation is inevitably of genuine concern to the members of others.

April 18, 1994

Buying More Products Won't Save the World

Most people have some concerns about threatened species, the erosion of wildlife habitat, and the pollution of streams, forests, and lakes. Just about everyone supports, at least in theory, the idea of saving wildlife and protecting wilderness areas.

What's interesting, though, is that we're almost always invited to contribute to conservation by means of our money.

We seem to have two choices. We can give money directly to an environmental charity dedicated to protecting threatened species and threatened lands. Or we can buy something, and a portion of the cost is given by the retailer toward environmental action.

A recent example of the latter approach is in the catalogue of an American clothing company called Lands' End. On page three of their July catalogue is a picture of an elephant poster, with the following message:

> This poster helps protect endangered species. When you buy this poster, you're also helping protect wildlife and its natural habitat. Proceeds go to Global Communications for Conservation, Inc., a non-profit group dedicated to environmental education, species protection and habitat conservation.

But posters don't really protect endangered species.

There's something peculiar about trying to save endangered lands and animals by buying more things. Surely part of the reason animal species and wilderness areas have become endangered is simply that we human beings buy things — too many things.

In the western world much of life is built around consumption. People of the West use up, consume, more and more of the world's resources to feed our false hope that both entertainment and self-realization can be achieved through acquiring more objects.

Retailers and advertisers encourage us to devote our leisure time to buying things. As a result, shopping malls have become areas of entertainment, places for people to go when they don't have

anything else to do. And shoppers are invited to see purchasing not just as a way of acquiring necessities but also as a form of fulfilment, and even as a way of being socially responsible.

So does it really make sense to buy yet another thing, in order to save animals and lands that are being threatened partly because we buy so many things?

It might be argued that, given the psychology of the North American consumer, this is the only kind of appeal that's likely to trigger a willingness to support environmentalism. So the end, environmental action, justifies the means, selling a product.

But it's the reverse reasoning that motivates corporations. For them, the goal is to sell, and the ideal of saving a species through one's purchases is just another marketing ploy. Moreover, the "shop to save species" approach salves the conscience of those who wish to go on buying things but want the added benefit of feeling virtuous as they do so.

It's significant that campaigns to persuade us to buy something to save the elephants (or whales, or pandas, or chimpanzees) seldom if ever tell us other actions we could take to save lands and species, actions not connected to money.

Certainly no business is likely to tell us *not* to spend our money or to reduce our consumption of things. Obviously, that would be counterproductive from the merchandisers' point of view.

Most corporations also don't tell us there are other ways of gaining enjoyment and fulfillment — through sports and games, reading, participation in the arts, walking in the park, visiting with friends, or creating and building things.

Unless, that is, those activities require the buying of more things.

In addition, big business doesn't usually tell us that there might be other ways — besides spending more money — of supporting endangered lands and species. It rejects the ancient ideal of moderation, of not buying or consuming more than we need, and of not escalating our notion of "need" to include the frivolous.

Corporations are not eager to tell us we could help protect the environment by recycling everything possible, refusing to litter,

cleaning up the land, planting trees, refraining from using chemical pesticides, reducing or eliminating our consumption of meat, not buying products made from endangered species' bodies, using less water and electricity, and reusing as many items as possible.

And the reason for their silence is obvious: Most of those steps result in people buying fewer things.

So, the cost of our spendthrift habits is environmental degradation. Or, to put it the other way, one "cost" of preserving the world in which we live may be to give up our addiction to shopping.

June 24, 1996

Fast-Paced World Overlooks Value of Introversion

IMAGINE you're at a party. There are many people in the room. You know scarcely any of them. The noise levels are high; there's lots of food and drink; conversations are dodging from one topic to another.

Would you enjoy the occasion, feeling happy to meet a variety of new people? Would you find yourself introducing yourself to strangers, standing close to them, making direct eye contact?

Or instead, would you find the party awkward, perhaps embarrassing, an ongoing struggle? Would you be standing back from the other partygoers, averting your gaze, perhaps looking for excuses to leave the room?

If you are the happy bon vivant, readily meeting and interacting with new people, you are probably an extrovert. You like to be spontaneous. You are optimistic, relatively willing to take risks, and able to handle conflict.

If you struggle to stay in the conversation, find the noise distracting, and soon look for excuses to go home, you may be an introvert. You prefer to make careful plans. You are pessimistic, relatively cautious, and dislike conflict.

An extrovert is someone whose brain is chronically under the level of arousal needed for optimal functioning, whereas an introvert is a person whose brain is chronically over the level of arousal needed for optimal functioning. As a result, the extrovert is constantly looking for new sources of excitement and mental stimulation from the environment, whereas the introvert searches for peace and quiet in an effort to reduce his or her level of stimulation.

I was reintroduced to the concepts of introversion and extroversion in a lecture delivered by Brian Little, 3M Teaching Award winner and Professor of Psychology at Carleton University, Ottawa. Confessing to be an introvert himself, Professor Little changed my attitude towards introversion.

I had always been somewhat ashamed of my own introvertive characteristics. I need and enjoy lots of time by myself, which I spend thinking, reading, or writing. I find it hard to meet new people. I struggle to speak spontaneously, and I need to plan what I want to say.

I used to see these traits as character flaws, weaknesses of the will.

Brian Little instead encouraged me to see the value of introversion. I formerly believed that extroverts are social assets whereas introverts are liabilities. But the introvert is just as valuable a person, just as intelligent, just as productive. Introverts even have a few advantages over extroverts in terms of long-term memory, the capacity to plan ahead, and the ability to produce high-quality work.

Introverts and extroverts simply have different strengths and weaknesses. While extroverts are "fast-paced and error-prone," introverts are slow but careful. Extroverts are "intense, animated and opinionated," but introverts tend to be guarded and circumspect. Interestingly, too, extroverts are motivated to seek rewards, whereas introverts are primarily motivated to avoid punishments.

Thinking about introversion and extroversion also helped me to understand and reassess some of the differences among my students. The student who writes insightful essays but seldom speaks in class may find group discussion an unbearable addition to her already high neurophysiological level of stimulation. Conversely, the student who talks brilliantly and at length in class but never produces a comparably brilliant essay may find the sustained work of writing papers a major challenge to his powers of concentration.

In general, however, the social world seems to be set up in such a way as to promote and value extroversion. Business, entertainment, and politics reward extrovertive behaviour.

So much so, in fact, that Brian Little thinks some introverts become "pseudo-extroverts." Pseudo-extroverts are persons whose innate high level of neo-cortical stimulation inclines them to introversion, but who learn to feign extroverted behaviour in order to survive the demands of employment and social occasions. Introverts can do this, according to Little, but it exacts a cost that is not paid

by individuals to whom extrovertive behaviour is a natural concomitant of the search for greater brain stimulation. That cost may include high stress levels and even burnout.

As we head toward the millennium, the western world continues to place a premium on extrovertive behaviour. The pace of government, employment, and entertainment favours quick decisions, gregariousness, and high levels of stimulation.

Imagine instead a social environment in which contemplation, long-term planning, quietness, and an awareness of the risks and dangers of rapid decision-making are as highly valued as extrovertive skills. Wouldn't introverts' abilities provide a much-needed balance for the impulsiveness and reward seeking of extroverts?

December 2, 1996

It Doesn't Feel Right to Eat Beings That Have Faces

THE START of a new year is a time when people make resolutions to change their behaviour.

There's one resolution I'd like to make but never do, because I don't seem able to keep it.

The biblical saying "the spirit indeed is willing, but the flesh is weak" is usually associated, in the late twentieth century, with sexual temptation. But in my case it describes my relationship to meat eating.

In the holiday season there is a surfeit of meat. This year, as I ate turkey on Christmas Day, then dealt with the turkey leftovers on Boxing Day, I pondered again my own inability to become a vegetarian.

From my cultural background, meat-centred meals are easy and familiar. Eating meat is associated with relatively greater affluence. I've learned to enjoy most types of meat.

In his book *Animal Liberation: A New Ethics for the Treatment of Animals*, ethicist Peter Singer says, "For the great majority of human beings, especially in urban, industrialized societies, the most direct form of contact with members of other species is at meal-times: We eat them. In doing so we treat them purely as means to our ends. We regard their life and well-being as subordinate to our taste for a particular kind of dish."

There are lots of good reasons not to eat meat.

The environmental costs of raising cattle and chickens are high. In South America, rain forest is destroyed to create grazing lands for cattle.

It's inefficient to use meat as food for human beings. It's estimated that to produce one pound of protein in the form of beef or veal, we must feed 21 pounds (42 kg) of protein to the animal. This is a very expensive way of feeding people.

Animals raised as meat often live lives of suffering. And there is

no reason to believe their suffering is any less morally significant than that of human beings.

In so-called factory farming, millions of animals are raised entirely indoors, in very crowded conditions. Infant animals are removed early from their mothers, to live out their lives in conditions of psychological and physical misery. They are often limited in movement, and can't walk or even stretch their bodies. The lighting is artificial and their diet unnatural, supplemented by the use of steroids, antibiotics, and other drugs to promote growth and prevent disease; these drugs are passed on to those who consume the meat.

But even if the millions of animals we devour could all be raised in conditions that did not cause them suffering, it's still questionable whether non-human animals exist just for human use, for us to kill and eat.

Human beings tend to think there is a moral and spiritual hierarchy with human beings at the top. We believe our technologically aided power entitles us to kill and consume at will. We assume our intelligence justifies our taking advantage of species with different kinds of intelligence from ours.

Are these assumptions justified? If they are, then it follows that if members of a species that was smarter and more technologically advanced than human beings travelled to Earth from another galaxy, those beings would be justified, by virtue of their greater intelligence and power, in killing and eating us. They could confine human beings to crowded cages, breed us, fatten us up, or leave us to live in the wild, then hunt us down for sport.

Such ideas may seem outrageous or horrifying. But, morally speaking, they are not so different from what human beings do to non-human animals.

A vegetarian friend of mine advocates a simple principle: Don't eat anything that has a face.

The presence of a face is a symbolic and real representation of another life, a life not so distant from ours. An animal with a face has feelings and thoughts. We recognize this life when we shower love and care on our pet dogs and cats.

It seems morally arbitrary to designate some animals as worthy of our care and respect and other animals as deserving only of suffering, slaughter, and consumption.

Finally, there are both individual and social health costs arising from the consumption of meat. Human beings can be more than adequately nourished by a meatless diet. In the western world, human beings pay the price of heavy meat consumption, especially red meat, in the high incidence of cardiovascular disease and certain forms of cancer.

The arguments against meat eating force me to recognize that I regularly engage in behaviour that is not morally justified.

My moral compromise, for what it's worth, is to try to reduce my consumption of meat. I have several meatless days a week, with meals emphasizing pasta, rice, beans, and vegetables.

I'm not happy about my carnivorous lifestyle. Maybe some year I'll have the moral courage to give it up. It no longer feels right to eat beings that have faces.

January 6, 1997

What's It Mean To Be A Feminist?
Not What You Might Think

I'M PROUD to be a feminist. It's a political and moral identity that helps to define the kind of person I want to be.

My definition of feminism is brief: You're a feminist if you believe women have been and are subjected to unjust and oppressive treatment, and if you're committed to helping to end that treatment.

People sometimes have inappropriate and irrelevant expectations about what it means to be a feminist. I refer to this as the "How can you be a feminist if ...?" phenomenon.

For example, some people have said to me, How can you be a feminist and still like men?

The assumption behind this question is that all feminists hate men.

Some feminists may hate men. But some non-feminists hate men too.

Just as significantly, some people hate women. In fact, maybe a lot of people hate women. There's even a word for it in English: misogyny. Human history abounds with evidence of woman-hating behaviour, ranging from the infanticide of female babies and the infliction of female genital mutilation, to violations of women's civil rights and the treatment of women as sexual and reproductive property.

There's no comparable English word for the hatred of men, a fact that suggests that hatred of men is a comparative rarity.

One lesson feminism teaches is to avoid generalizations about large groups of people. I work with many congenial and helpful male colleagues; some of my smartest students are men; and I have a spouse and a son whom I love deeply. So, as a feminist, I don't hate men.

But I do hate some of the things some men have done: the violence and sexual assaults committed against women by male predators; the restrictions on girls' access to literacy and education endorsed by male educators; the wars, tyranny, and enslavement established by male governments; the racist, sexist, and heterosexist laws enacted by male politicians.

People sometimes criticize feminists who wear makeup and "feminine" clothes. They say, How can she be a feminist and care so much about her appearance?

Feminists vary. Some, like me, just want to be comfortable, and can't be bothered with the fuss of makeup and fancy clothes. Others enjoy the rituals, sensuality, and theatricality of "dressing up."

Feminists don't always lead perfectly consistent lives, and like everyone else we are subjected to persistent cultural messages about femininity. Perhaps some, like me, are careless about their appearance. Perhaps others succumb, unintentionally, to the beauty myth. Figuring out how to live one's life in keeping with one's moral principles is an ongoing challenge.

People sometimes say, How can you be a feminist and have other interests beyond women's issues?

In one way the question reveals a mistaken assumption, for, it's often said, "All issues are women's issues."

Feminists, like other people, have a variety of responsibilities and interests: jobs, families, children, homes, friends, pastimes, and athletic and artistic pursuits. Many of these aspects of ordinary human lives can be approached from a feminist perspective.

For example, we can see that women continue to be paid less than men, and that the jobs in which women predominate involve traditional "women's work." We can see that women are still expected to carry much more than their share of domestic work and childcare.

We can also see that funding and media attention still favour men's sports over women's sports. On the other hand, we can see that women's contributions to literature and other arts are not only increasing, but are receiving greater recognition and appreciation.

In the last analysis, feminists are not so different from non-feminists. But feminists bring to their lives and their concerns a political analysis that tries to discern the ways that power is unequally and unfairly distributed in the social world.

People sometimes say to me: How can you be a feminist and hang around with people who are not feminists?

Many women who don't call themselves feminists nonetheless live their lives as if they are feminists. If a woman is strong and independent, thinks for herself, and values other women, she is a feminist whether she uses the label or not.

Since feminism is, in my view, a set of political and moral commitments, it's also possible for men to be feminists. A man who actively opposes violence against women, who rejects sexist criteria for access to jobs and education, who supports and encourages the women in his life, is a feminist whether he uses the label or not.

It may be that common media misrepresentations of feminism have convinced a lot of people that feminism is bizarre or bad. Hence, many individuals continue to reject the feminist label for themselves, and are suspicious of those who adopt it.

But being a feminist is, after all, not so very strange. It's simply a matter of believing, sincerely, that women are people, not lesser beings than men.

March 31, 1997

The Great Debate: Can A Man Be A Feminist?

Can a man be a feminist?

The immediate answer to this question might be, Why not? A man can be a socialist, a capitalist, a libertarian, a liberal, a fascist, or a Marxist. A man could, just as well, be a feminist.

But the issue is not so easy as this. Some women claim that only women can be feminists. They believe there is something about being female that is necessary to being a feminist. Men can be "pro-feminist," but not feminist.

Is being biologically female a necessary condition of being a feminist?

The answer is no. Bodily characteristics like breasts, clitoris, or vagina are not necessary to being a feminist, for a girl who has not yet developed breasts could still be a feminist. A woman who has been subjected to a clitoridectomy could still be a feminist. And a woman who has had a hysterectomy could still be a feminist.

Perhaps, then, it is the experiences that a woman has that are essential to feminism. A man cannot be a feminist because he does not have the experiences that a woman has — experiences such as menstruation, pregnancy, childbirth, and menopause.

But there is a problem with this approach too. A young girl who has not yet undergone any of these experiences could still be a feminist. So could a woman born with reproductive anomalies such that she never goes through menstruation or pregnancy, or a woman who chooses never to have children.

So it can't be these experiences that are necessary to being a feminist.

But this observation introduces an important point. Perhaps the crucial experiences for being a feminist are not based directly on biological characteristics, but come from being oppressed. Regardless of her specific biological characteristics, a woman in a sexist society is subject to discrimination just for being a woman.

So, should we say that a person has to be subject to discrimination for being a woman, in order to be a feminist?

Some women, of course, are fortunate enough never to be subject to discrimination for being a woman. For example, a woman might be born to a very wealthy and powerful family, and hence be protected from sex discrimination because of her class background. Or she might just be very lucky, and never experience sexism.

Is it therefore impossible for women such as these to be feminists? Surely not.

This suggests that it is not even the experience of being subjected to discrimination for being a woman that is necessary to being a feminist.

Nonetheless, there is something important here. The wealthy, privileged woman might be less likely to be a feminist, or might find feminism hard to understand. For to be a feminist, one has to be *aware* of undeserved discrimination, injustice, and oppression. In a sexist society, a woman faces the possibility of being sexually assaulted, or being discriminated against in the work place. Understanding such facts is the foundation of feminism.

Men also have experiences of discrimination and oppression. They may experience oppression on grounds of their race, if they are not white; on grounds of their sexual orientation, if they are not heterosexual; on grounds of their bodily condition, if they are disabled; or on grounds of their class, if they are poor or working class. They may also experience oppression in their childhood. Most children are subjected to discrimination on grounds of being young, small, and immature.

If this is true, then men can have some experience of oppression. But what is just as important to feminism is the *understanding* of oppression, in particular, understanding oppression on the basis of sexual identity.

A man is not barred from an understanding of sexist oppression purely by virtue of being male. It is true that his biology is different from women's, and that many of his physical experiences will be quite different. It is also true that he is very likely to receive certain privileges just because he is male.

But feminism is a political position, a moral assessment that the oppression of women is not justified.

To say that there is some political position a man cannot adopt because he is a man is to say, in effect, that some people are barred from certain sorts of understanding, no matter what they do or experience. This is to give in to a kind of political hopelessness.

The feminist perspective is not inaccessible to men by virtue of their being male.

I conclude that a man can be a feminist. There may not be very many male feminists. But such beings are not a contradiction in terms. And I think there are more of them all the time.

February 9, 1998

There's No Reason Women Can't Do "Male" Jobs

MANY PEOPLE would like to think that the bad old days of discrimination against women are over. Girls can be anything they want to be, right?

Maybe we should think again.

In mid-March Statistics Canada released data showing the top ten occupations in Canada for women and men — in other words, the jobs women and men are most likely to hold. One occupation showed up on both lists: retail sales clerk, which was the number one occupation for women and the number two occupation for men. Otherwise, the two lists had no occupations in common.

They did, however, share one characteristic: Each list is amazingly gender stereotyped.

Men's number one occupation is truck driver; and the number two occupation for women is office secretary. Included on the men's list are janitor/caretaker, farmer, vehicle mechanic, carpenter, and construction labourer. Included on the women's list are cashier, registered nurse, elementary/kindergarten teacher, waitress, babysitter, and receptionist.

Every one of these jobs, in both categories, represents important work that is valuable to Canadian society. What's hard to understand is why some of these jobs are conventionally women's and others are men's. Is there something about a saw or a hammer that makes it inherently male? Is there something about a cash register or a thermometer that makes it inherently female?

I don't believe it's poor judgment or lack of imagination that continues to send women and men into stereotyped jobs. But for a variety of economic and social reasons, it's tough to break gender stereotypes. (The low pay and lack of respect accorded women for much of their work are certainly a disincentive for men to do stereotypically women's work.)

Even Hedy Fry, the Secretary of State for the Status of Women,

seems to buy into these stereotypes. She claims that as long as women go on bearing children they will never have the same relationship to paid labour that men do, "unless you want to stop society right now and have zero population growth."

This is a surprisingly old-fashioned view of women.

The fact that women bear children simply means that we need social policies to accommodate pregnant, parturient, and nursing mothers. Otherwise, however, it is hard to see why having the capacity to bear children should make any difference to the nature of women's labour force participation.

Those who believe that childbearing somehow invalidates women's capacity for certain kinds of jobs make the false assumption that all women are mothers, or that all mothers spend all their time mothering. But in fact, when given the means, via birth control and control over their own bodies, women are choosing to have fewer and fewer children, and some women choose to have none.

There is, of course, considerable work involved in child rearing, but I should have thought, in these supposedly more enlightened times, that a politician responsible for the Status of Women might recognize that women are not the only people inherently suited for raising children. Fathers are just as important to children as mothers. If there needs to be labour force accommodation for the work of parenting, there is no reason that it should disadvantage people of either sex, and certainly no reason that it should disadvantage women.

The fact that women, not men, are the ones who can get pregnant does not make women necessarily any less suited to do stereotypically "male" jobs like construction work or carpentry. Being female isn't such a liability that women are incapable of doing so-called men's jobs. The question should always be, does the person have the ability to do the job?

Even where there is special strength required for a given job, in fairness the hiring issue should be whether the candidate has the strength to do it. That's why there is an effort to get away from gender stereotyping for work like firefighting and policing. Instead of simply assuming no woman wants those occupations, or is

capable of handling them, the trend in most places is to specify in reasonable ways the strength, stamina, and skill criteria necessary for doing the job, and then test women applicants to see if they meet the criteria.

Some people think that combat jobs in the military services should be off-limits to women. I don't believe this occupation is desirable for people of either sex. But if men are going to have the chance to be cannon fodder, then women should have that chance too. It's doubly sexist to suppose that men can be sacrificed whereas women must be protected.

In the end there's not much justification for gender stereotyping any jobs. Women's capacity to bear children should be seen as a social asset, not as a reason to stream girls into "female" jobs. Anatomy isn't destiny any more.

April 20, 1998

Refusing Rights to Homosexuals Boils Down to Prejudice

In 1991 Delwin Vriend, a gay man who taught chemistry at the Christian-based King's University College in Alberta, was fired on the grounds that his sexual orientation was inconsistent with the College's religious tenets.

When he complained to the Alberta Human Rights Commission, he learned that the law in Alberta permitted discrimination against gays and lesbians. Any gay person could be fired, denied rental accommodation, or refused service at commercial outlets. But when the case reached the Supreme Court, the Court decided that sexual orientation should be considered a prohibited ground for discrimination under Alberta's Human Rights Code. The Charter of Rights and Freedoms entitles homosexuals, like heterosexuals, to freedom from discrimination in employment, tenancy, and services.

The ruling immediately provoked protest, primarily from rightwing Christian groups and other social conservatives, including the Canada Family Action Coalition and the Alberta Civil Society Association. One of their main objections was that extending legal protections to gays and lesbians would harm the family.

This is a fascinating point of view.

Some psychologists used to say the reason some people seem to hate gays and lesbians is that deep down inside, maybe at an unconscious level, such people think that they themselves are or may become homosexual. I don't know whether this theoretical explanation for homophobia has any truth to it. But when some Albertans claim that families will be harmed by protecting gays and lesbians from discrimination, the puzzled observer might be forgiven for having suspicions about the unconscious motives of those Albertans.

Maybe the opponents of the Supreme Court ruling are covertly assuming that homosexuality is so attractive that card-carrying heterosexuals will convert to homosexuality, and that the only factor stemming this potential flow of straight individuals to a gay and lesbian lifestyle is the existence of profound discrimination against homosexuals.

The opponents of the Supreme Court ruling also believe the family will be harmed by ending discrimination against gays and lesbians because they fear it will open the door to same-sex marriage.

It's hard to see why allowing more people to be married would negatively affect families. Extending the right to marry to same-sex couples doesn't detract from the value of marriage, unless you assume that putting limits on what kinds of adults are permitted to marry somehow makes marriage more special or valuable. But if heterosexuals think marriage is a good thing, a social and legal recognition of an enduring bond between two adult human beings, then why not extend it to partners of the same sex?

The Albertan protests also claim that the Supreme Court ruling will eventually allow gay and lesbian couples to adopt children. Here, I would guess, there may be two fears animating their protests.

One fear is that gay or lesbian couples will raise their children to be homosexual. Of course, in order to fear this, one has to make the prior assumption that being gay is bad. And that is precisely the assumption that is at issue in this debate.

Leaving aside that question-begging assumption, the further assumption is that people learn their sexual orientation from their parents. But if that's the case, then it is a real mystery how so many gay and lesbian people manage to emerge from families headed by heterosexual parents.

Of course, many, perhaps most, heterosexual parents do try to raise their children to be heterosexual. They assume and expect that the children will be heterosexual, and some parents even punish or ostracize their kids if they are not. But the only result of this approach is that gay and lesbian offspring end up estranged from

their parents and siblings. Such treatment is unlikely to contribute to strengthening families.

It seems doubtful that child-rearing practices can determine the sexual orientation of children. I think parents' best approach to their children's sexuality involves teaching basic values of respect, mutual support, and understanding, and helping children to be knowledgeable about their bodies. This approach would be appropriate for both heterosexual parents and gay and lesbian parents. I don't know of any evidence that heterosexual parents are better at giving their children a good sex education.

The other fear that some people may harbour with respect to same sex adoption is that somehow the children in such cases are in danger of sexual abuse. Such a fear conveniently overlooks the fact that the majority of child abuse in families is perpetrated by heterosexual relatives, usually but not always men — fathers, boyfriends, grandfathers, uncles, and brothers. Having heterosexual parents is no guarantee for a child of safety from sexual abuse.

All the arguments in support of the belief that granting freedom from discrimination to gays and lesbians will harm the family are groundless. The belief appears to be irrational.

But maybe that's precisely the point. The opposition to extending basic legal protections to gays and lesbians is nothing more than the expression of an unreasonable prejudice.

April 27, 1998

Communing With Nature Reveals Humanity's Inhumanity

In August my family and I spent a week at a secluded cottage. We were far from other human habitations, but surrounded by an abundance of non-human animals.

In the evenings, just before sunset, we canoed down the lake to watch the beavers at work and play. Often the first clue to their presence was a diverging V upon the calm water, the wake left by a swimming beaver with only his nose and forehead protruding. Occasionally what we saw first was a small branch, moving seemingly without effort across the surface of the water. We soon discovered two different beaver lodges, each recognizable by a large pile of twigs and branches arranged apparently haphazardly to span the edge of the lake. Sometimes we could hear little humming sounds coming from the lodge, or a "chuck chuck" sound that we thought might be a beaver chewing on her evening snack.

The beavers tolerated some human observation, but drew an invisible line across which we were not supposed to venture. If we did, the beaver under observation slapped its large flat tail against the water, creating a noisy "splat!," and dove beneath the surface. Speaking as a large mammal, I can attest that the sudden splash, which shocked me every time, is probably effective in frightening away most predators.

One evening, as we walked back to the cottage after canoeing, we surprised a porcupine on its nightly ramble. Turning its back to us and presenting its large spiny tail, the porcupine seemed willing to take aggressive action if we came any closer. Momentarily anxious, we made elaborate efforts to get out of its way, and after that, when walking in the evening, we created sufficient noise to warn any porcupines in the area of our presence.

During the day we enjoyed watching hawks, cranes, and loons.

One time a grouse stood in front of our approaching car and eyed us snootily, clearly conveying the impression that we had no business coming along in such a mechanical monstrosity. Another time I was sitting out in the brilliant sunshine when I heard a deep droning sound. Looking up, I found I was being cruised by a hummingbird. Since I was wearing a bright yellow T-shirt, perhaps the bird hoped I was an enormous flower. As it hovered just above me, its rapidly moving wings were virtually invisible, but its tiny body, head, and long beak were distinctly identifiable. I'm not sure which of us was more perplexed by the encounter.

We also saw deer. Now, some people are unmoved by deer sightings, being only too used to seeing one dash across Bath Road here in Kingston. I, however, am less blasé. Walking down our cottage road one day, we turned a corner to find a group of three. The male and the juvenile instantly hurtled themselves off the road and disappeared into the underbrush. The female lingered for a moment, looked at us appraisingly, and then lunged after her family.

Some of the animals we saw during our cottage week were intimidated by us; others did their best to scare us away. These experiences made me think about predators and their prey, hunters and the hunted.

My philosophical training leads me to assume that people are usually capable of rethinking a viewpoint, of re-evaluating their activities. But in the case of sport hunting, I suspect that those who support it will never reconsider their "hobby," and those who do not already know the moral arguments against hunting

So, I would not attempt to argue hunters out of engaging in their activity. But putting aside the moral objections I have to hunting, I do not understand the human taste for it. Why does killing animals appeal to some people?

Perhaps the difference between those who are pro- and those who are anti-hunting has something to do with people's feelings about killing, their visceral reactions when they see a wild animal. When I see an animal my first impulse is to want to watch it, holding my breath and hoping I will not scare it away. Always I wish it were possible to transmit the message that I am a safe human being.

Yet when human hunters see a wild animal, their response is to want to kill it. So from the animals' perspective, most human beings are not at all safe. In fact, the grouse that would not move from in front of our car was running a life-endangering risk, and probably needed to learn more fear of human beings.

It is often said that human beings are a species that is willing to kill other living things for sport. It is an aspect of humanity that remains incomprehensible to me.

September 7, 1999

Church-Imposed Celibacy a Burden, Barrier to Priesthood

SEXUALITY IS ENORMOUSLY important in human lives. It's not surprising that human societies have always found ways to create, contain, direct and subdue people's expression of their sexuality.

For centuries the social control of sexuality has been enacted with the aid of God's supposed approval. Human beings have introduced moral and legal strictures on homosexuality and lesbianism, on sex before marriage and sex outside of marriage, on "illegitimacy" and divorce, on the use of contraception and abortion, on masturbation, and on sodomy, oral sex, and other so-called deviations from divinely ordained man-on-top, penis-in-vagina sex.

Many people, in their beliefs and their actions, have rejected these limitations on human sexuality. But some interesting remnants persist. One of these is the value placed on celibacy, which remains a requirement for the Roman Catholic priesthood.

According to Canadian scholar Elizabeth Abbott's fascinating new book, *A History of Celibacy*, the requirement of priestly celibacy was not decreed until the fifth century. The Church hierarchy proclaimed that celibacy was essential for priests because Jesus himself had been celibate. Moreover, it was feared that relationships with children and a sexual partner would distract the priest from his devotion to God, and perhaps even tempt him to distribute church property to his offspring.

The traditional religious significance of celibacy was reaffirmed by Pope Paul VI in 1967. He called priestly celibacy a "brilliant jewel," arguing that it generates great charity, love, and spiritual devotion, that it contributes to maturity and psychic integration, and that it is not unnatural, since logic and free will can overcome sexual drives.

The implication of the celibacy requirement would seem to be that those who are celibate are closer to God. But why would abstention from sex be seen as the path to piety?

Feminists have argued that the Catholic Church's requirement of priestly chastity is just another expression of its implicit contempt for women's bodies, its view of female sexuality as essentially adulterating and polluting. The priest must shun sex because physical contact with a woman will contaminate him.

This idea, that contempt for women's bodies lies behind the demand for celibacy by priests, is reinforced by the Church's insistence that women cannot be priests. Possessing female genitalia is sufficient to render a woman ineligible for this significant spiritual role.

Certainly Christianity has a long history of misogyny. But I believe that the requirement that priests be celibate may also reflect an implicit idea that male sexuality, almost as much as female sexuality, is defiling.

Think of the value, in Europe and North America, that was traditionally placed on female virginity. While female virginity was highly prized, a woman who had lost her virginity, either through chosen sexual activity or through rape, was considered to be defiled. This belief system seems to imply that contact with male genitalia destroys women's purity.

Consider also Mary, the mother of God's son Jesus. Apparently it was not inappropriate for God's son to be incarnated within a female body. Gestation within a womb did not dishonour Jesus. An outsider to Christianity might think that if God's son could have one human parent, then surely he could have two. But, according to Christian doctrine, Mary was a virgin. Though married to Joseph, she did not have sex with him, and her body was untouched by a penis.

The message of traditional Christianity would seem to be that male sexuality is inherently corrupting, just as female sexuality is.

Elizabeth Abbott argues that the vow of priestly celibacy has not always been honoured. She cites a study indicating that in contemporary times, 40 percent of US priests, both heterosexual and homo-

sexual, are routinely uncelibate, a figure that excludes those whose lapses are infrequent. Some of these lapsed celibates are married, and although in the eyes of canon law they still remain priests, they have been stripped of their right to administer the sacraments.

So the evidence suggests that thousands of Roman Catholic priests reject chastity. In addition, over the past thirty-five years over 100,000 priests worldwide have abandoned their vocations, and the vast majority identify their discomfort with celibacy as a primary motive.

When celibacy is freely chosen it may be a source of strength and autonomy. But when it is imposed from without, it is a burden and a barrier. This exodus of priests provides a very practical reason why the Catholic Church should reconsider its attitude toward sexual expression.

Maybe if human sexuality had been seen for the last two thousand years as a gift rather than as a source of contamination, the social control of sexual expression would have been less oppressive to women and men of all ages and sexual orientations.

September 20, 1999

How Do I Love Thee? Let Me Count the Conditions

In discussions of relationships, especially family connections, it's commonplace for people to speak of the importance of unconditional love.

In many ways the idea of unconditional love is attractive. We all want to be loved and we hope that people will continue to love us, even when we are irritable, impatient, rude, careless, or unkind. We want our parents, our children, our lovers, and close friends to overlook our faults and focus on our good qualities. We want them to cherish us, even — or maybe especially — on our bad days.

The idea of unconditional love may have an additional importance with respect to individuals who are subjected to discrimination or violence. For example, a recent newspaper article stated that women who have been beaten by their partners need to be met with "unconditional love" from the rest of their family and their friends. Friends and family must try to show the battered woman that her mistreatment is not her fault, that there is not some character flaw in her that somehow makes her deserving of being beaten. The battered woman's allies must demonstrate that they love her and support her in leaving her abuser.

This seems right. Human beings should be held responsible for the things they have done, and not held responsible for things that are not their fault. To say that the battered woman is entitled to unconditional love is to say that having been beaten does not make her less worthy of love. The typical approach of the batterer is to try to get his victim to believe that she is worthless, but being a victim in no way takes away her value as a human being.

Yet in other contexts I'm inclined to say I don't believe in unconditional love. I suspect that even the fans of unconditional love are doing little more than paying lip service to an unattainable ideal.

The idea of unconditional love implies that we should cherish a

friend or family member no matter what he or she does, and that all behaviour, no matter how abominable, should be forgiven and forgotten. Maybe unconditional love is related to the Christian tradition of turning the other cheek. The book of Matthew exhorts the reader to "Love your enemies, bless them that curse you, do good to them that hate you, and pray for them which despitefully use you, and persecute you" (Matthew 5:44).

But when it comes to unconditional love, I think there are limits both on what people are capable of, and also on what should be expected from them.

If I reject unconditional love, it might seem as if I'm advocating only conditional love. Is love, then, something to be earned? Is it the product of a bargain? Conditional love is what goes on in some school playgrounds: "If you share your candy with me, I'll be your best friend." Conditional love is what some parents offer their unfortunate children when they give their kids the message that they will be loved only if they behave, if they achieve in school, or if they become outstanding athletes.

But that's not what I mean when I reject the idea of unconditional love.

I think the problem is that if love for a person is truly unconditional, then it seems unrelated to who the person actually is. According to the ideal of unconditional love, no matter what someone does, no matter what someone is, I am supposed to love him or her. This suggests that it does not really matter whom I love.

Instead, most of us want to be loved for who we are. We want our own personal characteristics to be appreciated. We hope that it is our individual features, values, and behaviour that are lovable.

If someone I dearly loved became a vicious batterer, a rapist, or a serial murderer, I would probably no longer love him. People are responsible for what they do, and if what they do is consistently cruel and vicious, then why should I love them? The female victim of a batterer should certainly not be expected to continue to love her abuser.

Maybe instead of unconditional love, we should seek compassionate love. We want to be acknowledged and accepted for who we

are. We want room to make mistakes. We don't want to lose a friendship because we were temporarily rude, or forgot our friend's birthday, or wore the wrong shirt.

But unconditional love is an ideal so ethereal that almost no one could manage it. And maybe no one should have to.

September 27, 1999

Nine Good Reasons Why the 1990s Were So Important

I DON'T KNOW about you, but I find thinking about a millennium is almost impossible. Even a century is too much to really comprehend.

No, December 31, 1999 seems important to me simply because it's the end of a decade.

The 1990s were a crucial time in my life. Not in terms of material acquisition (though that's how big business wants us to understand our lives), and not just because of personal milestones, but in terms of a few things that I finally understand.

1. Parents won't be around forever.

From a child's perspective a parent is eternal, and for most of us, Mum and Dad were always there, just part of the domestic landscape. But while we were growing up, exploring the world, working hard, having a life, Mum and Dad were getting older.

We all need to cherish our parents while we can. They are our lifelines to the past, and we are their message to the future.

2. Kids do grow up.

There are times when childhood seems endless — not just to the children themselves, but to their hapless parents. Changing endless diapers, getting up at 2:00 a.m. to comfort a child with nightmares, enduring one illness after another once they start school, all make the early years pretty intense.

But it won't last forever, and one day you find yourself having civilized conversations with people who are almost-but-not-quite adults with a life of their own. And you wonder what happened to the little ankle-biters who used to follow you everywhere and leave handprints on your shirt.

3. Burning out isn't worth it.

It's not really necessary to struggle to keep up with the standard of living that corporate America tells us we should aspire to. And it isn't worthwhile to try to do the work of two people, even if your employer has downsized and never replaced the people that were let go. And it's not a good idea to try so hard to be superwoman that you miss out on your kids' childhood. Because — see number 2 — kids do grow up.

4. We weren't put on this earth to get rich.

My spouse reminds me of this whenever I worry about money. I think he's right.

5. It's possible to have fun even when you're not a kid.

My parents' generation took on responsibility early — getting jobs while still in their teens, marrying and starting families in their early twenties, struggling through the Depression, and participating, close at hand or at a distance, in a world war. They didn't have much time for play. They were too busy working.

But today's grownups can play hockey or basketball, take part in amateur theatre, create art, play in a rock band, collect bugs, or climb a mountain. I think my generation, the boomers, are fortunate that even while we're working and raising kids, we can still have fun.

6. There's no need to be self-conscious.

Especially when you're young, it's easy to be shy and to feel that everyone is looking at you. But the reality, it turns out, is that everyone else is so preoccupied with their own lives they are probably not even noticing you. So, when you're having fun (see number 5), you don't need to feel conspicuous about it.

7. Enjoy your health.

A bout of serious illness taught me not to take for granted my capacity to walk, pick up a baby, climb stairs, or even just to read a book or listen to the radio.

Most of us are never going to have the body that the media say

we should have, and the older we get, the less it's going to look like the ideal. That's okay. We can still appreciate the bodies we do have. If your heart's still beating, your lungs are pumping, and your brain is functioning, it's a lot better than the alternative.

8. People never stop learning.

When I gave a lecture at Kingston's Later Life Learning series, the audience showed me that one of the great joys in their lives is the opportunity to absorb new ideas. When people keep learning, they keep growing — intellectually, psychologically, and morally. Our capacity for learning is one of the most powerful reasons I know to be optimistic about the future of the human race.

9. We're all connected.

Being part of a community is also part of what makes us human. Real human beings are endlessly interesting. Once you get to know people, understanding them makes it easier to appreciate them. I think it's only possible to fear or hate people in the abstract.

December 28, 1999

Afterword

THE ANCIENT Greek philosopher Plato attributed to his mentor Socrates the claim that a life that is unexamined is not worth living.

I wouldn't go quite that far. Lots of people don't have the time, energy, or opportunity to examine their lives, yet their existence is not worthless. But I do think that the unexamined life is truly a diminished life. Reflection about who we are, what we know, the nature of our values, and the direction of our politics is central to our humanity.

You might say that as a philosopher and writer, I get to make a profession of examining my life. Producing my column is a bit like writing personal history, putting out my autobiography and my ideas in instalments each week. I have the chance to talk publicly about my experiences as a mother and an academic. I can write about some of my favourite people and things, and about my deepest passions and concerns. I preserve stray thoughts, experiences, observations, cultural events and news reports, compost them, and grow them into stories.

In *Thinking Out Loud,* her collection of columns from *The New York Times,* Anna Quindlen remarks, "The reader I write for is myself, which is the act of arrogance that powers the work of most columnists."[1] And she's right. In some ways writing a column like mine is highly self-oriented.

But I hope that the column is not just about me. I genuinely want to engage with my audience, with all the different kinds of people who turn to the editorial page or to this book and consider reading my ideas. In making my personal life and political ideas public, many readers feel that they are coming to know me. And in coming to know me, I hope they find it easier to consider seriously my feminist claims.

Quindlen notes that in her writing she has been accused of "wearing her gender on her sleeve." In response she says, "Right here, right now, I believe it is not only possible but critical, not only useful but illuminating, for a woman writing an opinion column to bring to her work the special lens of her gender."[2]

I agree. For the foreseeable future, gender categories will continue to define our ways of being human in this culture. So what it means to experience the world as a woman, and what it means to engage with political issues and ethical questions as a woman, will continue to deserve our attention.

But it's not just a matter of looking at the world as a woman. The political and moral perspective of feminism is also necessary. I don't think oppression will end in my lifetime, and feminist analyses will remain vital for understanding the construction of gender and for deconstructing sexism, heterosexism, racism, classism, ageism, and ableism.

Much as I would like to hope that we have made progress, I know that feminists will have to keep probing the themes that are crucial to women's well-being, themes such as sexuality and reproduction, especially abortion access and the marketing of reproductive technologies; women's future at work and in politics; the prospects for employment and educational equity; provisions for childcare and the socialization of girls and boys; and protections against sexual harassment and violence against women.

All issues are women's issues. Adopting a feminist perspective, we can see that "gender-neutral" journalism often reports issues in ways that overlook their significance for girls and women. Feminists bring a woman-positive political and moral perspective to bear upon the structure of our education and health systems, the needs of the family in all its different forms, the role of the government, and the preservation and protection of the environment.

I'm not a political scientist, economist, or sociologist, so I'm diffident about trying to predict our future. But I can see that the corporation is turning into the model for all our cultural institutions. Financial exchange has become the metaphor for human

interactions, and the "bottom line" is the moral criterion for evaluating ethics and policy. So feminists will have to give more attention to the commercialization and corporatization of our culture.

Another big concern for the future of feminism arises from the ascendancy of so-called "social conservatism," a polite name for a moral and political juggernaut that seeks to return women to the nineteenth century, and to ensure that immigrants and any others who are not white, well-off, and heterosexual remain on the margins. Social conservatism constitutes a threat to abortion access, to employment equity, to legal protections for gays, lesbians, bisexuals, and transsexuals, and to any social welfare system that benefits the poorest and most vulnerable members of our society.

In the Introduction of this book I said, "In my contribution to the cultural symphony I play the countermelody of feminism, a tune that may occasionally create some dissonance in the human orchestra, but whose ultimate goal is the promotion of greater social harmony." But I don't seek social harmony just for its own sake. If the price of social concord is injustice, to individuals or to groups, then give me discord instead. I seek a social harmony to which every member of society can contribute, and in which everyone's role, no matter how small or how different, is valued.

I've also learned that cultural dissonance is the price we pay for progress. People are bound to be uncomfortable when traditions are called into question and moral habits are undermined. As feminists challenge the social conservative agenda, we have to destabilize white middle-class complacency and continue to offer a radical alternative to the sexist, heterosexist, and racist status quo.

My writing is my small contribution toward creating social change. My goal is not merely to amuse or distract and not necessarily to make people comfortable or contented. Instead, my aim is to pose questions and stimulate the reassessment of that which is taken for granted.

In a modest way, I want to engage people in discussion. You might think that writing a column is a one-way activity, but I don't

think that's correct. From their letters, their e-mail messages, their phone calls, and chance encounters, I know that people are talking back to me.

A friend asked me recently whether I'm able to change people's minds by means of what I write. Of course I'd like to think so. I'd like to believe that a reader reads the column of the day, says to herself, "I never thought of it that way before. I'm completely convinced," and immediately changes her mind. But personal change is seldom that sudden or complete. In my pessimistic moods, I sometimes suspect that what the column does is to confirm anti-feminists and other conservatives in their opposition to me.

More realistically, however, what I hope for is to provoke people, to make them pause and think a bit. Many readers say to me, "I always read your column, but I don't always agree with you." I know that my audience is not homogeneous. With very different class backgrounds, educations, and life experiences, people accept parts of what I say and call other parts into question. Perhaps the most useful lesson that writing the column has taught me is that I don't have to think the same way as other people in order to reach them. I just have to care about my subject, and care about my readers.

I hope you have enjoyed reading *Thinking Like a Woman* as much as I have enjoyed creating it. Please contact me. Let me know what you think about this book, about my feminism, and about the challenges feminists will be confronting in the next decade.

Tell me about your contribution to the cultural symphony. Tell me what you learn when you think like a woman.

You can reach me through the Department of Philosophy, Queen's University, Kingston, Ontario K7L 3N6.

1 Anna Quindlen, *Thinking Out Loud: On the Personal, the Political, the Public and the Private* (New York: Fawcett Columbine, 1993), 129.
2 Ibid., xvii, xviii.

REFERENCES

Abbott, Elizabeth. *A History of Celibacy.* Toronto: HarperCollins, 1999.

Bartky, Sandra. *Femininity and Domination: Studies in the Phenomenology of Oppression.* New York: Routledge, 1990.

Brande, Dorothea. *Becoming a Writer.* 1934. Reprint: Los Angeles, CA: J. P. Tarcher Inc., 1981.

Brownmiller, Susan. *Against Our Will: Men, Women and Rape.* New York: Simon and Schuster, 1975.

Dillard, Annie. *An American Childhood.* New York: Harper and Row, 1987.

Flack, Marjorie. *The Story About Ping.* New York: Viking Press, 1933.

Fox, Michael Allen. *Deep Vegetarianism.* Philadelphia: Temple University Press, 1999.

Gullette, Margaret Morganroth. *Declining to Decline: Cultural Combat and the Politics of the Midlife.* Charlottesville: University Press of Virginia, 1997.

Harding, Sandra, and Jean F. O'Barr, eds. *Sex and Scientific Inquiry.* Chicago: University of Chicago Press, 1987.

Heilbrun, Carolyn G. *The Last Gift of Time: Life Beyond Sixty.* New York: Dial Press, 1997.

Hurka, Thomas. *Principles: Short Essays on Ethics.* Toronto: Harcourt Brace, 1994.

James, P. D. *The Children of Men.* London: Faber and Faber, 1992.

Johnson, Paul. *To Hell With Picasso and Other Essays.* London: Orion Books, 1997.

Keller, Evelyn Fox. *Reflections on Gender and Science.* New Haven: Yale University Press, 1985.

Lakoff, Robin. *Language and Woman's Place.* New York: Harper and Row, 1975.

MacGregor, Roy. *The Home Team: Fathers, Sons and Hockey.* Toronto: Viking, 1995.

MacKinnon, Catharine A. *Feminism Unmodified: Discourses on Life and Law.* Cambridge, MA: Harvard University Press, 1987.

Mairs, Nancy. *Remembering the Bone House: An Erotics of Place and Space.* Cambridge, MA: Harper and Row, 1989.

Moss, Zoe. "It Hurts to Be Alive and Obsolete: The Ageing Woman." In Morgan, Robin, ed. *Sisterhood is Powerful: An Anthology of Writings From the Women's Liberation Movement.* New York: Random House, 1970.

O'Reilley, Mary Rose. *Radical Presence: Teaching as Contemplative Practice.* Portsmouth, NH: Boynton-Cook Publishers, 1998.

Overall, Christine. *Ethics and Human Reproduction: A Feminist Analysis.* Boston: Allen and Unwin, 1987.

_____. *Human Reproduction: Principles, Practices, Policies.* Toronto: Oxford University Press, 1993.

_____. *A Feminist I: Reflections From Academia.* Peterborough, ON: Broadview Press, 1998.

Pogrebin, Letty Cottin. *Getting Over Getting Older: An Intimate Journey.* New York: Berkley Books, 1996.

Quindlen, Anna. *Thinking Out Loud: On the Personal, the Political, the Public, and the Private.* New York: Fawcett Columbine, 1993.

Royal Commission on New Reproductive Technologies. *Proceed With Care: Final Report of the Royal Commission on New Reproductive Technologies.* Two volumes. Ottawa: Minister of Government Services Canada, 1993.

Singer, Peter. *Animal Liberation: A New Ethics for our Treatment of Animals.* New York: Random House, 1975.

Strunk, William Jr., and E. B. White. *The Elements of Style.* 3rd ed. New York: Macmillan, 1979.

Tompkins, Jane. *A Life in School: What the Teacher Learned.* Reading, MA: Perseus Books, 1996.

Werner, Jane, ed. *The Golden Book of Poetry.* New York: Simon and Schuster, 1949.